Wendy Tait's
Watercolour
Flowers

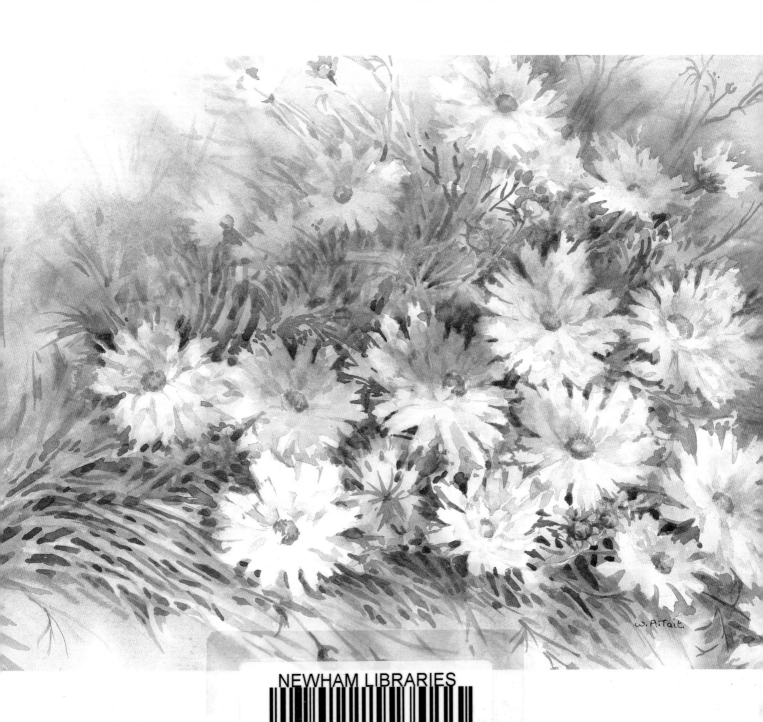

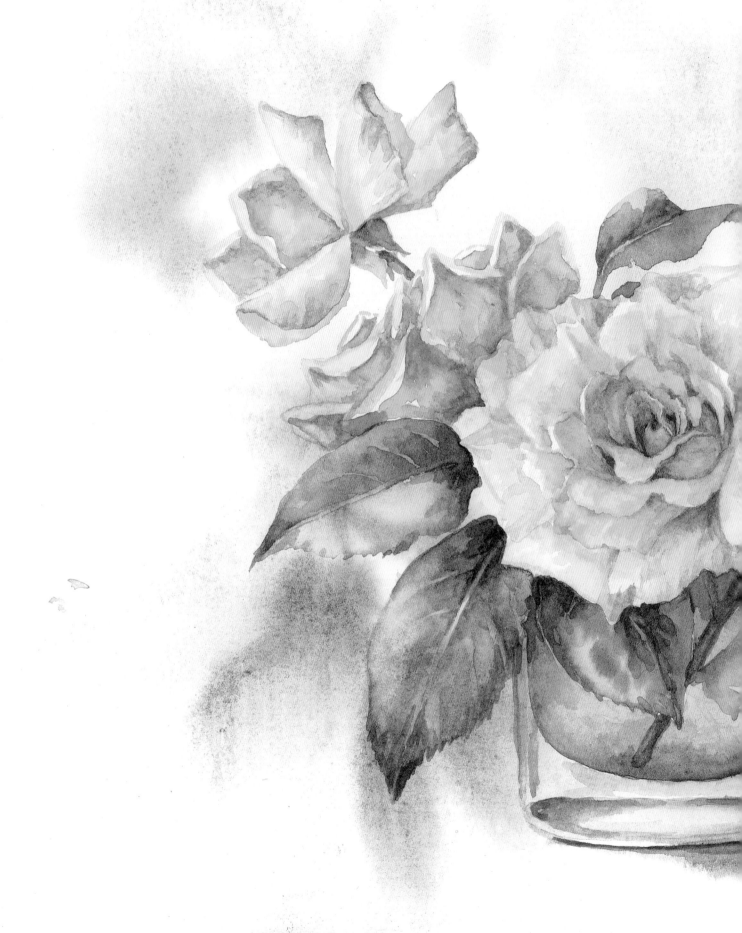

Wendy Tait's

Watercolour Flowers

Search Press

First published in 2015

Search Press Limited
Wellwood, North Farm Road,
Tunbridge Wells, Kent TN2 3DR

Text copyright © Wendy Tait 2015

Photographs by Paul Bricknell at Search Press Studios, except for pages 62, 63, 72, 78, 84 and 98, supplied by the author; and page 114, supplied by Claire Austin Irises. Used with permission. Copyright © Search Press Ltd 2015

Design © Search Press Ltd 2015

ISBN: 978-1-78221-017-7

The Publishers and author can accept no responsibility for any consequences arising from the information, advice or instructions given in this publication.

Readers are permitted to reproduce any of the paintings in this book for their personal use, or for the purposes of selling for charity, free of charge and without the prior permission of the Publishers. Any use of the paintings for commercial purposes is not permitted without the prior permission of the Publishers.

Suppliers
For details of suppliers, please visit the Search Press website: www.searchpress.com.

Publisher's note
All the step-by-step photographs in this book feature the author, Wendy Tait, demonstrating how to paint flowers in watercolour. No models have been used.

Printed in China

Dedication

For Mum, to thank her for all her imaginative talent and courage in overcoming all the odds to use her gifts throughout her life. I hope I can follow her lead.

Acknowledgements

I owe thanks to my early art teachers for giving me inspiration; and to my students who taught me so much while I was attempting to teach them!

Also to the team at Search Press for giving me the chance and the help to write this book.

Thank you to David Austin Roses and Claire Austin Irises for allowing me occasional use of the photographs from their beautiful catalogues.

Lastly, to four very special people – my children Shelley, Robin, Hazel and Murray, and to their families, for always giving me so much encouragement and support in all I do.

PAGE 1
Tumbling Marguerites
48.5 x 34.5cm (19 x 13⅝in)

I came across these daisies that had broken free from their stakes while on a painting trip visiting gardens near Ross-on-Wye. I loved their joyous, sprawling, untidy freedom and decided to paint them *in situ*. It was a showery blustery day, so I had to dash for cover several times while I painted! Very few of the flowers are pure white, as this can look very stark. The dark tones behind them make them appear white, though several are the tone of the initial wash.

PAGES 2–3
'Compassion' Roses in Blue Glass
40.5 x 27cm (16 x 10½in)

These are some of my favourite roses from my garden. I picked them early in the morning and had a lovely day painting them in my studio. The colour is so beautiful: pale pink and lilac at the edges of the petals, deepening to rose and apricot in the centre. As a bonus, they have a wonderful perfume too.

I began with a wet-in-wet background in paler versions of the colours used throughout, leaving the golden glow behind the position of the roses. The blue glass and glossy green leaves, make a lovely foil for the roses.

OPPOSITE
Margaret's Jonquils
42 x 30cm (16½ x 11¾in)

Most years I visit my friend Margaret and paint these exceptionally beautiful flowers from her garden. I love the delicacy of the white petals and the tiny bright golden centres, tipped with orange. The way they move in the cold spring breeze reminds me of Wordsworth's daffodils 'bending their heads in stately dance'. They certainly lift the spirit on dark days.

Contents

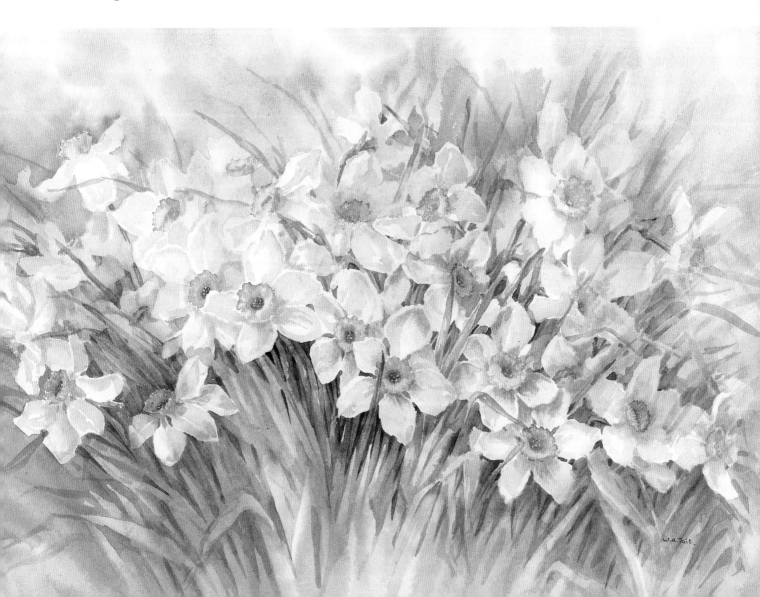

Introduction

When painting flowers, I do not make measurements, do a preliminary drawing, or trace the design out before I begin. Instead, I prefer to go straight into painting, using my brush as a drawing tool to produce soft graded washes rather than hard-edged lines. I love to wet the paper and let the myriad colours swirl about, tipping it this way and that to let the colours find their own way, and getting wonderful effects and a different background every time. I can then adapt this background to the flowers I want to paint. Although a more methodical way of painting can be easier, it can be inhibiting to the creative spirit.

I prefer to paint from the actual flower and enjoy the delicacy, detail and smell of what is in front of me, especially when I am using watercolour. However, I often use photographs taken *in situ* as reference for the backgrounds and use fresh flowers for the more detailed focal point of my painting. This way I try to get the best of both worlds.

To me, letting my imagination rule is the most important aspect of my painting – I want to enjoy being swept along with the sheer magic of the flowers in front of me. Of course, if this is not the way you want to work, I encourage you to take some of the ideas in the book and bend them to suit your own style. The way I work can occasionally seem daunting to a beginner, but the only way to help yourself improve – and enjoy yourself – is to have a go. Remember also that just because I do things in a certain way, this does not mean it is the only way.

I have many unfinished paintings – indeed, spoiled paintings where my enthusiasm has outstripped my talent – but each one is part of an addiction to the enjoyment of the painting process. Each of the unsuccessful paintings is also a learning process that is one step nearer the 'masterpiece' next time!

I have not yet reached my masterpiece, and perhaps never will, but I invite you to join me in the pleasure of painting flowers my way, and hope this book will help you to say what you want to say when you are painting flowers. Above all else, I hope that you will enjoy it.

Japanese Anemones
45.5 x 35.5cm (18 x 14in)
The simple shapes of these flowers attract me, along with the delicate shades of pink and lilac. I like the shape of the little round seed pods as a contrast to the larger flowers. I grow them with the wild purple loosestrife in my garden, which makes an ideal complement to use in a painting.

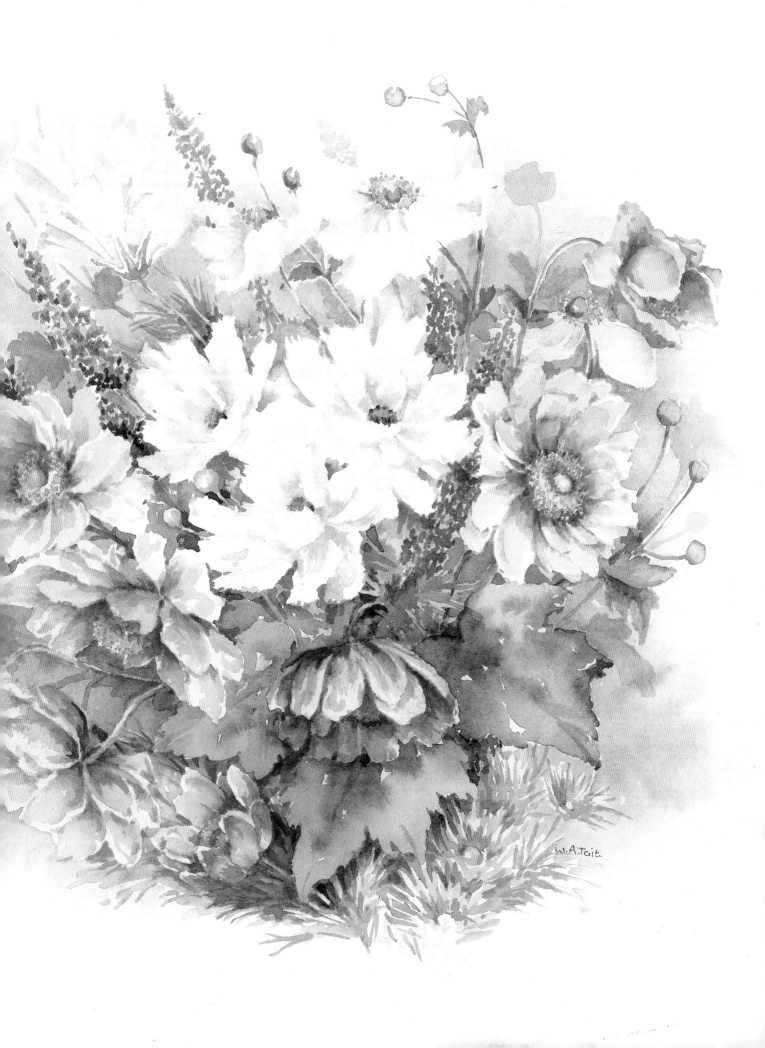

Materials

Before you begin to paint, it is a good idea to do a little research on all of the materials that are available. It can seem like a minefield at first, but it is not really necessary to buy all the latest gizmos on the market. Described on the following pages are the basic materials you will need to begin painting flowers in watercolour.

Brushes

The range of brushes available to the watercolour flower painter is enormous. Although you will not need many brushes, it is essential that those you buy are of good quality. Note that this does not necessarily mean the most expensive!

Brushes come in different sizes and shapes. They also vary by the type of hair used for the bristles. This can be natural hair, such as sable, or synthetic hair. The types of brush you buy will depend on how you want to paint. Some artists only use sable brushes, but one look at a catalogue will show you that these can be pretty pricey. Personally, I find sables too soft and prefer to use brushes with bristles made of either a sable/synthetic mix, or completely synthetic brushes.

I usually use round brushes for the majority of my painting, and have a selection of sizes: 8, 10 and 14. I also use a very small size 2 round or a rigger (a brush with long bristles) for tiny details such as twigs. I also use a 50mm (2in) flat hake brush for wetting the paper to add large washes of colour, or to wet the paper when beginning.

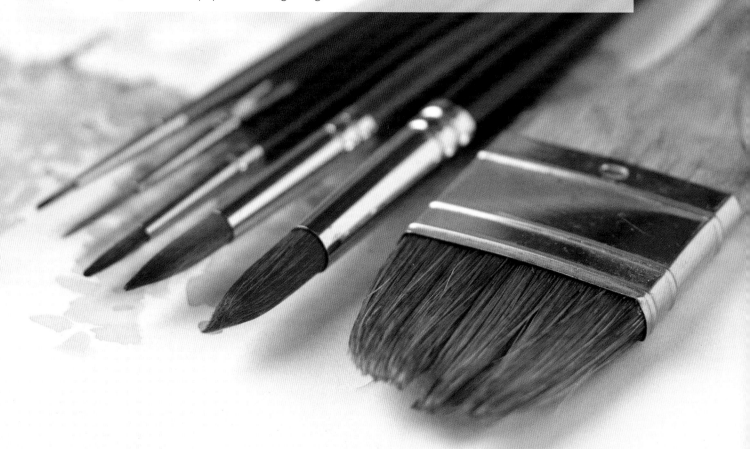

Paper

The paper you use will determine how the finished painting will look – perhaps more than you realise. Good quality paper is essential, though as with brushes, the most expensive is not necessarily the best. The paper that best suits the way you work can only be found through trial and error, so take advantage of manufacturers' offers of trial packs where possible until you find your favourite.

Watercolour paper is different from ordinary cartridge paper as it is specially made to hold water and paint without cockling. It comes in different surfaces and weights. The three main surface types are:

• **Smooth** This is sometimes called HP or Hot Pressed. As the name suggests, this is a very smooth paper with very little surface texture, or 'tooth'. This type of paper is well-suited to detailed work such as botanical illustration. I have used this paper for the inktense pencil and artbar paintings at the end of the book (see pages 136–137).

• **Not** Sometimes called CP or Cold Pressed, this paper has a slight tooth that I find suits my way of working, as I tend to work more loosely than the very detailed botanical style, but still need some detail. This middle range of paper is just right. I have used Not paper for most of the paintings in this book.

• **Rough** This paper surface is usually used for loose energetic styles of painting. It is good for dry brush work as the paint skims the surface, allowing little bits of white paper to shine through the paint, which adds sparkle to the finished piece.

Paper also comes in different weights. If you use a lightweight 190gsm (90lb) or 300gsm (140lb) paper, you will need to stretch it to get a good taut surface on which to work. I prefer to be able to just pick a sheet up when I need to paint without any stretching or other preparation. This is why I prefer a 425gsm (200lb) paper. Occasionally I treat myself to a more expensive heavyweight 640gsm (300lb) sheet, particularly when working on larger subjects.

Watercolour paints

Paint comes in many guises: oils, acrylics, inks and gouache. All have different properties and each can be used to express our response to the world around us.

In this book I use the beautiful medium of pure watercolour to express my love of flowers, supported by a select few other watersoluble paints. Good quality paint will keep its creamy properties for far longer than the manufacturers would have you believe. I think they just want to sell more paint! This said, I am often faced with students trying to reconstitute hardened old pans and tubes from their school days. This is usually a lost cause and eventually new paint is needed. Happily, a new tube or pan will last many years, so it is not an unnecessary expense.

I mainly use transparent colours, some of which are staining, which give the delicacy that I need by allowing the white paper to shine through the colour. This is in contrast to opaque colours, which I use only occasionally. Information on transparency is explained more fully in the section on glazing on page 21, but when purchasing your paints, check the tube or pan for information on the paint's transparency.

It can be a mistake to begin with students' quality paints as although they can be quite adequate, they contain a filler which makes it more difficult to get a true rich colour. I began with these until I had a class with an artist I admired. His advice was to buy a few staple colours in artists' quality rather than a box full of students' quality paints. I found this excellent advice and have followed it ever since.

Pans and tubes

Watercolour paint is sold in pans and tubes. Although I do use pans, I prefer my colours in tubes as they are immediately rich and juicy. I squeeze paint from the tubes into the small wells around the edge of my palette, replacing the paints only if they dry out too much. These wells of paint can be left for months as they will 'come alive' each time water is added.

Other materials

As well as the main materials of paper, paint and brushes, you will need a few other supporting tools and materials. These are my choice to help give new artists some guidance, but not all of them are strictly necessary. You will probably have some of them already so can avoid some of the expense.

Palette I use a plastic palette, as it is cheap and easy to transport. I like one with small wells around the edge, into which I can squeeze colours from the tubes, and larger divided wells in the middle for mixing. A bigger one is ideal for studio work and a folding one fits into my bag without spills.

Small plastic spray bottle This is good for a quick dash of water to help the colours merge if the background is not wet enough.

Pencils and sharpener I use a variety of pencils, ranging from soft to hard, for drawing and sketching; though never to draw before painting – it is too tempting to erase and alter lines, which spoils the surface of the paper. If you feel you must place the flowers on the paper, draw a curve very lightly to give a guide, then leave the pencil mark when you have finished painting.

Drawing pen A fine-tipped permanent sepia pen is sometimes useful for adding a little definition in the last stages of a painting. A size 01 will be useful for most work.

Sketchbook I have a lot of these in varying sizes and enjoy using them to record different ideas when I do not have my paints with me.

Water pot I have several of these so that I always have a source of clean water to hand. In my opinion, the divided ones are best.

Masking fluid, old brush and colour shaper tool Sometimes called frisket, masking fluid is a rubber-based liquid that is used to temporarily protect areas while you paint. I apply it to the paper with an old brush or a rubber shaper tool. The latter is ideal as the fluid can be rolled off it when dry. Never use a good brush to apply masking fluid as it will quickly ruin it.

Soft rag and/or kitchen paper I am known for my preference for using a soft rag instead of kitchen paper. (My students call it my comfort blanket as I am rarely without it!) I use it mainly to adjust the amount of water on my brush to exactly the right amount of dampness. I have it on my lap or in my hand most of the time. I use kitchen paper if I need to lift out colour or water quickly.

Drawing board You can use a sheet of heavy card, wood or plastic to support your paper, or there are pads of paper that have stiff card at the back so that you do not need a board at all. I like to be able to move the paper to allow the paint to flow, so I use a bulldog clip to attach the paper to the top of the board so I can easily move the paper to assist the flow of paint or water.

11

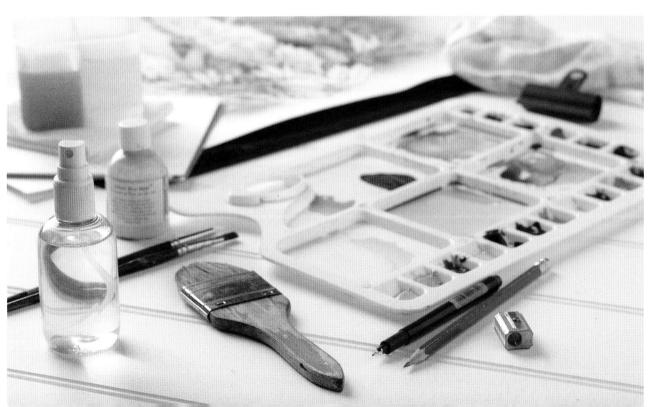

Colour and tone

My palette

It is impossible for me to demonstrate the myriad hues that can be mixed from the colours I have used in this book. All I can do is give you a guide to the way I work and explain why I have chosen the colours I use.

My colours are, of course, specifically for flower painters, with the earth colours used by landscape painters missing. Flower colours are brighter, richer and more intense; it would be impossible to reproduce the glowing colours of florals if they are missing from your palette. The emphasis is on transparent yellows, pinks and blues. The amount of transparency in the colour on the paper is determined by how much water is added – you can read more about applying your paint on pages 16–17, and on colour and tone on pages 20–21.

I do not feel I need black in my palette, although I have seen other artists use it successfully. For example, some mix a touch of black with lemon yellow to make dark green. My personal choice for a similar dark green would be to use indigo in my mix. You can read more about my green mixes on pages 26–29.

The majority of my paints are transparent, though I do use some opaque colours, such as Naples yellow and cadmium orange. The following colours are perennial favourites of mine, and make for a good basic palette.

Lemon yellow A clear fresh yellow that I often use in my initial background wash.

New gamboge yellow A golden buttercup yellow.

Quinacridone gold A very warm, deep, yet transparent gold.

Cadmium orange Although this is opaque, a little mixes well with permanent rose to make a range of pinks and reds.

Permanent rose This beautiful clear rose colour is a 'must-have' for flower painters.

Quinacridone magenta Another essential, this is a strong blue-pink.

Cobalt blue A must in any palette, this is a cool clear blue.

French ultramarine A rich, warm deep blue.

Cobalt violet A rich deep purple.

Sap green A mid-green I sometimes use in my green mix.

Indigo This is to be used vary sparingly as it is very intense. Not to be confused with my other blues. A little mixed with a lot of water can be used for shadows on white flowers, but it can look cold. I mainly use it in my green mix.

Brown madder A rich brown, which can be mixed with cobalt violet for rich darks, such as those used in the centres of pansies.

I have recently extended my range of colours and occasionally add the following:

Naples yellow This warm creamy yellow should be used sparingly, as it is very opaque.

Cerulean blue A very cool blue with a green tinge.

Perylene violet A rich brown violet with red tones.

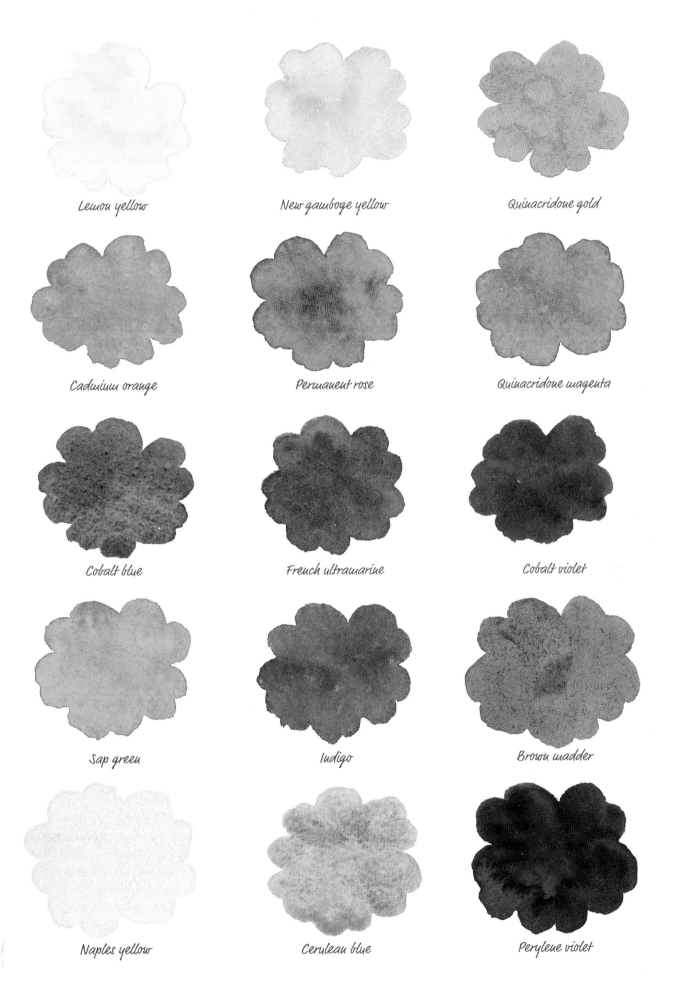

Lemon yellow

New gamboge yellow

Quinacridone gold

13

Cadmium orange

Permanent rose

Quinacridone magenta

Cobalt blue

French ultramarine

Cobalt violet

Sap green

Indigo

Brown madder

Naples yellow

Cerulean blue

Perylene violet

Preparing your paints

Laying out your palette

When laying out the colours on a palette, I prefer to use colours from a tube as I know that they are moist and ready to use. Give them a decent squeeze to fill most of the small colour wells, but not so much that they overflow (see the image on the right).

I usually fill the palette with the full range of colours (see page 13), even if a particular painting uses only some of the colours. I prefer to lay the paints out in groups, and in the same order. When I am concentrating on the painting and not necessarily looking at the palette, it is very helpful to have the palette laid out in a familiar way. Time is sometimes of the essence when you are painting and I find this helps.

I begin by putting out two identical lemon yellow wells. It is so annoying if you find a colour is contaminated with another and you inadvertently pick it up on your brush. Having two wells of particularly bright colours, like lemon yellow, means that you have one you can keep pure, while the other can be used when adding it to mixes. It does not matter so much if this second well gets a little of another colour mixed in.

The next group is made up of indigo, sap green and quinacridone gold. These form the basis of my basic green mix (see page 26). I then lay out a group consisting of new gamboge yellow, cadmium orange, permanent rose, quinacridone magenta and cobalt violet.

Next to this I lay out the blues: French ultramarine, cerulean blue and two cobalt blues. As with the lemon yellow wells, one cobalt blue is to use with greens and one is kept pure or mixed with violets. Perylene violet, brown madder and Naples yellow are then slotted in the remaining empty wells.

Occasionally, when I notice that several colours have become a bit old and gritty, I will have a spring clean by washing the whole palette clean and beginning again.

Colours laid out in the wells, squeezed from your tubes of paint. Pure colours can be left in the small wells for months, refreshing and cleaning them with water or adding new paint on top of the used colour when necessary.

A palette with watery washes prepared in the mixing wells.

Creating washes

To begin a painting, you need to prepare paint in your palette wells. I usually start with watery washes of paint, which will be dropped onto wet paper to form a light background. As I work through a painting, I gradually add more detail and darker tones, both of which require you to use stronger mixes of thicker paint.

The ratio of water to paint will depend on the area you wish to cover. Using less paint and more water will result in a fluid wash suited to large areas, while a very thick mixture of paint with little water would only be used for small details.

When preparing my paint, I make watery mixes of colour in the large mixing wells of my palette. As I work, I add more pure colour to these washes to thicken them, and ensure that I use the same colours to finish a painting as I used to begin it.

Washes of lemon yellow, cobalt blue, cobalt violet and a pale green mix are the usual background colours with which I begin most paintings; though I vary the amounts of each colour according to the subject.

14

The advantage of large mixing wells

As you work through your paintings, you will use the large mixing wells in the palette to create your mixes, which will begin to dry as time passes. The in-progress palette pictured below shows examples of the half-mixed colours, dried edges and lots of different tonal variations. These are very valuable: as you go through the painting you may suddenly see the very colour or tone for which you are looking. Bring them to life with just a splash of water and they can provide exactly what you need.

I tend to keep most of these 'messed-up' colour mixes throughout a painting, only cleaning the large mixing wells in the palette when I begin a new project. As long as you reserve particular wells for like colours – blues in one, greens in another, for example – you will achieve lovely and sometimes unexpected mixes.

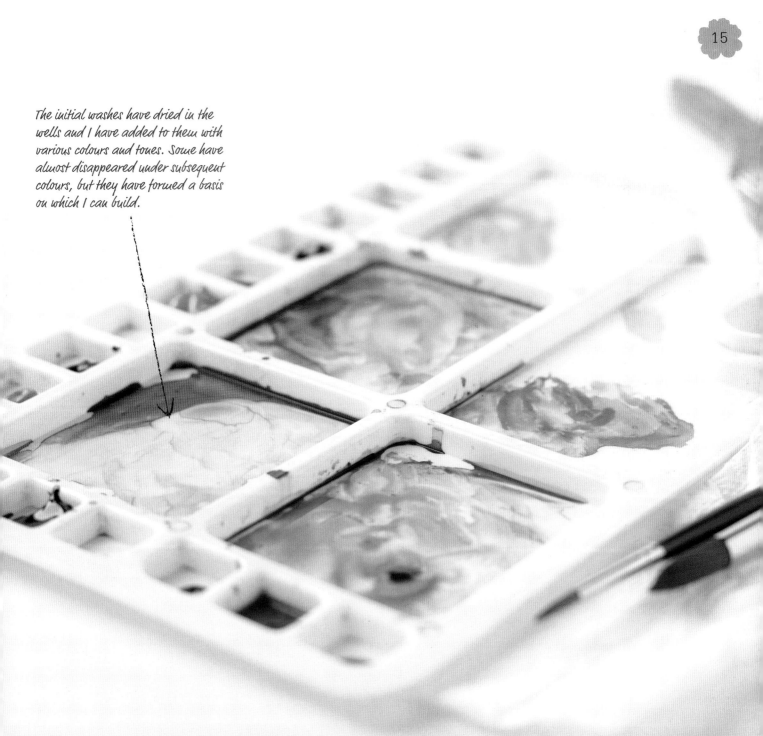

The initial washes have dried in the wells and I have added to them with various colours and tones. Some have almost disappeared under subsequent colours, but they have formed a basis on which I can build.

Applying your paint

Generally speaking, the ratio of paint to water increases as you go through a painting, which means that a wet-in-wet background – one produced by wetting the paper all over first with a large brush and clean water, then dropping colour into the wet surface – will use much more water than subsequent layers, where you use less dilute mixes to add smaller, more controlled details to develop the painting. The way that you apply these different consistencies of paint is important to help you achieve the effects you want.

These pages explain how to get the paint onto your brush, and how to get that colour onto the paper.

16

How to use your brush

The way you use the brush is important. It is not just the point that can be used. The full body of hair holds a huge reservoir of colour and water which is there to be used. Loading a brush simply means filling it with wet paint. It is surprising how far a brushful of paint will go when it is loaded correctly. It is a good idea to practise on a spare piece of watercolour paper to see how the paint and brush can be used before you begin your flower painting.

T I P As explained on page 8, a good quality brush is vital. Only using different types will show you the one best suited to the way you work.

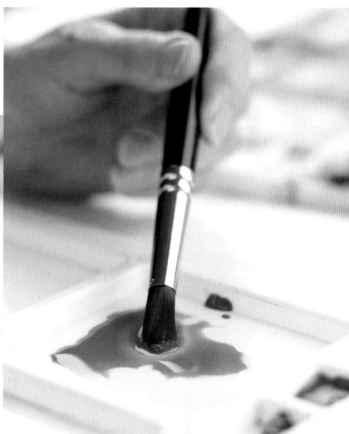

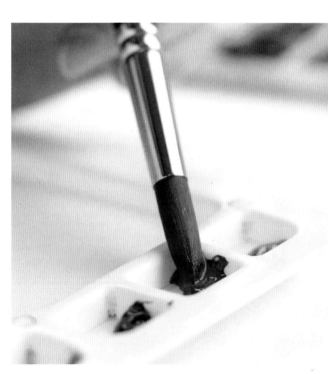

Picking up your paint

Wet the brush by dipping it into your water pot until it is dripping wet. You may need to repeat this once or twice to fully saturate the brush. Push the point gently into the neat colour in the well. Lift the brush over to the palette repeatedly to create a well of colour.

Loading your brush

Roll the brush in the well of colour, twisting it to soak the dilute paint up into the bristles.

Getting the paint on the paper

My flower painting technique uses two basic ways of getting the paint on to the paper: using the point of the brush and using the whole side of the bristles – the 'body' of the brush.

Using the point is useful for adding small details and strengthening tone while the body of a loaded brush can create a smooth wash without hard lines. This is especially useful when covering larger areas.

17

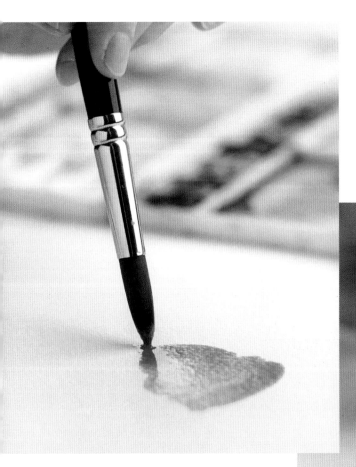

Using the point

Take the loaded brush to the paper and begin with the full brush on the paper, releasing the pressure as you draw it along so that it finishes on the point.

T I P *Use a bigger brush for the majority of your painting, as this will give a fresher effect with fewer fiddly lines in a wash. Keep the small brush for tiny final details.*

Using the body of the brush

Hold a fully loaded brush to the paper, touch the point on the paper, then apply pressure to splay the brush out as you move it. Lift gently as you go, to finish on the point again.

The wet-in-wet technique

This technique produces soft effects that are perfect for looser backgrounds.

1 Wet the paper with clean water. Use a large hake brush and saturate the paper. It should have a gloss of water as shown.

2 Load the brush and drop in your palest colour.

3 Repeat the process for the other pale colours. There is no need to rinse the brush for the very lightest hues.

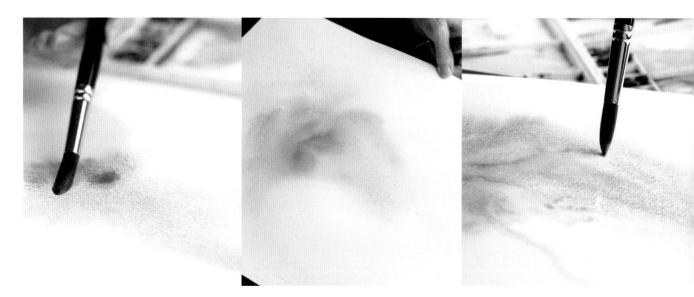

4 As you work into the deeper colours, rinse your brush when you change between them. You can continue adding different colours while the paint remains wet, and they will merge into one another.

5 You can tip and tilt the board to encourage the diffusing colours to merge further; giving you some control over where they end up.

6 While the paint remains wet, you can drip paint from a fully loaded brush into the mix.

T *If the colour does not run and merge, it is not wet enough. Use a*
I *spray bottle to add more water, then add more colour with the brush.*
P *This stage must be done quickly in order to avoid hard edges forming.*

The wet-on-dry technique

Applying paint to dry paper offers you more control over where the paint will go than with the wet-on-wet technique. This makes it perfect for later stages or more detailed areas of your flower painting.

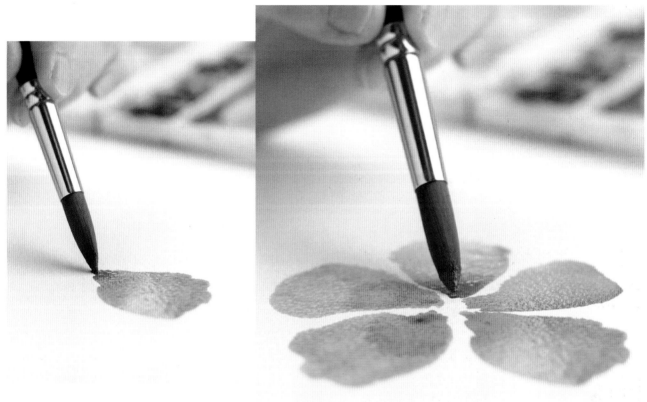

1 Ensure the paper is dry, load a round brush with colour and use the body of the brush to apply the paint. Draw the brush down while releasing the pressure, allowing the brush to come back to a point to create a petal shape.

2 Repeat the process, adding four more petals around the central point. Leaving small gaps between the petals ensures that the neat paint which is applied using the point of the brush flows only within the area of wet paint created using the body of the brush.

T I P

As you lift the brush away, it will deposit a little more paint at the point, creating a slightly darker tone. This can be useful when creating form.

This effect can be heightened by reloading your brush and using the point to touch more colour into the wet paint in this area.

Colour and tone with washes

It can sometimes be confusing when artists talk about colour and tone. I have tried to simplify it with these examples. The tone of a paint colour changes when it is made paler or darker. In watercolour, this is changed by the addition of water to the paint.

When a tube of colour is squeezed onto the palette, then picked up with the brush, this is called the pure colour. When water is added, this dilutes the colour and enables different tones of the same colour to be painted. The more water added, the paler the tone of that colour.

Throughout the book I have given tonal values for my colours: numbers from 1–10; with 10 being the pure colour (darkest tone) and 1 a very dilute light tone. These numbers are only a guide, as some colours are stronger than others so have more depth to begin with. For example, perylene violet is naturally darker in tone than lemon yellow.

On this page I have used naturally midtoned colours to illustrate this principle: new gamboge yellow, permanent rose and cobalt blue. The examples show three diagrams of flowers, each painted with solid colour straight from the palette. The bars of colour to their right show how the tone changes with the addition of water. Painting in such a way that the colour gradually fades out is called a graded wash. This technique can be used in very small areas, such as individual flower petals, or in larger areas, like backgrounds or skies.

Making a graded wash

It is helpful to make a tonal chart yourself, and to check the tonal number throughout your flower painting. To do so, load your brush with plenty of colour, then gradually add more water as you advance down the shape until you end with tone 1. This needs to be done quite quickly while the paint stays wet.

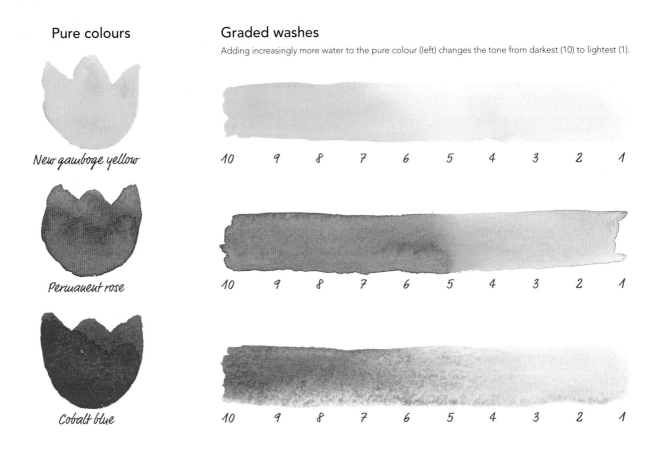

Pure colours	Graded washes

Adding increasingly more water to the pure colour (left) changes the tone from darkest (10) to lightest (1).

New gamboge yellow — 10 9 8 7 6 5 4 3 2 1

Permanent rose — 10 9 8 7 6 5 4 3 2 1

Cobalt blue — 10 9 8 7 6 5 4 3 2 1

Flat washes and overlaying

Because the watercolour paints I use are mostly transparent, some of what is underneath can be seen. Where a wash of paint is laid over clean paper, this ensures the colour is bright and fresh. However, when a light tone is laid over another colour, a mix is produced. This is called glazing, or layering, and an example can be seen below.

Overlaying graded washes

Graded washes are used extensively on the following pages – often mixing different colours within the wash – but the basic principle of tone, meaning either a paler or deeper version of a colour, remains the same.

The flower below right has been painted with the same basic colours as shown opposite, but they have been allowed to mix a little with the next petal of another colour. You do not have complete control over this process, but this is an example of watercolour ruling the artist and not the other way round! This can be a happy accident; the best way to approach watercolour is to be relaxed about it and be prepared to be constantly surprised by the way it behaves. That way different effects can be welcomed rather than worried about.

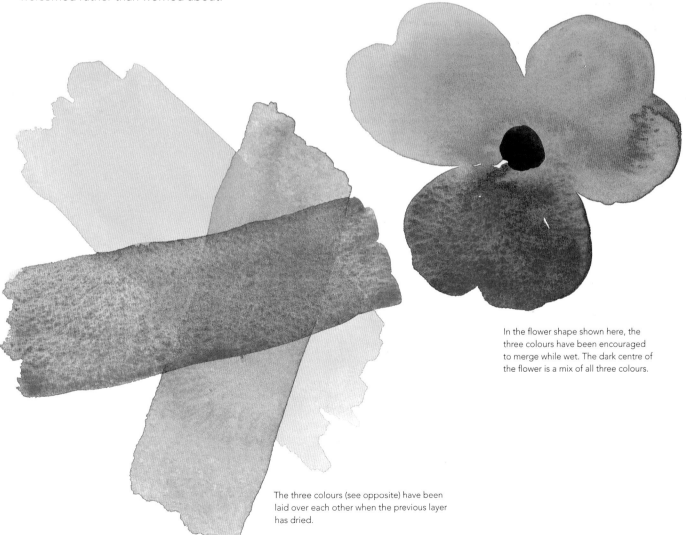

In the flower shape shown here, the three colours have been encouraged to merge while wet. The dark centre of the flower is a mix of all three colours.

The three colours (see opposite) have been laid over each other when the previous layer has dried.

Creating form with tone

The following pages show simple paintings made with just three or four very similar colours, each of which demonstrates how you can use a limited palette to create a painting made up of tonal values. Each of the three flower paintings includes a coloured background with no white areas; so everything you see is produced through the use of tone.

In each case, I began by mixing puddles of the range of colours (yellows, in the case of *Golden Yellows* on the facing page) on my palette. I then wet the paper thoroughly with clean water and dropped in the various paints adjacent to each other. By tipping the paper this way and that I let the colours merge a little. This results in a relatively light-toned background as the colours were added to already wet paper, further diluting them.

The paintings were allowed to dry, then I drew the images with a drawing pen, taking advantage of the swirls of different tones that the initial paint formed in the background. I then painted as I normally would, using stronger tones of the colours for the petals, and sometimes using the background colour that was already there. I then added deeper tones where necessary, gradually building up the colours using progressively deeper tones. The deepest tones in each case were used for the leaves.

The deepest tones were put in last of all in small touches, using the paint almost neat, with hardly any water added.

T I P

The darker the tone, the smaller the area covered. If you need to 'fiddle', only allow yourself to work on these small dark areas, never the lightest parts or freshness will be lost. Learn how to recognise tone, not just colour.

OPPOSITE
Golden Yellows
28 x 38cm (11 x 15in)

With the background in place and dry, I drew the basic shapes of the sunflower with a fine pen, then began using lemon yellow to develop the shapes. I introduced new gamboge yellow and quinacridone gold as I went along, working from lighter tones to darker tones. Compare this painting with the two overleaf to see how the darkest tones are reserved for small details, whatever the colour.

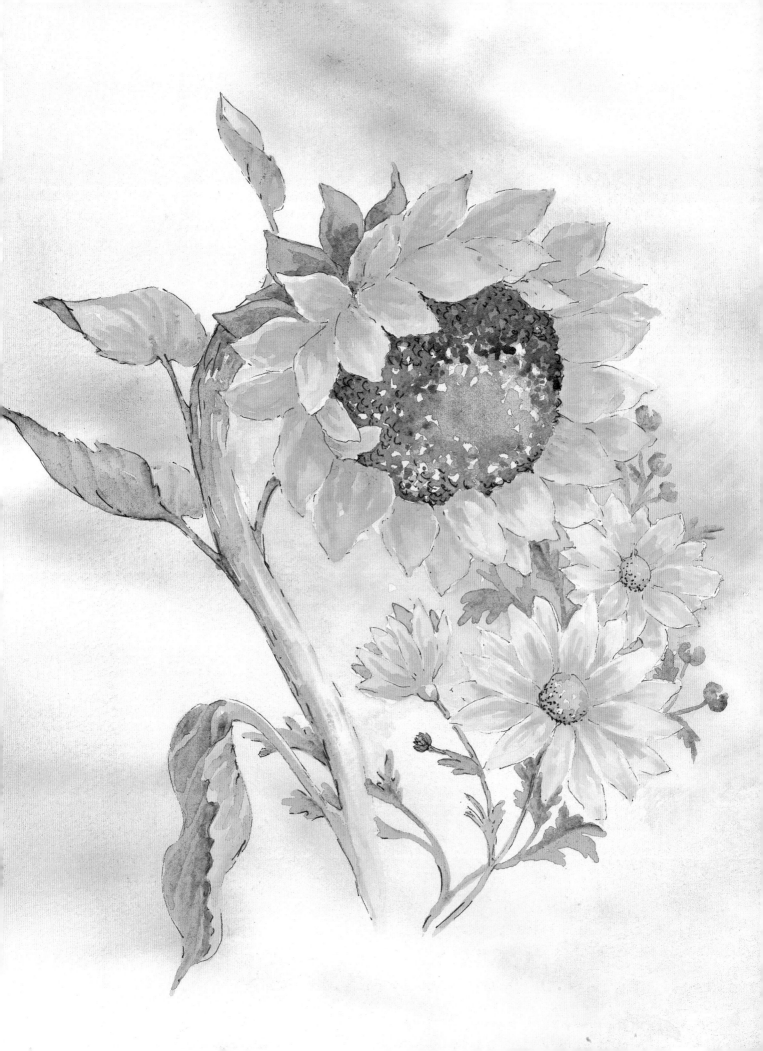

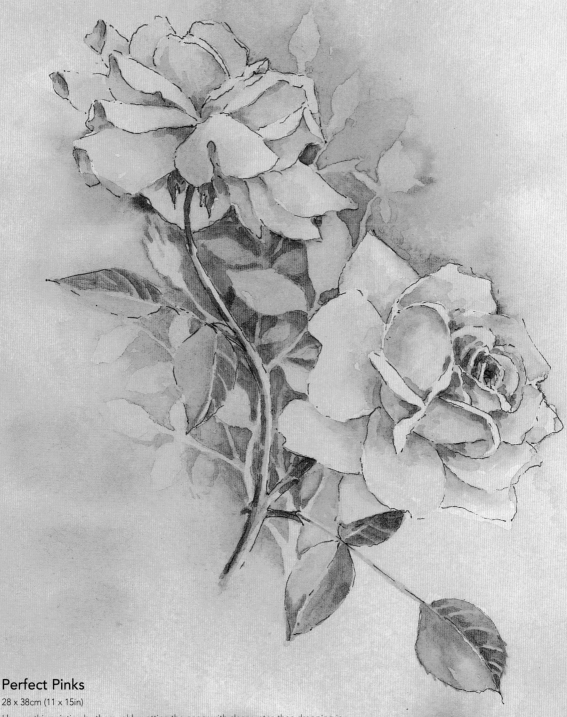

Perfect Pinks

28 x 38cm (11 x 15in)

I began this painting by thoroughly wetting the paper with clean water, then dropping in varying amounts of the three colours I use for pinks and reds: cadmium orange, permanent rose and quinacridone magenta. I used the same technique as for *Golden Yellows* (see page 23), dropping in various amounts of the three colours onto the wet paper.

 The background wash was used for the palest tones of the flowers. I then drew the rose with a drawing pen and deepened the tones to give form to the flowers using a pale mix of cadmium orange and permanent rose.

 I finished the painting by using deeper tones of permanent rose to darken the background wash behind the roses in order to bring them forward, then painting still deeper tones of the same colour negatively between the leaves.

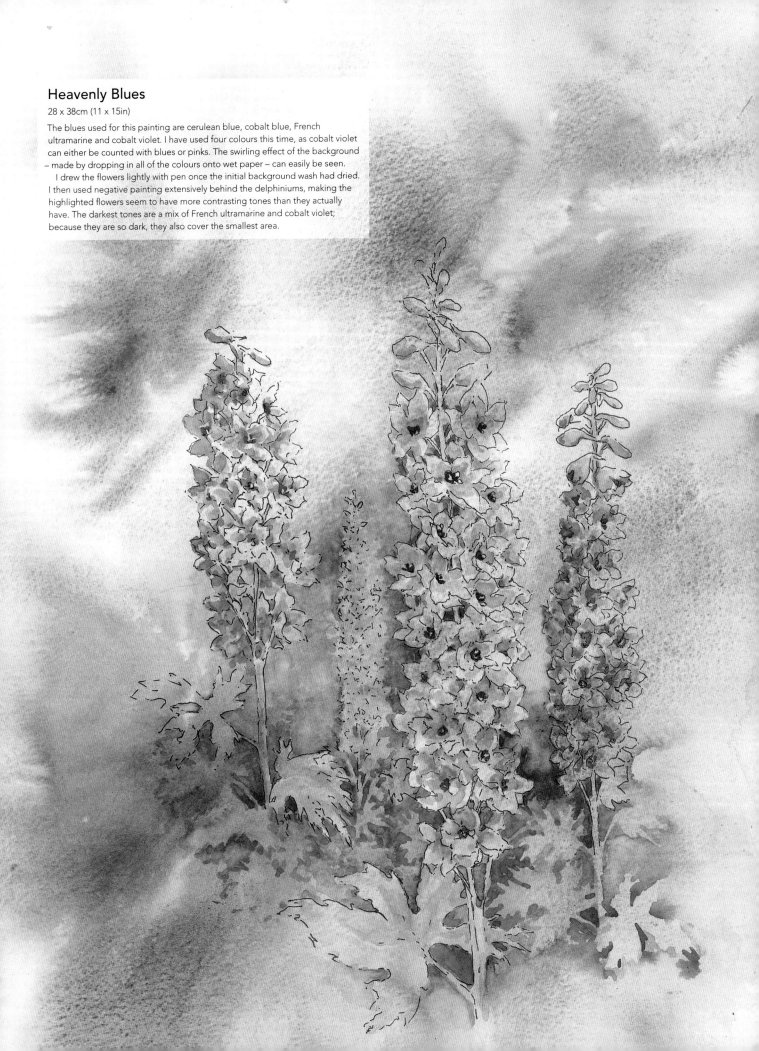

Heavenly Blues

28 x 38cm (11 x 15in)

The blues used for this painting are cerulean blue, cobalt blue, French ultramarine and cobalt violet. I have used four colours this time, as cobalt violet can either be counted with blues or pinks. The swirling effect of the background – made by dropping in all of the colours onto wet paper – can easily be seen.

I drew the flowers lightly with pen once the initial background wash had dried. I then used negative painting extensively behind the delphiniums, making the highlighted flowers seem to have more contrasting tones than they actually have. The darkest tones are a mix of French ultramarine and cobalt violet; because they are so dark, they also cover the smallest area.

My green mix

Greens can be difficult as there are so many colours and tones involved. They are very important to get right, especially in a flower painting as they must never have a stronger presence than the flowers. The ideal is for your greens to create a natural background to support the flowers themselves. Large expanses of green should be avoided by breaking them up tonally, either with smaller flowers or lighter areas. If the green needs to be very dark – behind a focal flower, for instance – then it should cover only a very small area.

My basic green mix is lemon yellow with a little indigo added. Adding more indigo gradually makes the mix deeper in tone. It is important to remember that when the tone of colour needs to be deeper, the colour also needs to be denser. This means that you need to add both more yellow and more indigo to the mix in order to make the mix thicker. By varying the ratio of the colour and water, I can achieve a great deal of variation with just these two paints. The leaves to the left show some of the variations.

You can then experiment with finding out what happens to the green mix when you add other colours, such as sap green, cobalt blue, quinacridone gold and indigo. On the following pages, I show some simple mixes of different greens, along with notes on how they were mixed.

There are so many different greens and artists usually have their favourite combinations, so it is worth experimenting to find which mixes work for you. It may help to look at the leaf diagrams on this and the following pages to see the mixes that I use, and then try them out.

The basic green mix

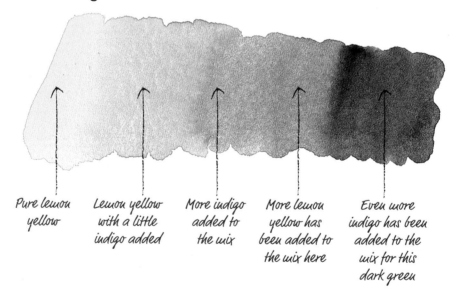

Pure lemon yellow

Lemon yellow with a little indigo added

More indigo added to the mix

More lemon yellow has been added to the mix here

Even more indigo has been added to the mix for this dark green

The simple leaf shapes to the left show examples of the basic green mix of lemon yellow and indigo in different proportions. The topmost is almost pure lemon yellow, and increasing amounts of indigo are added for those further down. Note that more lemon yellow is added alongside the indigo, in order to help thicken the mix for the deeper green mixes.

OPPOSITE
Leaves
28 x 38cm (11 x 15in)
The leaves on this page show a number of different greens, painted to show the tones within the colours. I began by dropping different green mixes onto wet paper and letting them blend. I drew some of the leaves with a pen, while others were painted straight on top.

The ivy and holly are tonally very similar, but this is achieved with the addition of different colours to the basic green mix: quinacridone gold for the warm green of the ivy and cobalt blue for the cool green of the holly.

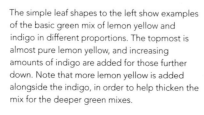

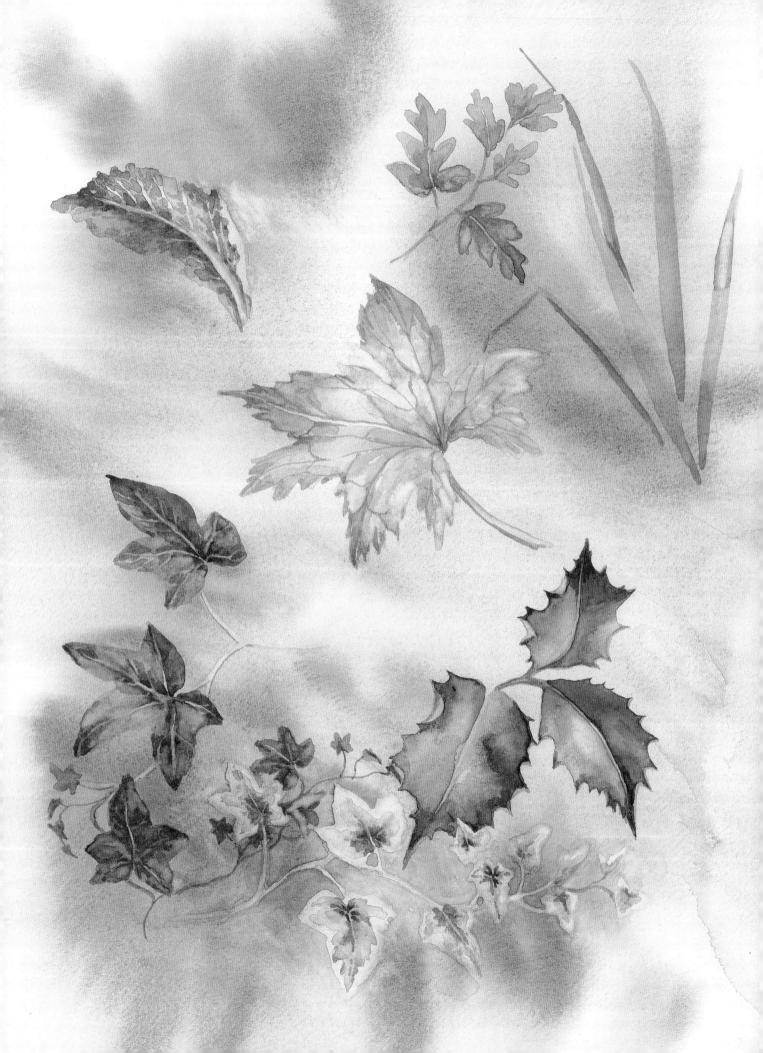

Other green mixes

While versatile, the basic green mix is not suitable for all flowers and foliage, so experiment with adding varying amounts of the following colours, according to the colour and tone required: lemon yellow, quinacridone gold, sap green and indigo.

Other colours can also be introduced for particular effects. The following are my most often used green mixes:

- **Spring greens** The basic mix of lemon yellow and indigo is very fresh and particularly suitable for spring greens.

- **Summer greens** New gamboge yellow with sap green and indigo is perfect for lush mid greens.

- **Autumn greens** Quinacridone gold and indigo are the ideal basis for warm rich greens.

- **Winter greens** The basic green mix of lemon yellow and indigo, with a higher proportion of indigo, is excellent for cool winter greens.

28

T I P *Never use a green with a different base mix to the one already used in your painting. Instead, adjust the tones and colours of the green that you have used elsewhere. This will ensure a harmonious finished picture.*

Warm greens

Basic green mix of lemon yellow and indigo

Basic green mix plus sap green

Basic green mix plus quinacridone gold

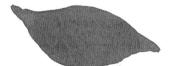

Basic green mix plus quinacridone gold and more indigo

Cool greens

A pale version of the basic green mix of lemon yellow and indigo made by adding more water

Pale green mix plus cerulean blue

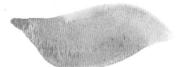

Pale green mix plus cobalt blue

Pale green mix plus cobalt blue and sap green

Pale green mix plus quinacridone gold and more indigo

Brown greens

Pale green mix (see left) plus cadmium orange

Basic green mix plus cadmium orange and brown madder

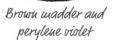

Cadmium orange and brown madder

Brown madder and perylene violet

Alternative mixes for cool greens

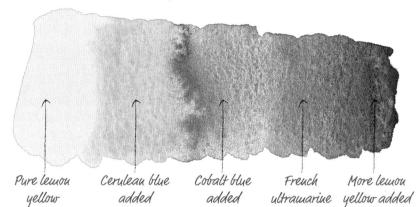

Pure lemon
yellow

Cerulean blue
added

Cobalt blue
added

French
ultramarine
added

More lemon
yellow added

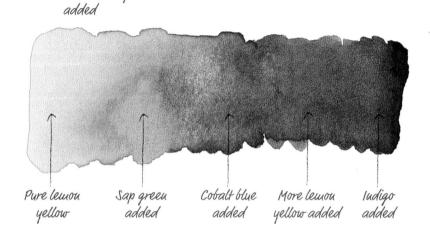

Pure lemon
yellow

Sap green
added

Cobalt blue
added

More lemon
yellow added

Indigo
added

Alternative mixes for warm greens

Pure new
gamboge yellow

Sap green
added

Indigo
added

More
quinacridone
gold added

More
indigo
added

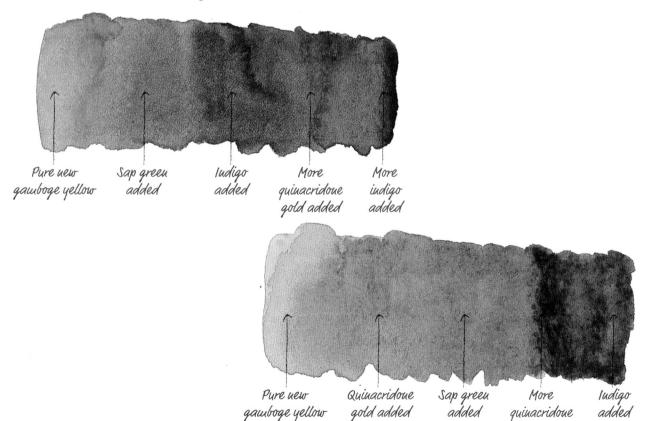

Pure new
gamboge yellow

Quinacridone
gold added

Sap green
added

More
quinacridone
gold added

Indigo
added

Simple flowers using graded washes

On page 20, we looked at simple graded washes. This page shows a number of flowers alongside washes with the same 1–10 scale of tone, so that you can see with which tone different parts of the flowers were painted.

Monochrome fuchsias

The flowers on this page show how to draw an image with your brush. Each uses graded washes in very small areas, which are easier to manage than a large wash. If you find it scary to use colours, painting in monochrome can be easier, as it helps you to understand the tones and build your confidence. It is then a simple progression to move on to working with more than one colour. As on page 20, the tonal chart on the right shows how tones change as water is added to the colour. The numbers on the tones range from 10 (darkest) to 1 (lightest).

To paint the fuchsias, I suggest using a size 6 or 8 round brush. Begin with a pale wash of indigo on your brush and draw each petal separately with one stroke of the brush. If you do not manage to get the graded wash correct first time, do not worry. The colour can be deepened in the shadowed parts later once it has dried.

To get deeper tones, mix the watercolour using less water than the first wash. Gradually build up the tones in the flowers, allowing the paint to dry in between brushstrokes. The deeper the tone, the smaller the area covered. Paint the tiny details using almost neat paint, with hardly any water.

Indigo tonal chart

10 9 8 7 6 5 4 3 2 1

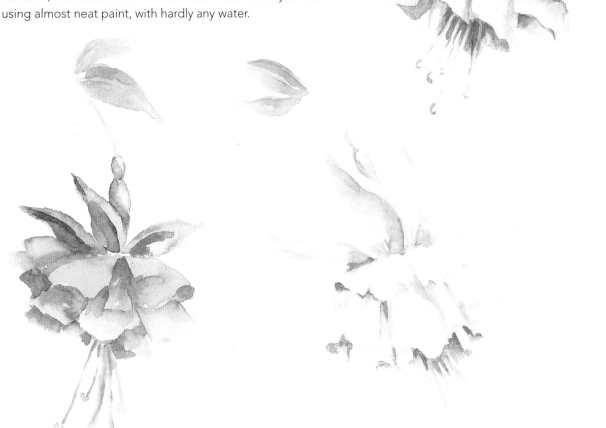

30

Colour fuchsias

Once you are confident painting the shapes in monotone, try the full-colour fuchsias on this page, using the same techniques with the tonal charts below.

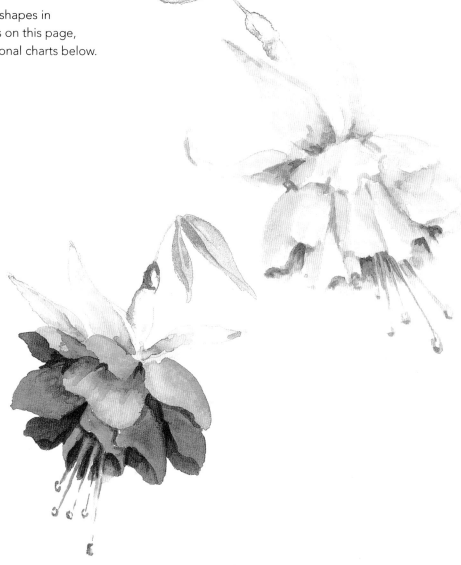
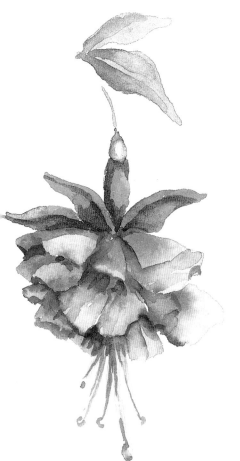

Quinacridone magenta tonal chart

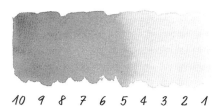

10 9 8 7 6 5 4 3 2 1

Cobalt violet tonal chart

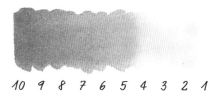

10 9 8 7 6 5 4 3 2 1

Mid green tonal chart

This mid green is a mix of lemon yellow and indigo.

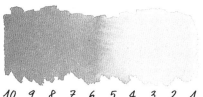

10 9 8 7 6 5 4 3 2 1

Permanent rose tonal chart

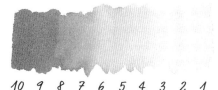

10 9 8 7 6 5 4 3 2 1

Lilac tonal chart

This lilac is a mix of cobalt blue and cobalt violet.

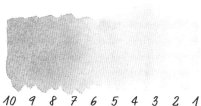

10 9 8 7 6 5 4 3 2 1

Pansies

Pansies are perennial favourites and one of the simplest flowers to paint. As with the fuchsias on the previous pages, use a size 6 or 8 round brush, and begin with a pale wash of indigo to draw each petal with one stroke of the brush. Gradually build up the tones in the petals, allowing the paint to dry in between brushstrokes, and gradually paint smaller and smaller areas with deeper tones. Paint the tiny details using almost neat paint, with hardly any water.

The same mixes and graded wash techniques used for the flowers on this page are also used for the more complex paintings of pansy buds and seed pods on the opposite page.

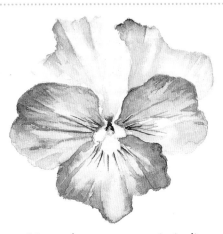

Monochrome pansy in indigo

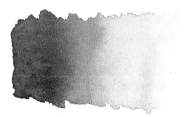

10 9 8 7 6 5 4 3 2 1

Pansies

The petals of each of these pansies were painted with different tones of one of the mixes below. The centre of each was painted with new gamboge yellow and a little of the green mix below.

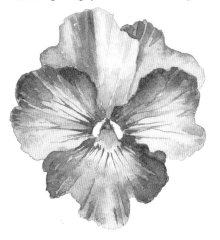

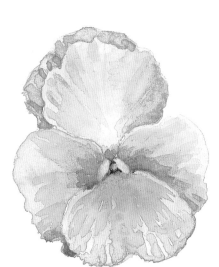

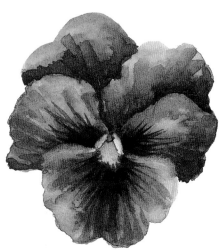

Green mix tonal chart

This green is a mix of lemon yellow, sap green, indigo and quinacridone gold.

10 9 8 7 6 5 4 3 2 1

Violet mix tonal chart

This violet is a mix of quinacridone magenta and cobalt violet.

10 9 8 7 6 5 4 3 2 1

Yellow tonal chart

This yellow is a mix of lemon yellow, new gamboge yellow, cadmium orange and a touch of the basic green mix (see page 26).

10 9 8 7 6 5 4 3 2 1

Pink tonal chart

This pink is a mix of quinacridone magenta, permanent rose and brown madder, along with a touch of the basic green mix (see page 26).

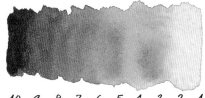

10 9 8 7 6 5 4 3 2 1

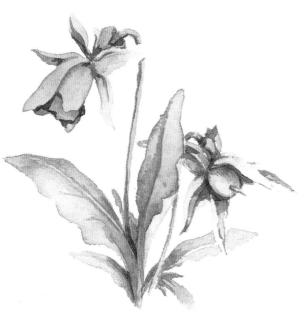

Monochrome pansy

This pansy bud and seed pod was painted using the indigo tonal chart on the opposite page.

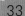

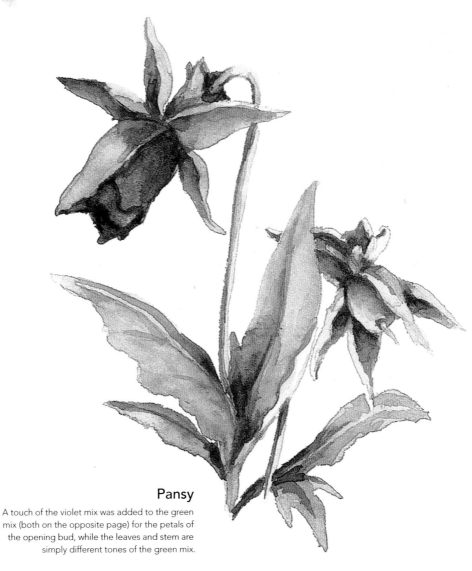

Pansy

A touch of the violet mix was added to the green mix (both on the opposite page) for the petals of the opening bud, while the leaves and stem are simply different tones of the green mix.

White flowers and negative painting

White flowers provide a particular challenge. How do you paint white flowers on white paper? The simple answer is that you do not. Instead, you look for every tiny shadow and petal edge and paint those, leaving the white of the paper as the highlight on the flower. The background colours, painted in negative around the flower, give white flowers their form. The approach of leaving the positive shapes (flowers, leaves and so forth) untouched and painting the spaces around them is called negative painting.

Snowdrops and Ivy

The critical difference between preparing a background for coloured and white flowers is that you need to reserve the areas where you want white flowers to sit, by tilting the board to leave areas of clean paper. Careful attention must be paid to how the flowers grow. Snowdrops form clumps of varying sizes, and this can be used to your advantage when planning the composition; using the largest clump as the focal point (see page 40 for more on the focal point).

I began both of the snowdrop paintings on the following pages by thoroughly wetting the paper, dropping in dilute versions of the final colours, then tipping and tilting the board (see page 18 for more information on the wet on wet technique). Once the background was dry, I began to put in the shadows of the snowdrops using a size 6 round brush and a pale blue-green mix (tone 1–2) of lemon yellow, indigo, quinacridone gold, cobalt violet and French ultramarine. The same green is used in the paler ivy leaves as the snowdrop greens, which helps to carry the colour through the painting, as do the darker tones. More indigo was added to the paler green in use for deeper shades as the painting progressed.

The shadows on the snow are a surprisingly warm mix of cobalt blue, cobalt violet and brown madder towards the back of the painting, which was made a little cooler towards the foreground with the addition of more cobalt blue. These colours are echoed in the background shadows behind the ivy leaves.

Some of the snowdrops were painted in the background shadows through the use of negative painting. This has the effect of pushing the focal point of the whitest flowers forward.

The sketches below show the main stages of how I built this painting. A soft background was laid in with clean space reserved for the flowers, and then the stems and leaves of the main group of flowers were sketched in using a brush. The white petals of the flowers were left as clean paper.

The next stage (bottom) involved bringing in deeper tones and using negative painting techniques to add the shadows behind the flowers and leaves.

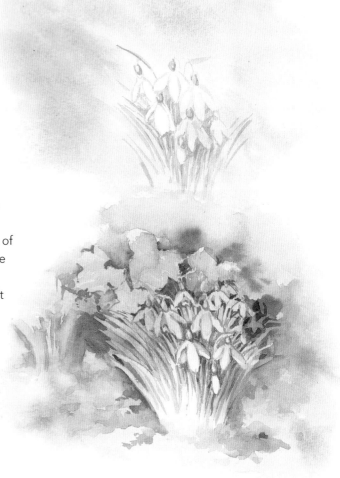

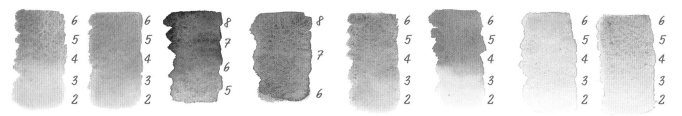

Tonal charts of the main colours and mixes used for this painting. From left to right: cobalt blue; cobalt violet; brown madder and cobalt violet; brown madder and cobalt blue; indigo and brown madder; sap green; a basic green mix of lemon yellow and indigo; and brown madder. Note that the tonal range for the snowdrops and leaves sits in the middle of the colour range, erring towards the lighter tones, while the background has a much deeper range of colours and tones, designed to bring the focal points forward.

This graded wash shows the blue-green mix (lemon yellow, indigo, quinacridone gold, cobalt violet and French ultramarine) used for the shadows behind the snowdrops. It is a combination of the mixes used elsewhere in the painting, which results in a harmonious overall finish.

Snowdrops and Ivy

28 x 21cm (11 x 8¼in)

I used a good bit of imagination in this painting as I had the snowdrops in a pot in front of me and brought the ivy in from the cold garden. There was snow on the ground, so I included it, taking care to make sure that the tonal values were subdued and the white of the snow was not brighter than the snowdrops.
This painting uses a limited palette and relies on strong tonal values. The darkest tones, which are also the warmest darks, are behind the main focal point of the largest group of snowdrops. The other groups of snowdrops are slightly softer, both in colour and tone.

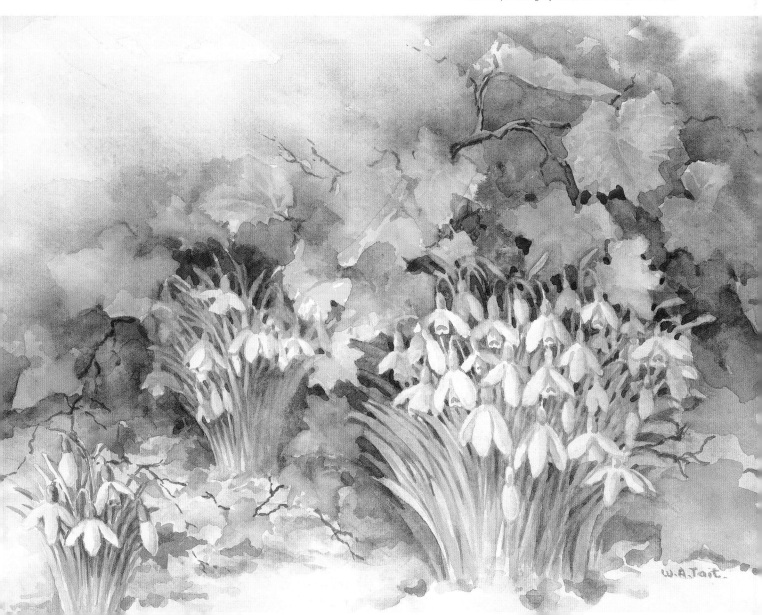

Using pen to enhance white flowers

This painting, *White Magic*, uses the same palette as *Snowdrops and Ivy* on the previous page, but I added cerulean blue, which made the colours cooler overall. I also used a sepia fineliner pen to draw the snowdrops and some of the twigs and similar background details. This gives a sharper look to the finished painting, which helps to evoke the feeling of the crispness and freshness of early spring.

Tonal range for white flowers

Below I have included some examples of the colours and tones I used for this painting. As before, I have numbered the tones I used. I did use some darker tones than shown for the final tiny dark areas, but the majority of tones used in this painting sit around the middle of the tonal range available, as shown in the tonal charts below.

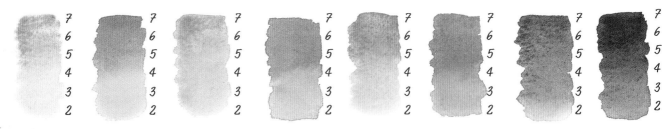

Tonal charts of the colours and mixes used for this painting. From left to right: cerulean blue; a basic green mix of lemon yellow and indigo; the basic green mix with cerulean added; the basic green mix with quinacridone gold added; cobalt blue; cobalt violet; brown madder; and brown madder and cobalt violet.

This tonal chart shows the beautiful range of shadow hues available when you combine the colours shown. It is a fascinating exercise to play with various colours, and encouraging them to merge like this will teach you so much about colour mixing.

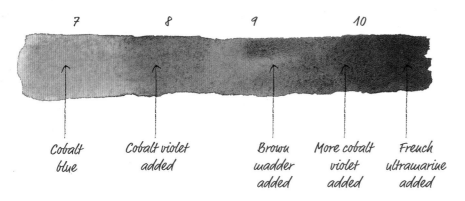

Cobalt blue — Cobalt violet added — Brown madder added — More cobalt violet added — French ultramarine added

OPPOSITE

White Magic
18.5 x 28cm (7¼ x 11in)

Slightly different colours were used in this painting than in *Snowdrops and Ivy* (see page 35), but the tonal contrasts shown are still strongest behind the main group of snowdrops. The softening tones show greater recession to include the small tree. Pen was added at the end to delineate the snowdrops and the twigs on the tree.

36

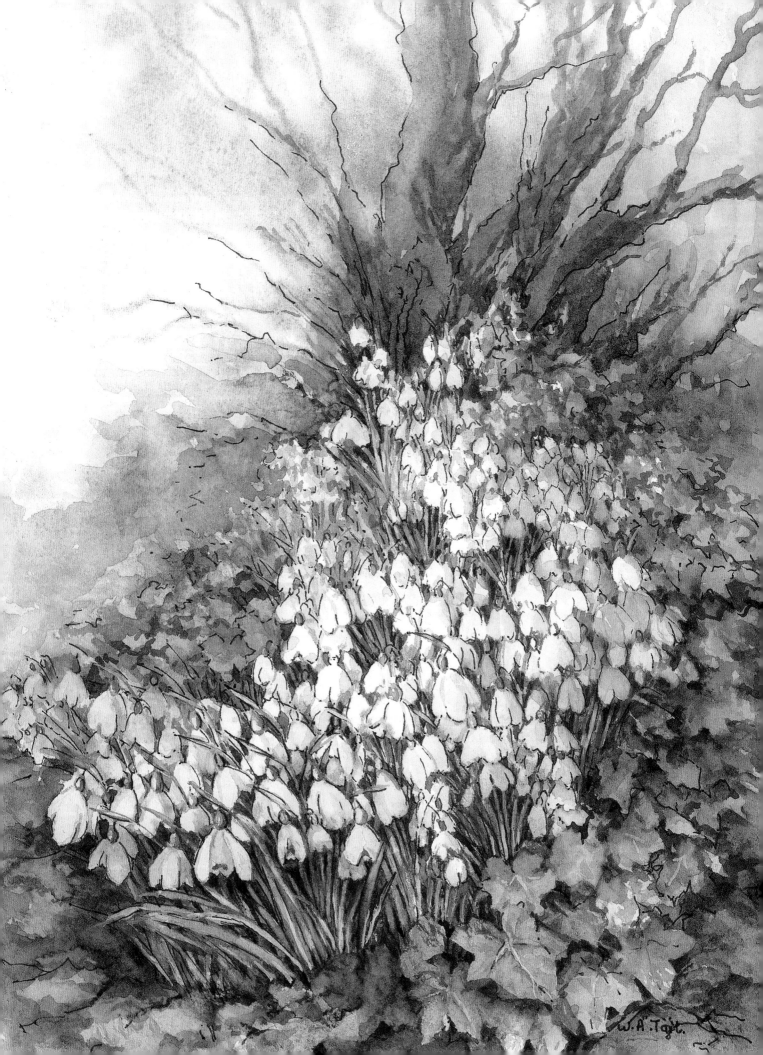

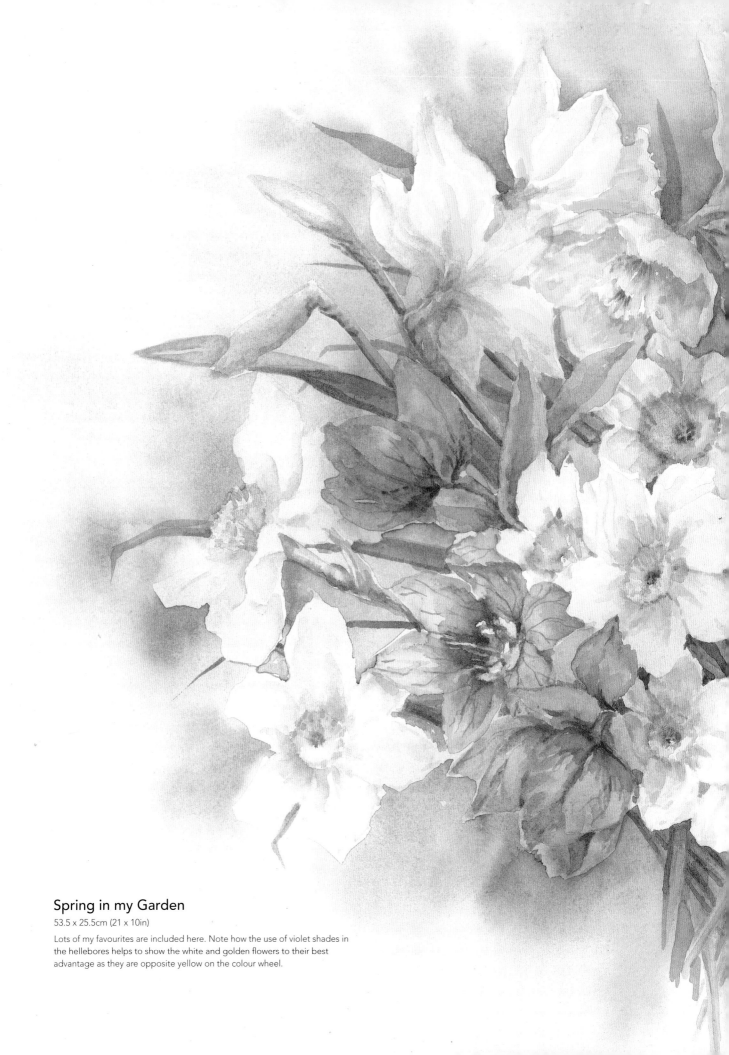

Spring in my Garden

53.5 x 25.5cm (21 x 10in)

Lots of my favourites are included here. Note how the use of violet shades in
the hellebores helps to show the white and golden flowers to their best
advantage as they are opposite yellow on the colour wheel.

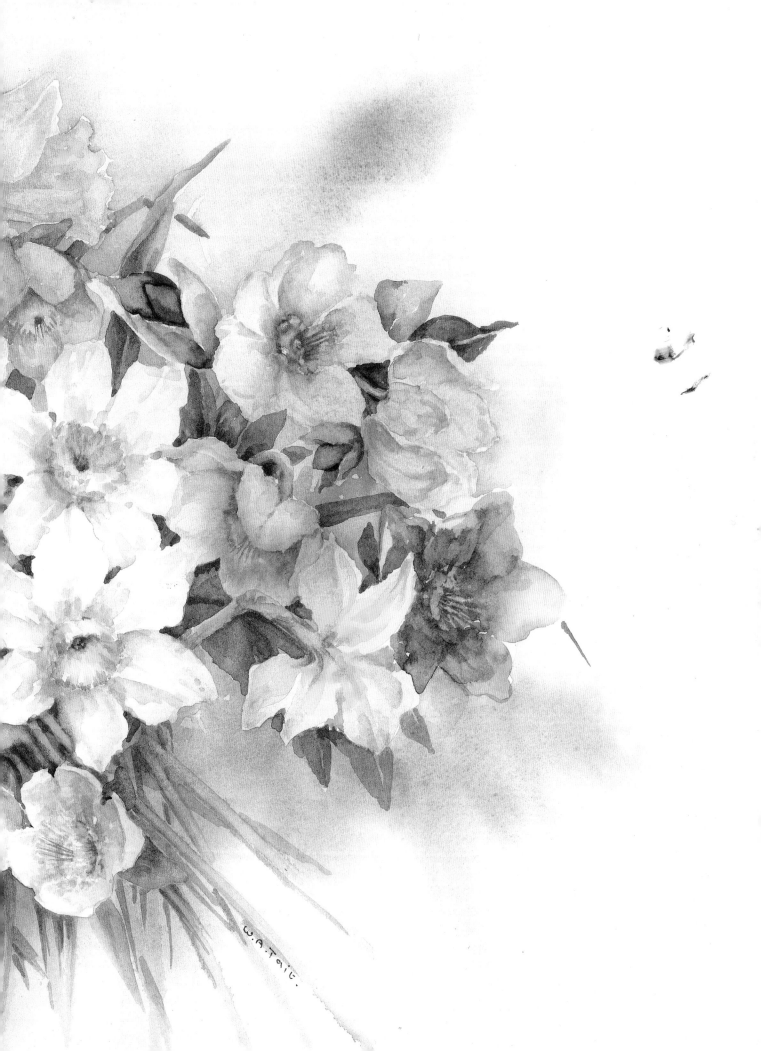

Composition

Composition is not only a big subject, it can also be a contentious one! There are several basic rules that help to compose a painting of flowers, and it is a good idea to keep them in mind as you work. As with most aspects of painting, rules on composition can be – and often are – broken. Some experienced artists deliberately flout the rules and still achieve wonderful results, but when setting out, having an understanding of the rules is a great help.

The focal point

A focal point is a particular point of interest in your painting, and the eye should be drawn to it. I think of the flower at my focal point as my 'ballerina' and all the surrounding flowers, leaves and other parts of the painting as the supporting cast. Everything else takes second place to the ballerina, which can be a group of flowers or a single bloom.

Some ways of drawing the eye to the focal point include using lines to lead the eye. Stems, blades of grass or branches are excellent in this role.

The eye is drawn to high contrast in both tone and colour, so keep the darkest darks and lightest lights you use in the painting together in the focal point. You might consider using different-coloured flowers here, too. Size and detail also attracts the eye. Making your ballerina larger than the other flowers or elements in the painting will help draw the eye.

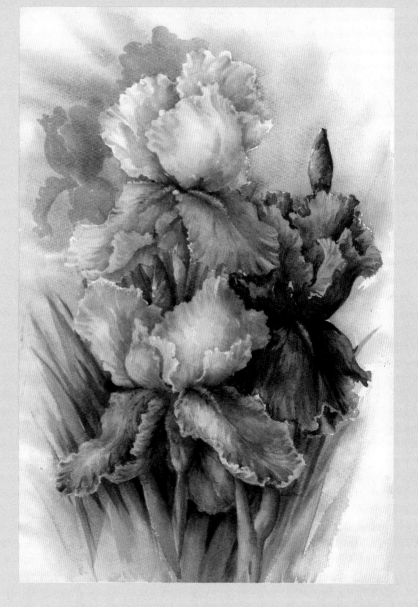

Irises
46 x 61cm (18 x 24in)

It is easy to locate the ballerinas in this painting, as there is only one group of flowers. Although the eye identifies the lowest flower as the focal point because the strong colours behind it push it forward (especially the tiny darks between the leaves at the bottom), all these flowers are important. The paler tones on the top flower lead gradually out of the painting after the eye has travelled in a curve from the lowest to the darkest, before coming to rest on the softest tones at the top.

The grid

I use an imaginary grid of four lines to keep me on track when composing a painting. The sketches shown below have dotted lines drawn on them to split the drawing into three, both horizontally and vertically. Each of the four points where the lines of the grid intersect are a good location for your focal point.

Following the grid method you achieve a 'balanced imbalance' that is all-important to an interesting composition. Sometimes this area is called the golden section but this, in effect, simply means that the focal point is better if it is a little off-centre in the painting and the focal point is established.

Using the grid

This sketch shows how the grid can be used to help you plan a composition, and check that it will work.

The flower sitting on the focal point at the intersection of the grid is the largest of the group of ballerinas (see opposite). The supporting cast are the slightly smaller flowers near the focal point, and the still-smaller buds and leaves. When painted, these will be darkest behind the main flowers, which will serve to push the ballerinas into the limelight.

The stems are curved and help to lead the eye to the focal point. The light source is coming from one side, which gives definite direction and means that the shadows on the flowers follow throughout the painting, adding to the harmony.

The flowers face in different directions, which makes the group appear natural.

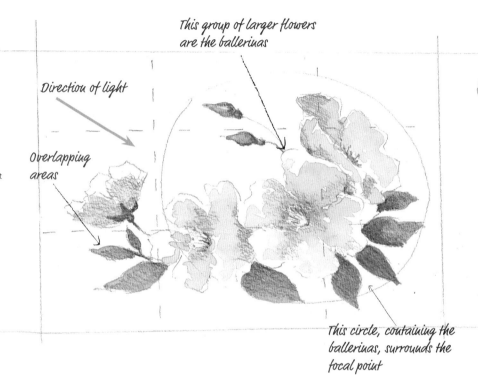

This group of larger flowers are the ballerinas

Direction of light

Overlapping areas

This circle, containing the ballerinas, surrounds the focal point

Identifying poor composition with the grid

The grid is also useful for helping to work out why a composition has not worked. The sketch to the right shows an unsuccessful composition along with some notes on what has gone wrong.

In this example, the roses are all facing forward, which makes them uninteresting. None are overlapping, so there is no group that draw the eye. There is no definite light source, so the eye wanders aimlessly.

None of the stems follow the growth of the flowers and their straight forms leads the eye out of the painting. Sometimes you must curve an otherwise straight stem to give you a better composition.

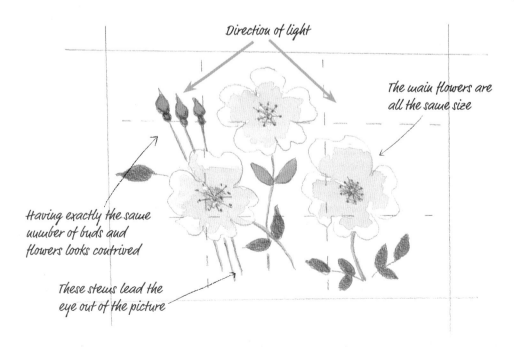

Direction of light

The main flowers are all the same size

Having exactly the same number of buds and flowers looks contrived

These stems lead the eye out of the picture

Headroom

When you begin a painting, it is easy to forget to leave enough space for every part of the composition.

It is a common mistake to place large flowers too high on the paper, leaving no room for the rest of the smaller flowers and leaves that form a good composition. This is a mistake that is often made especially when painting flowers in a vase.

The best idea is to begin painting in the lower half of the paper with the focal flowers first. If the vase is quite a tall one, shorten it a little.

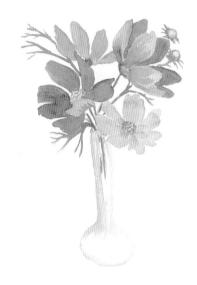

Here the cosmos flowers are too large and too crowded into the top half of the paper, which leaves no focal point in the bottom half.

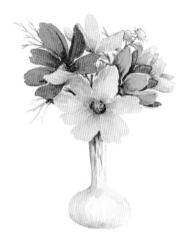

In this second example the space on the paper has been better utilised, with the flowers occupying the centre and the vase shortened.

The second example (top right) is better than the first, but it could still be improved as the subject is very central and not a particularly good composition.

To improve it further, I have brought the emphasis down the paper with a fallen flower at the base of the vase. Many artists have used this simple device as it leads the eye down the painting and improves the composition. This has often been used in famous paintings throughout history; and copying the old masters is always a good idea.

Adding the fallen flower makes a dramatic improvement to the composition by creating interest lower in the painting and moving the balance off centre.

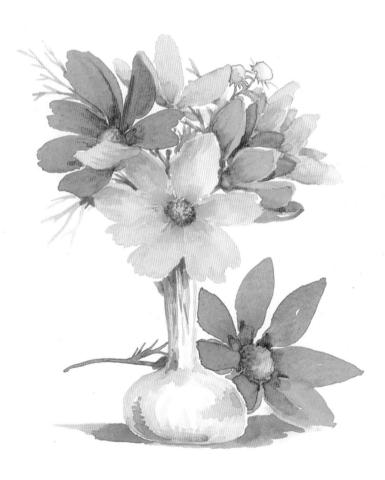

Paper size

Paper size is another trap for the unwary; me included! It is so easy to choose too small a piece of paper when beginning. This is illustrated very clearly in the painting *Spring*, below. Sometimes it it is a fear of wasting paper and wanting to use up small scraps you have left, or that you are out painting and that is all you have with you.

Whatever the reason, it is annoying when you can see that a painting is beginning to be successful and you are running out of space. In an ideal world this would not happen, as you would have worked it all out before you began, but painters, like me, are often not organised individuals!

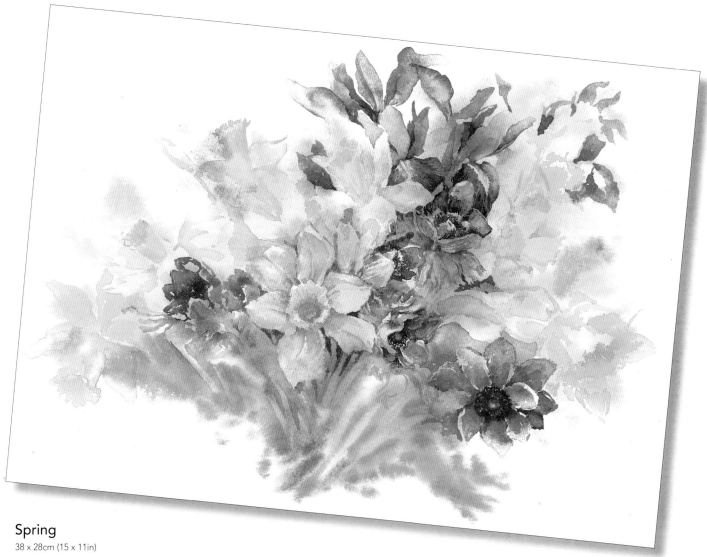

Spring
38 x 28cm (15 x 11in)

My daughter bought me this lovely bouquet and I got completely carried away by the thought that I must paint it immediately. I grabbed paints and paper without thinking or planning and this was the result.

Not only too small a piece of paper, but too many colours, so a failure on two counts! I enjoyed the process anyway, and maybe I will remember next time.

Leading the eye with flower size

There are several ways of leading the eye around a painting, one of them is flower size, another is careful management of tones around the focal point. Good composition is often a combination of both. The focal flowers are the largest, so immediately draw the eye. The darkest darks and lightest lights are the building blocks of a painting, and so these are also included in this focal area.

The paintings on these pages show a few examples of how you can lead the viewer's eye around your painting with clever composition. In each case, the orange line shows the path the eye follows.

Single Rose *(unfinished)*

This is a very loosely painted rose, but already your eye is drawn immediately to the large flower, then the outline of the bud. There is no doubt that this is a painting about the rose and the indeterminate blue flowers are just a background aid.

Although the painting is unfinished, I think I will only add a little colour to the bud on the left and leave it at that. Sometimes simplicity is best.

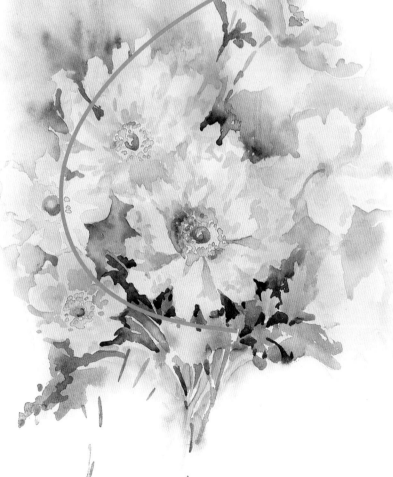

Japanese Anemones

There is not much detail in this loosely painted anemone, but the impact of the pale flower against the dark tones of the immediate background is what this painting is all about. The first thing you look at are the largest flowers at the bottom of the painting. Then the eye travels up in a curve to the smaller flowers, then the buds.

I love the drama of the tonal values that tell the story of the pale flower. Note that the leaves are a midtone, and the strong contrasts are provided by tiny background darks. The viewer provides the detail here.

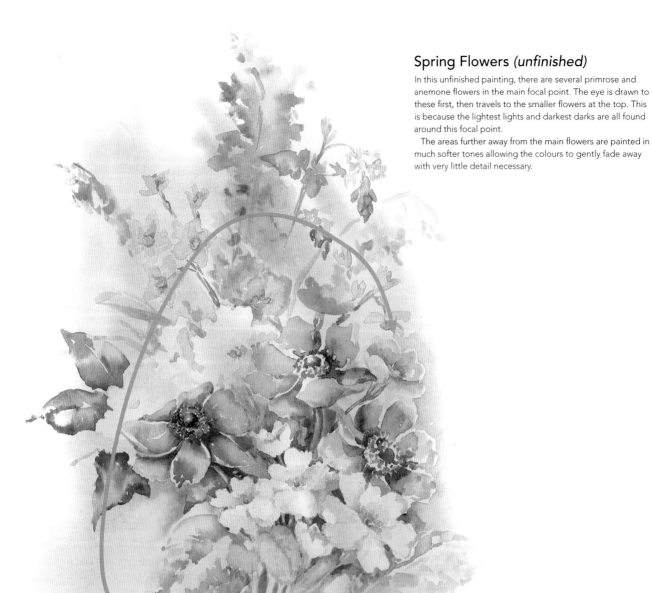

Spring Flowers (*unfinished*)

In this unfinished painting, there are several primrose and anemone flowers in the main focal point. The eye is drawn to these first, then travels to the smaller flowers at the top. This is because the lightest lights and darkest darks are all found around this focal point.

The areas further away from the main flowers are painted in much softer tones allowing the colours to gently fade away with very little detail necessary.

Important points to remember

- The balance of a painting. The 'weight' of the focal point should be approximately where the grid lines cross.

- Only one area should form the focal point.

- The largest flowers should always be in the focal point.

- The light source should always come from the same position, throughout. If several photographs are being used (see page 72) this must be remembered and checked.

- The side on which the focal point is placed is not important. The subject in front of you will have a lot to do with how you place it on the paper.

- Remember to site the main flowers fairly low on the paper, to allow for headroom.

Format

The shape and orientation of the paper on which you paint is important to ensure that you show the flowers to their best effect. If the flowers you want to paint naturally spread horizontally, a landscape format will show them off better; while tall, thin flowers such as tulips are often best in a portrait format.

When I have paintings framed for an exhibition I like to make each painting individual, and that begins with the shape of the flowers. Having all the paintings uniform in shape, size and frame means I can replace one that does not sell with a fresh one easily, but it can be a little boring, and I like each painting to be interesting in its own right, not part of a 'job lot' of mounts and frames. That said, botanical works are often framed identically, and make a beautifully coherent statement – but that is a much more stylised type of work than mine. When deciding upon the format for your painting, choose what presentation suits the way you paint and that will show the flowers off to the best advantage.

On the following pages are some flower paintings in common and more unusual formats to illustrate how different flowers need different formats to show how they grow.

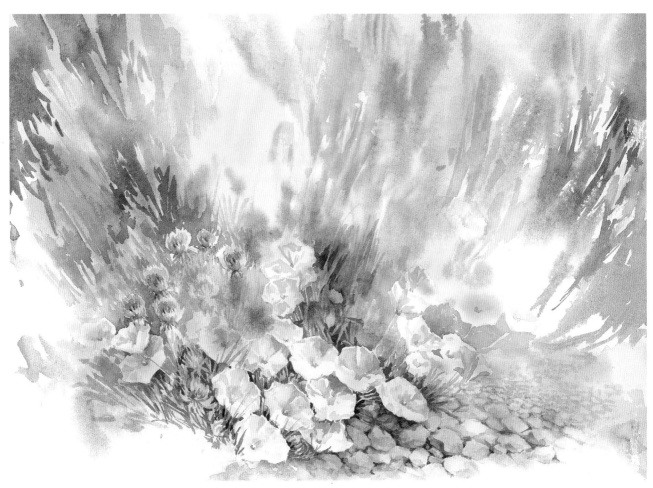

Landscape format: Kerbside

46 x 30.5cm (18 x 12in)

I think that this landscape painting will need more finishing, but care will need to be taken to keep the details soft and light. They must not detract from the delicate columbine which is the focal point. The green background marks need very little detail to read effectively as grass. I like the airy effect and will keep any detail as negative painting in the deeper green areas.

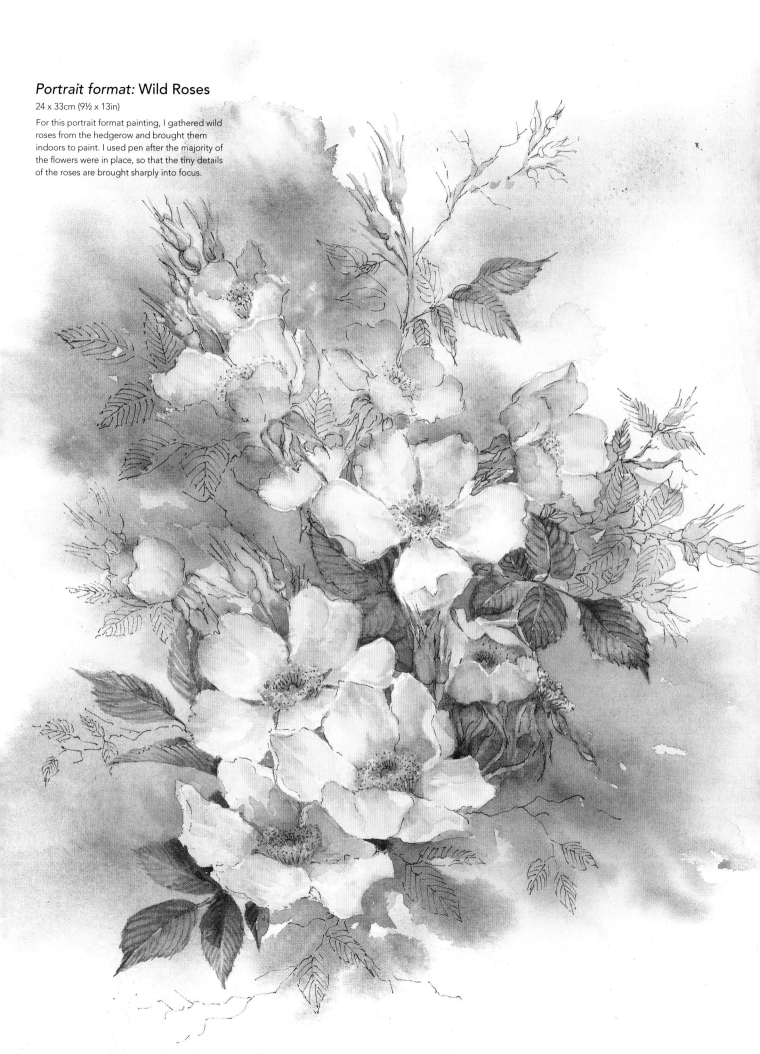

Portrait format: Wild Roses

24 x 33cm (9½ x 13in)

For this portrait format painting, I gathered wild roses from the hedgerow and brought them indoors to paint. I used pen after the majority of the flowers were in place, so that the tiny details of the roses are brought sharply into focus.

Common formats

The term for a painting that is wider than it is tall is 'landscape'. This shape is suitable for plants, flowers and bushes that are inclined to sprawl or that creep along a branch or the ground. The vertical portrait format – taller than it is wide – is generally more suitable for tall flowers and those in a vase. However, these general guidelines are not always the case.

When painting flowers in a vase, for example, a portrait format might seem obvious, but a closer look might reveal that the part you want to focus upon is not the vase, but the spill of horizontal flowers, which would be too wide for a vertical format and much better horizontally, i.e. landscape format.

Whatever the flowers you are painting, it is likely that several different formats are available to you to show the flowers off to their best advantage.

Landscape format:
Damsons and Bindweed
32 x 21.5cm (13 x 8½in)

The landscape shape of the painting was denoted by the branch of the damson tree. This tree was in my parents' garden and the bindweed had taken over, twining itself amongst the fruit, making it a lovely sight to a painter, though not to my father – an example of a painter's eye versus a gardener's!

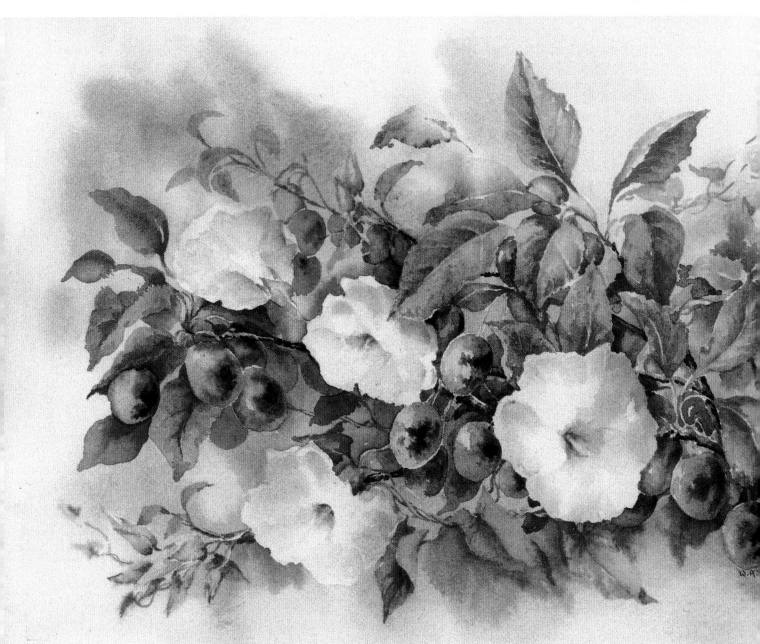

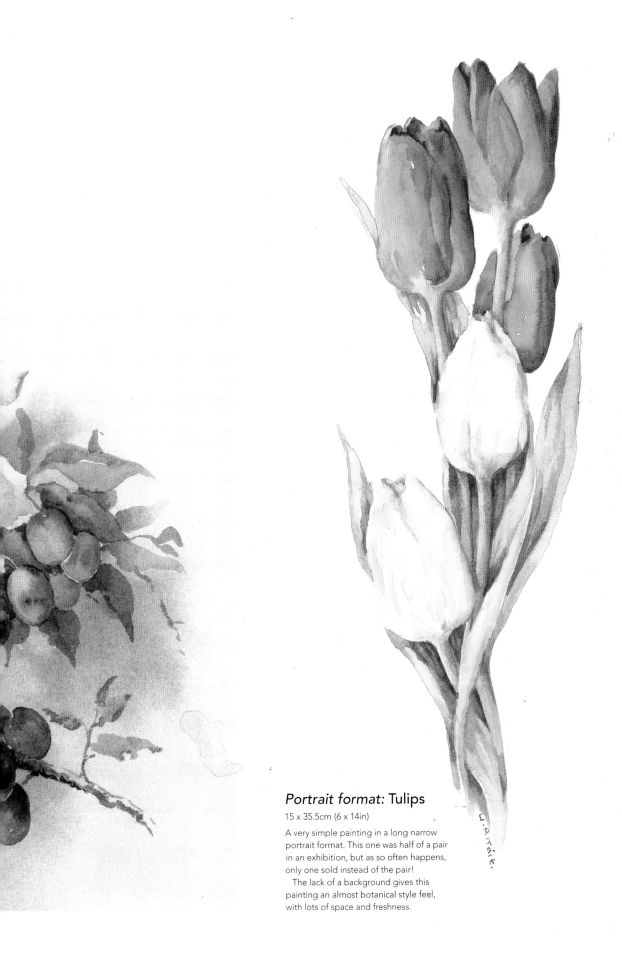

Portrait format: Tulips

15 x 35.5cm (6 x 14in)

A very simple painting in a long narrow portrait format. This one was half of a pair in an exhibition, but as so often happens, only one sold instead of the pair!

The lack of a background gives this painting an almost botanical style feel, with lots of space and freshness.

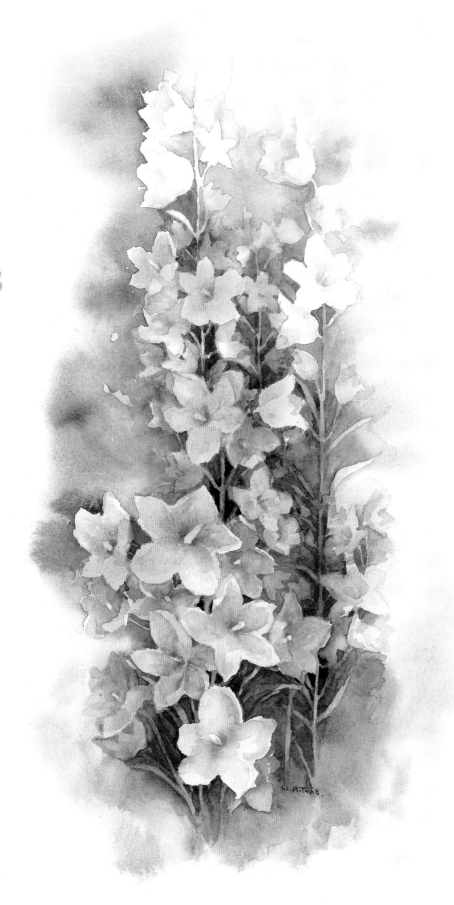

More unusual formats and groups

The way the flowers grow dictate the way to paint them. For example, the paintings of long, tall campanulas on this page have had the portrait format exaggerated to be especially tall and narrow in order to show how this slightly unusual approach can be very attractive.

Small low-growing flowers like pansies, primroses, crocuses and many others can be very appealing when brought to the viewer's attention in small circular formats, as shown on the facing page.

You may wish to paint a number of paintings to display together, using the same flowers in either a different colour range or a different view of them. Long thin paintings work very well as a pair, and circular paintings can work beautifully in a group of three, as shown opposite.

Exaggerated portrait format: Campanula

20 x 38cm (7¾ x 15in)

Another long format that shows how these flowers grow. The background extends to some edges of the paper, but the overall picture is a semi-vignette.

Circular group: Pansies

Each 15cm (6in) in diameter

Small flowers that grow in clumps can look
very good in a circular format as this draws the
eye immediately to the detail. If I use this
format I often paint two or three as a set as
they look good when grouped together.

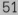

Backgrounds

Deciding whether to include a background in your painting can be a challenge. There are many advantages to using a background in your painting, and just as many reasons to leave the flowers on plain paper. For example, if you wish to paint a botanical study, this works best on plain paper; while a looser – perhaps more complex – painting involving leaves, grasses or other supporting areas will benefit greatly from a background to add definition.

The colours and types of flowers you include can help to guide you on whether to include a background. A red rose or strong sunflower will have enough 'body' to stand alone on white paper, while flowers that are very small and delicate or pale in colour will probably need a background to push them forward. Wild flowers painted *in situ* usually need a background such as grasses, leaves or bushes to help tell the story of where they have been painted and to convey atmosphere.

Over the following pages I show a few examples of flower paintings, both with and without backgrounds, in order to show you some different approaches that you might like to try out.

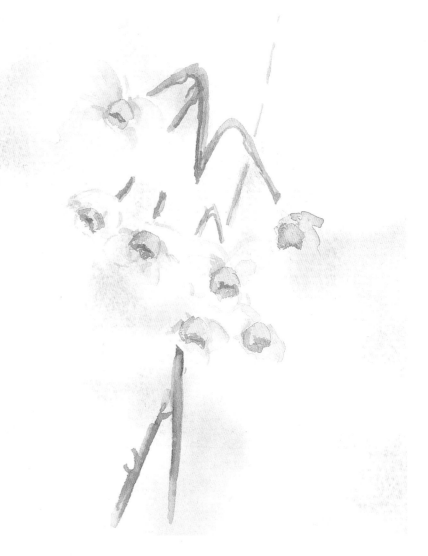

Poor use of background

This painting is not successful because there is not sufficient contrast between the pale flowers and light-coloured background.

Jonquils and Pussy Willow

This pair of paintings, of similar groups of flowers, show two different approaches to backgrounds that can be successful. One has been painted with no background, while the other has had a background added. Compare and contrast these with the picture on the opposite page.

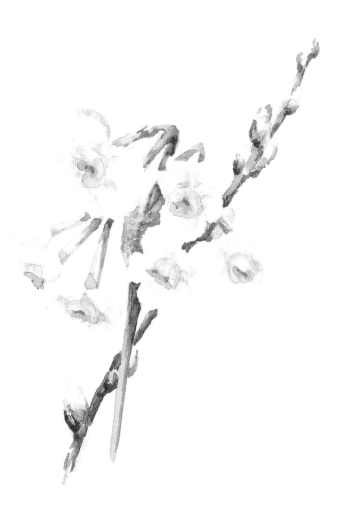

No background

The flowers have been painted on white paper with no background wash. The small darks behind some of the flowers provide enough contrast for the eye to 'read' the other white flowers even though some edges are lost.

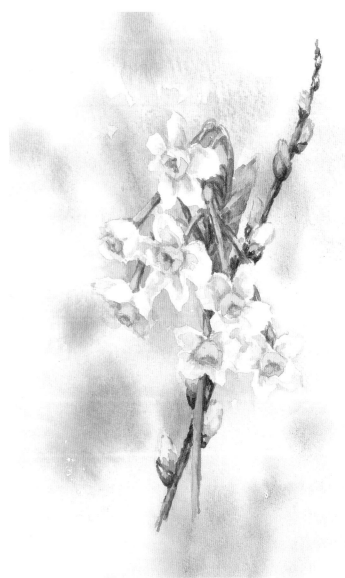

Strong background

The background has been painted in fairly deeply to contrast with the flowers and help them show up. The deepest tones are behind the central flowers, while tiny darks have been added to the stems to add detail and sharpen the contrasts.

Background first

Sometimes, painting a background first means that you avoid any potential problems with washes and runbacks before you have spent hours painting.

When painting the background first, it is best to keep the colours fairly dilute and light; as this allows you to paint over them cleanly. For this reason, a wet-in-wet technique is the best approach, as in the example painting below.

This small painting was begun by wetting the paper and dropping in cadmium lemon, cobalt blue and the pale green mix. I tipped the paper to let the colours merge a little, taking care to keep the palest tones where I wanted the primroses. This last point is important. You need to have an idea of where you want pale areas of the finished painting to be, so that you can ensure you leave these areas with a very light or completely clean background. When you paint on top of this background, you can still get vibrant effects, even for your light-coloured flowers.

The background can be deepened in colour later (see page 56), so keep the initial background wash light.

54

Primroses in a Pot
30.5 x 22.5cm (12 x 8¾in)

Once the background was in place, the pink flowers were painted with pale tones of permanent rose. I accentuated the flowers by painting in negative behind them in darker tones of green and blue. The leaves and twigs were then painted and the details added. I finished off by deepening the background immediately behind the flowers. Notice that the very darkest tones are very small.

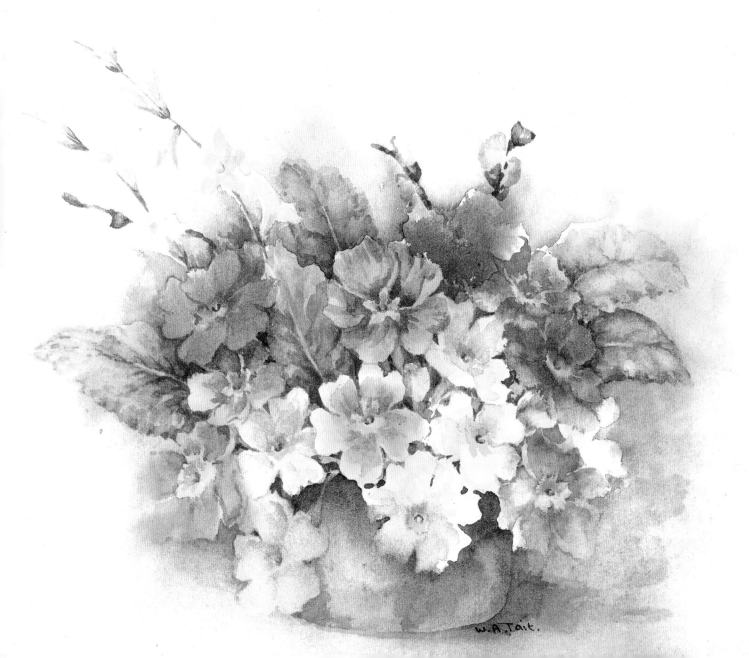

No background

This approach gives a more botanical style. To paint onto a white background needs strong contrasts within the flowers instead of relying on darks in a background to show them up.

The design needs to be kept simple with either a single or very few flowers to achieve an uncluttered effect, as in the example below. Note that the white rose was placed in front of the red one. Because enough information has been given about the white rose in the darker areas (against the leaves and red rose), the eye automatically 'reads' the white petals against the paper – even on the left-hand side, where the white petals directly abut the white background.

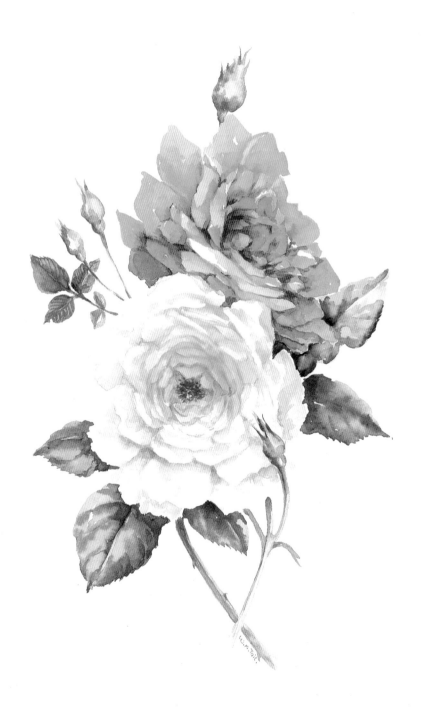

Two Roses
15 x 23cm (6 x 9in)

These roses were painted directly onto the white paper with no background added at all. I then painted the leaves strategically placed and very dark in tone, to give the rose the drama it needed.

Adding a background

Like *Two Roses* on the previous page, this painting was begun on white paper. However, a small amount of background was added near the end of *Dutch Iris* (below) to help the lighter flowers show up. Taking care to avoid wetting any of the completed flowers, clean water was taken right up to the edges of the paper, and then colour was added just behind the flowers. Next, I simply tipped the paper to let the colour run away, rather than using a brush. This way, dry edges can be avoided.

If you do add background colour like this and you wish to deepen the area around a flower on the outside of the group, always wet a much bigger area with clean water than you would be painting.

When adding a background, always use tones of colours that have already been used for the flowers or leaves. In *Dutch Iris*, for example, I used a paler mix of the pale blue-violet I had used for the blue irises.

I would advise never to attempt putting in a dark background last as you can ruin many hours of work.

Dutch Iris

25.5 x 38cm (10 x 15in)

This picture was begun on clean white paper, and a little background added to the irises at the end of the painting in order to help the yellow and white flowers show up. The background colour was only added between the leaves and stems just to give contrast where necessary.

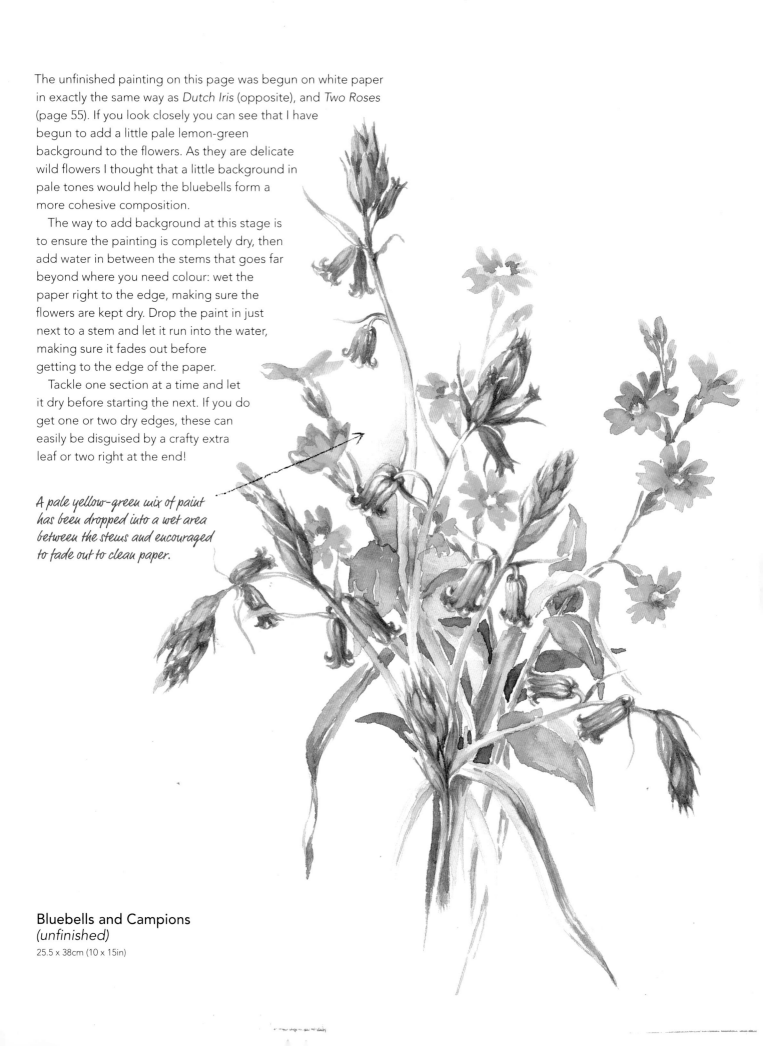

The unfinished painting on this page was begun on white paper in exactly the same way as *Dutch Iris* (opposite), and *Two Roses* (page 55). If you look closely you can see that I have begun to add a little pale lemon-green background to the flowers. As they are delicate wild flowers I thought that a little background in pale tones would help the bluebells form a more cohesive composition.

The way to add background at this stage is to ensure the painting is completely dry, then add water in between the stems that goes far beyond where you need colour: wet the paper right to the edge, making sure the flowers are kept dry. Drop the paint in just next to a stem and let it run into the water, making sure it fades out before getting to the edge of the paper.

Tackle one section at a time and let it dry before starting the next. If you do get one or two dry edges, these can easily be disguised by a crafty extra leaf or two right at the end!

A pale yellow-green mix of paint has been dropped into a wet area between the stems and encouraged to fade out to clean paper.

Bluebells and Campions
(unfinished)
25.5 x 38cm (10 x 15in)

Painting flowers

Now that we have explored a little about the theoretical and practical aspects of painting a picture – how to use our paints to create colour and tone, and how to use composition to make an attractive image, it is time to look at the creative process. This chapter will explore how to make decisions about which flowers to paint, and look at some finished or part-worked paintings in detail so that you can see how I approach the creative process.

Inspiration

Inspiration for a flower painting can come from almost anywhere. It can come from flowers in a garden, a field, a hedgerow or perhaps simply a single bloom. Sometimes I am suddenly attracted to a particular effect of the light on a subject. Most of all I like to paint *in situ*, taking inspiration from the flowers in front of me. However, if I cannot stay, I will capture the moment so that I can paint it later; either by taking a photograph or occasionally by making a pencil sketch. Collecting these photographs and sketches will also prove useful – and inspirational – for later work, as I begin to turn that initial spark into a painting.

Personal preference

I find it very difficult to paint to order, as I need the spark of enthusiasm to enjoy painting. Set arrangements or stiff formal flowers do not interest me at all. I have often been approached by well-meaning people who say they have a wonderful pot plant, bush or garden border that they are sure I would like to paint. Sometimes it is a perfectly formed botanical specimen, but I cannot respond to it at all, which can be rather disappointing – and a little embarrassing!

I am drawn to white or very pale flowers as they suit the way I paint, often in negatives. I also like tumbling masses of flowers or leaves so that I can push the paint about and make semi-abstract shapes rather than exact forms. I often stand for the last stages of a painting, in order to enjoy the freedom of painting loosely. Tidy gardens are not for me – flowers in a semi-wild situation with plenty of foliage and tonal drama around them get me going every time.

Inspiration will often follow from such personal preference. Everyone has their own favourite artists whose style they admire, and who they would like to follow. This is a good way to learn, but imitation should be used as a stepping stone to develop your own original paintings. Try to work out what it is about the artwork that you like, as this will help you to draw your own ideas.

T I P

Visit galleries and exhibitions of both contemporary artists and work by old masters. Inspiration can often be gained by seeing how another painter has approached a subject and it will make you look at your own work in a different way. Seeing other artists' work can spark new ideas and show different ways with composition, handling of paint or the way a new angle can be found on an old subject. However, your own work must always be original.

Making decisions

Painting is all about decision making. Even before we set out to paint we are making decisions: what to paint, how to paint it, what medium to use. Even once we have made these initial practical choices, we are still faced with our chosen subject and must decide how to best make it into a painting. Will it be landscape or portrait format? Shall I make it loose and bold? Do I paint everything I see, and if not, what shall I keep in or leave out?

The subject itself will often decide many of these questions for us, but most of all we want to put our own slant on it so that we paint something uniquely our own. For me, this means painting in a way that tries to convey my emotional response to the flowers in front of me and how I would like the viewer to share that feeling with me.

T I P

It is a good idea to think through your choices and make small sketches before you begin any painting – this will quickly let you see whether an idea will work.

Painting in different styles

The anemones below are painted in two different styles. Both use the same colours but the first uses very rich vibrant mixes, while the second uses more dilute mixes for a delicate effect. This demonstrates how the same flower can inspire many different impressions.

Anemones in different styles

The painting on the left is on a heavy 640gsm (300lb) paper with quite a tooth to it. I began painting straight onto the paper, with no background and using a size 10 brush throughout. I added a little background right at the end using lemon yellow, cobalt blue and cobalt violet mixes I already had out on my palette.

The painting on the right is a much more delicate study, mixing the pink anemones with other spring flowers from my garden. For this, I began with a background in pale mixes of the colours used for the flowers, guiding the wet paint away from where I wanted the palest flowers to be. I painted the anemones first, then moved on to the surrounding flowers, using negative painting behind the white narcissus. I finished with the small darks and by deepening the background behind the main flowers to push them forward.

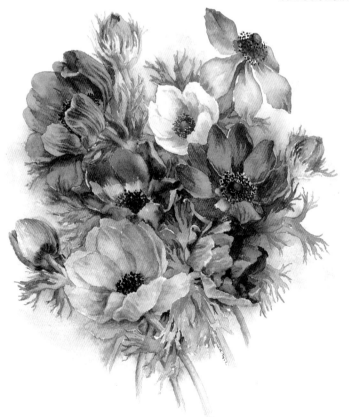

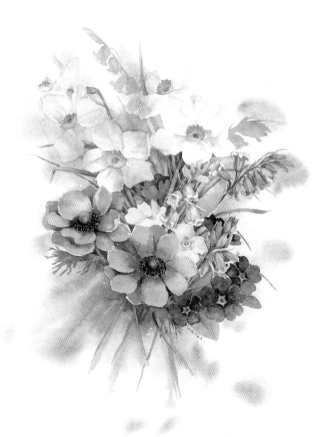

59

From photograph to painting

I take lots of photographs of flowers wherever I go. These are intended as a starting point for a painting, not as a botanical record. I want to have a record of something lovely that appealed to me at a particular time, that one day I may use in a painting.

Sometimes a photograph will come out 'just right', and can be used almost unchanged for a successful painting. At other times, you might find that you need to alter the composition, by adding elements from other reference, or combining a number of photographs into a final picture. The following pages explore the process of developing the reference you like into paintings.

T I P

Collect reference materials, photographs, magazine and newspaper cuttings. These can often be very helpful, especially to bring in a background, help you with a detail on a flower or the different effects of light.

Reference material

60

Sometimes I know what it is about a particular flower that inspires me, but have no time to paint it, so I keep it in the back of my mind to enjoy later. At other times, I cannot quite identify why I like the flower, so I keep a large plastic box which is filled with all of my photographs and sketches. These are useful for reference to remind you of particular details when you come to paint the flowers later on.

I also browse magazines, newspapers and old seed catalogues and make cuttings, adding them to the box for a day when inspiration is not coming easily. The images from these are not used in their entirety, but they help to provide interesting details, reference and inspiration to help build a painting. This way I am seldom stuck with 'what can I paint?' syndrome as I know I can rely on the box for inspiration.

My box of inspirational photographs, cuttings and sketches is always useful.

Collect and take as many photographs of flowers as you can to help inspire you, and let personal preference be your guide.

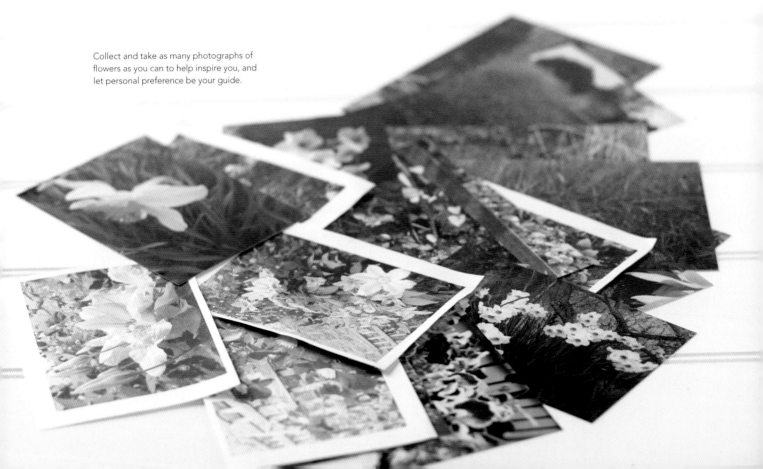

Using fresh flowers alongside your reference material

I frequently paint my main flowers from fresh ones, as a photograph sometimes does not capture enough information. However, even when I have fresh flowers in front of me, I may remember a detail – such as an effect of light – that I have cut out and kept, so out comes the box for a rummage through it to compare. I often combine parts of several cuttings, sketches and photographs along with fresh flowers in order to get the precise effect I need for a painting.

Using photographs

The example below, along with those on the following pages, shows that photographs may have to be extensively altered, using the information and techniques on the previous pages, to make a satisfying composition. The accompanying sketches show potential compositions inspired by, and developed from, the photographs; while the notes explain why and how I made my compositional choices.

T I P

Never copy a photograph in its entirety unless you have taken it yourself, or you may find you are infringing copyright.

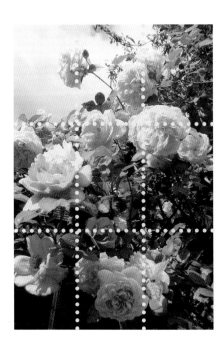

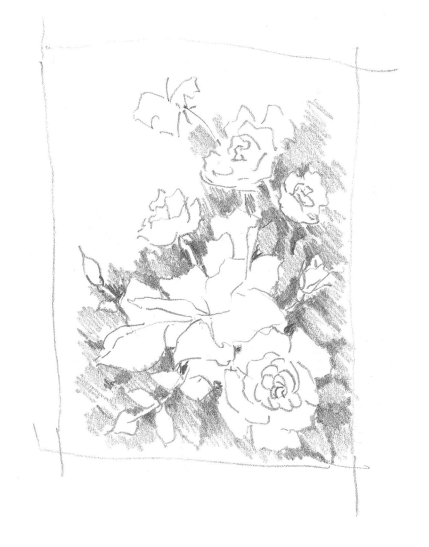

Yellow roses

This photograph is an example of a of superb flowers, colours and contrasts, but adjustments need to be made to the positioning of the roses. I put the grid (see page 41) on the photograph and then decided to bring the balance of the picture over to the right as the sky and distant leaves were already so attractive. The large open rose on the left is particularly attractive, so I enlarged it a little and brought it downwards to the right. I brought the bottom rose along and let the petals overlap.

There were too many roses to include so I chose one or two smaller ones, so that the focal point remained on the two larger ballerinas crossing the gridlines.

Purple clematis

The purple clematis in this photograph here are very badly placed. This can be seen clearly when a grid is placed over it. They are almost the same size and form 'bookends' around a dark central hole. However, I like the blue tinted foliage in the background, and the lighting (from the top right) is consistent and shows the flowers off well. It is only the positioning of the main flowers that need attention.

I brought the left-hand flower into the centre of the composition and balanced this by tucking the right-hand flower slightly underneath it, thus forming a strong focal point. The very straight stem of the bud has been curved slightly and moved to the right. By placing the grid over the sketch (below right), I am now satisfied that I can go ahead and enjoy painting.

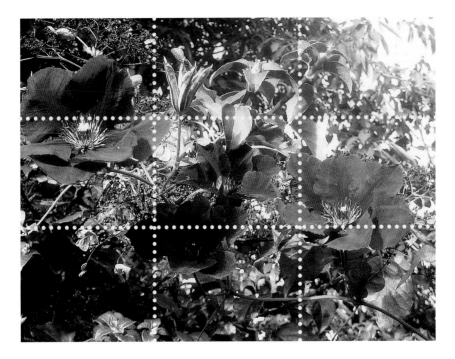

T I P

Artistic 'tweaking' usually improves the composition of any photograph.

T I P

Always remember that the light source must always come from the same direction throughout the painting. If you are using several photographs this is especially important.

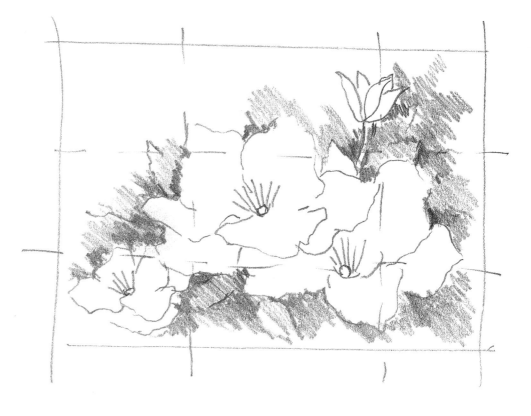

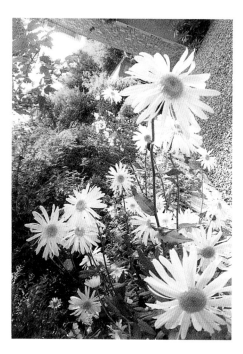

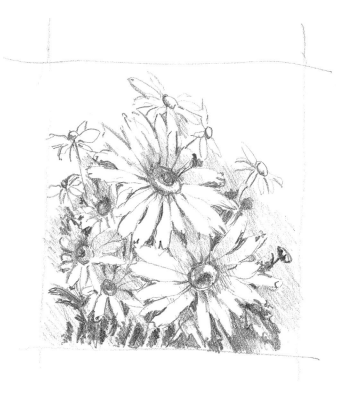

White daisies

This photograph has some good shapes and contrasts but no obvious light source and a worrying lack of composition. I decided to have the light source coming from the top right. This gave me the opportunity to throw the smaller daisies into shadow to make sure that the focal point was a little to the right of centre.

I liked the ragged shapes of the two large daisies, so I brought them together lower down the painting, relying on strong contrasting darks behind them to make the composition work. The tiny darks in between the stalks, leaves and flowers must be very dark to give the painting weight at the bottom.

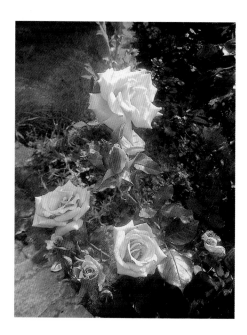

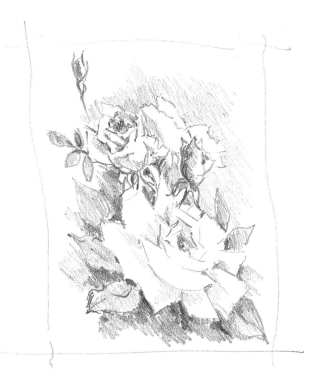

Pink roses

I had to study this photograph carefully to see that the light source is coming from the right, but quite low down. I must have taken this late in the afternoon.

In developing the compositional sketch, I have used quite a bit of artistic licence with these roses, moving them around until I liked the format. The large rose at the bottom of the sketch is actually the top one in the photograph. To make sure that the largest rose remains prominently my ballerina, I added the suggestion of a large rose in the background to add contrast. The buds have been added in positions that draw the eye in a curve towards the main flowers.

Analysing your painting

Painting flowers in the style I have described on the previous pages can produce pleasing effects which work to bring the form, the tones, the colours and composition together to form a whole. These effects can be achieved deliberately, but some are accidental, without the viewer actually being aware of how they were produced.

The following pages show two paintings with pointers to show some of these different effects and how they go towards building a painting.

Sweet Peas

The colours I used for the painting opposite were lemon yellow, cobalt blue, cobalt violet, permanent rose, cadmium orange, quinacridone magenta and my green mix.

The pale central flowers were painted first, then the darker-toned ones were popped behind them to show contrast. The leaves and stems were next. The blue background was dropped in after wetting each section, remembering to keep the flowers dry. Lastly, the fiddly bits of tiny leaves and tendrils were added to complete the painting.

Mixes used in *Sweet Peas*

Cobalt violet and cobalt blue

Cobalt violet, quinacridone magenta and cobalt blue

Quinacridone magenta and permanent rose

Permanent rose and cobalt blue

The green mix: lemon yellow, sap green and indigo in various combinations

OPPOSITE
Sweetpeas
23 x 30.5cm (9 x 12in)

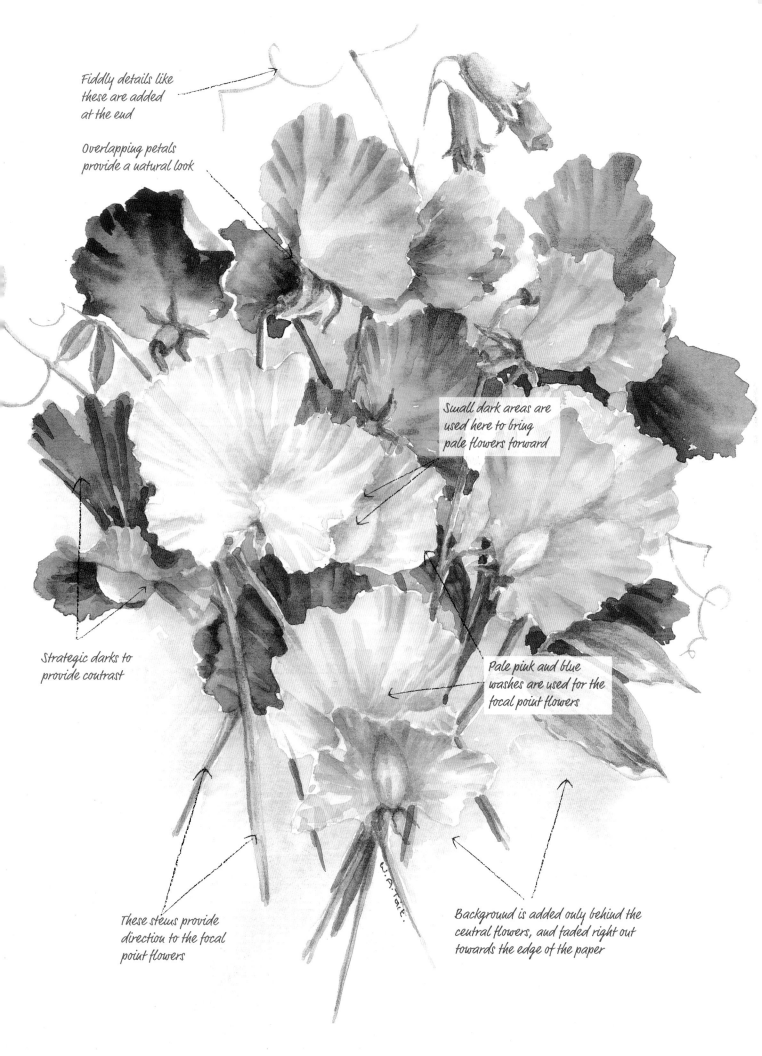

Fiddly details like these are added at the end

Overlapping petals provide a natural look

Small dark areas are used here to bring pale flowers forward

Strategic darks to provide contrast

Pale pink and blue washes are used for the focal point flowers

These stems provide direction to the focal point flowers

Background is added only behind the central flowers, and faded right out towards the edge of the paper

Cherry Blossoms – unfinished painting

I have left this painting unfinished to help show how some of the effects were achieved, and also to show where the painting could be developed further – this is intended to help you spot the opportunities that this way of painting flowers grants.

The background was painted first, leaving paler tones where the blossoms would be. The blossoms were then added, mainly using negatives – i.e. leaving pale highlights and putting in deeper pinks to suggest the form. I then decided to draw in some of the flowers, using a fineliner pen.

The leaves were added to bring out the contrast between the depth of tone on and behind the flowers. A deeper blue background was added in parts to bring the flowers forward.

The colours used were new gamboge yellow, cobalt blue, cobalt violet, permanent rose, quinacridone magenta and the green mix. Although no cadmium orange is obvious in these pink flowers, a little was used with permanent rose to help achieve the delicate tones.

Main colours and mixes used in Cherry Blossoms

Cobalt blue

Cobalt violet

Permanent rose

Quinacridone magenta

New gamboge yellow

New gamboge yellow and sap green

Brown madder and quinacridone gold

Indigo and quinacridone gold

Deeper background was added for contrast

Outlines of the flowers were added over the background with a fineliner pen

Paler tones were used further from the centre

Tiny dark areas were added to separate the flowers here

A deeper background was added for contrast

The leaf outlines were drawn with a fineliner pen, and placed using the background colours that were already established

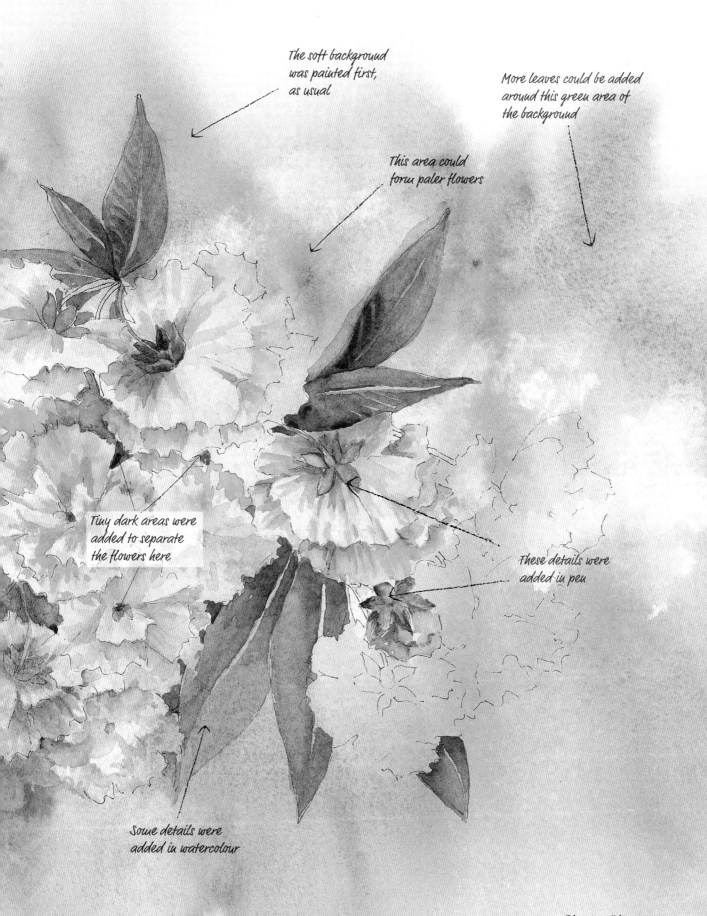

The soft background was painted first, as usual

More leaves could be added around this green area of the background

This area could form paler flowers

Tiny dark areas were added to separate the flowers here

These details were added in pen

Some details were added in watercolour

Cherry Blossoms
23 x 30.5cm (9 x 12in)

Peonies and Stephanotis

I was at a garden festival in France when I saw this particular display. It made my fingers itch to get painting, so I took a photograph and painted from it when I got home.

For this example, I took time to ensure the composition of the photograph was just as I wanted it so that I could paint from it directly. The main flower is well-positioned and the whole subject needs only a little tweaking.

Composition

When you are painting from a photograph, look at it through half closed eyes when planning the composition. This helps you to identify and concentrate on the main flowers while letting the surrounding ones become a little out of focus. This method helps you to block out the details and identify where the strongest contrasts are, which of course you want around the focal point: the main flower.

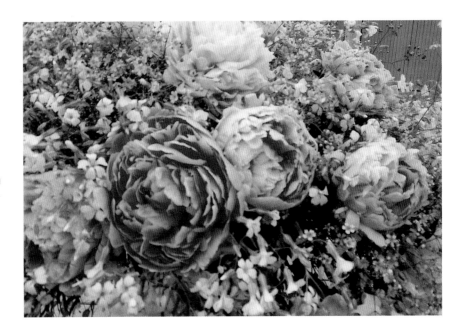

Tonal sketch

Once you are happy with the composition, it can be a good idea to draw a tonal sketch to check that you have the composition as you want it, and to help identify areas of tonal contrast before any colour is used. The sketch will let you change any parts of the painting with which you are unhappy, and can also be used as further reference as you paint the final picture.

For this example I used a watersoluble pencil, which meant I could smudge the tonal areas to get a softer effect.

Peonies and Stephanotis

Choosing colours and tones

On a spare piece of paper, try out the tones you intend to use in the initial stages of the painting. It is always a good idea to leave any really dark tones until right at the end of the painting.

After experimenting with the colours, I decided to use lemon yellow, cobalt blue, cobalt violet, permanent rose, quinacridone magenta and my green mix for this painting as they best matched the colours in the photograph.

At this stage, you can also decide if you would like to use any different techniques. For example, I could have used masking fluid to reserve space for the smaller stephanotis. In fact, when I half closed my eyes I found that they took second place and the main light and contrast was on the main flowers, so this was unnecessary.

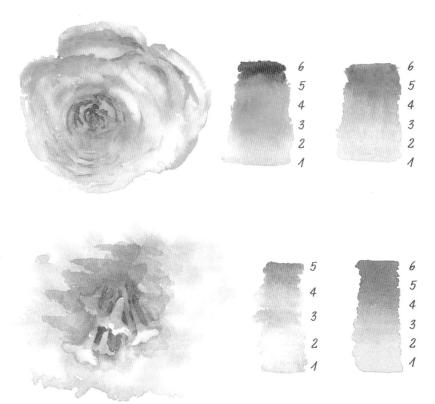

Creating the finished painting

With all your preparation complete, you can begin your painting with much more confidence. In the case of this painting, I began with my usual wet-in-wet wash, dropping in a blue, violet and green background and adding pale pink more or less where I wanted the peonies.

Although the photograph shows the largest flower in shadow, I ignored this as I needed it as my ballerina (see page 40) and therefore in the spotlight! The lightest lights and the tiny darkest darks would be in this area.

It was a challenge to keep the light on the peonies and to vary the tonal values of the pink. I used warmer tones of permanent rose towards the centres, gradually adding a pale mix of quinacridone magenta as the petals got cooler. Then, as the tones got bluer towards the outer petals, I added pale cobalt blue as the flowers were in shadow.

I developed the picture with a lot of negative painting using a pale blue-green wash, then used tiny touches of a dark mix to pick out the small flowers. I let the outer peonies softly merge with the background pale blue wash which also covered some of the white flowers. In the final painting (overleaf), note that the darkest negative tones are directly behind the largest flowers, which pushes them forward.

OVERLEAF
The finished painting
38 x 28cm (15 x 11in)

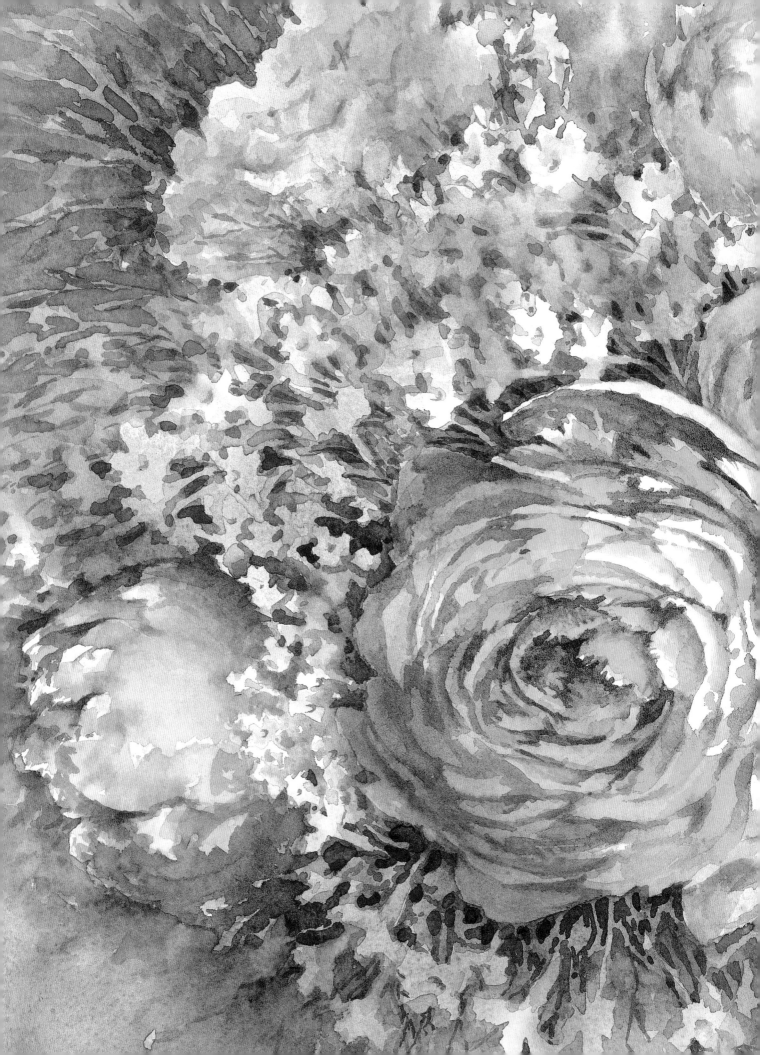

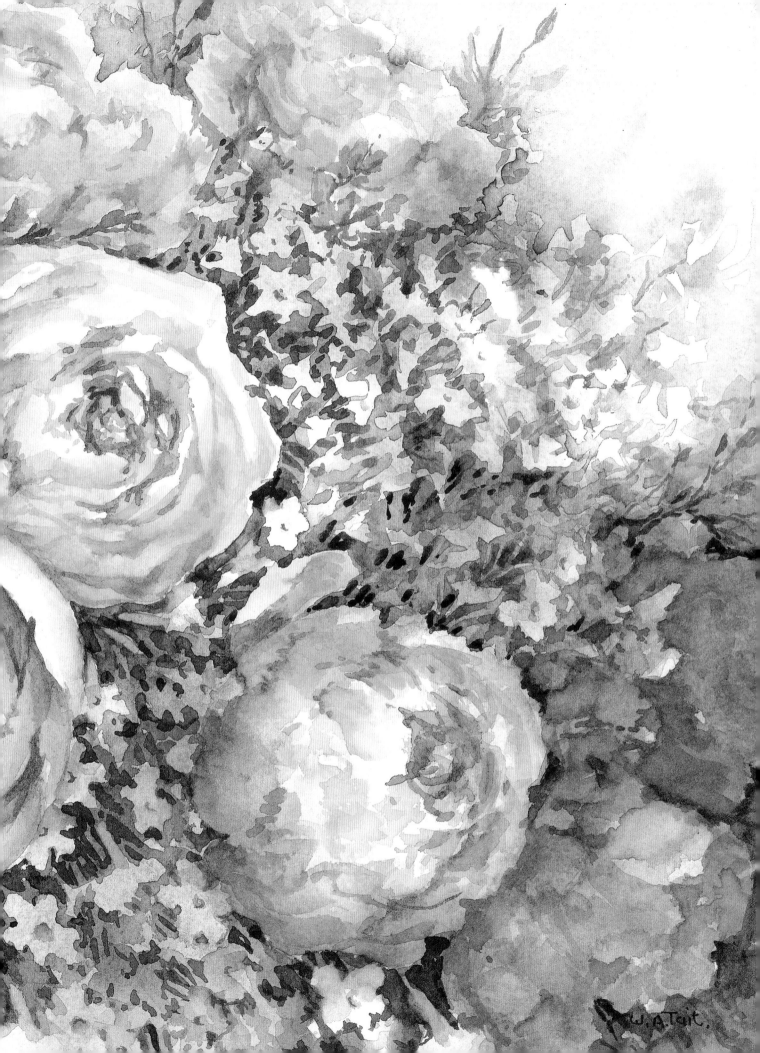

'Princess Alexandra of Kent' Roses

Combining photographs into a single picture

I took several photographs of these lovely roses as they were growing in order to get the feeling and atmosphere of them. Although I knew it would be a complex painting I enjoyed getting the dark mass of leaves behind the roses to push the ballerina (see page 40) roses forward.

Composition

When tackling something as 'busy' as this you must make sure you have reference material that will let you make a successful composition that contains:

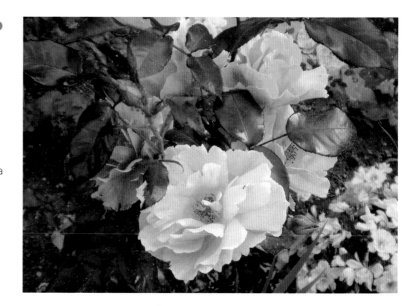

- A focal point.

- At least one flower that has enough detail to paint. You may wish to use fresh flowers, as a photograph sometimes does not contain enough information.

- Enough information to supply a background that can be 'fitted' behind the main flowers, making a cohesive composition.

For this painting I used the main flowers from the photograph at the top – these will form the focal point – and combined them with a mixture of elements from the lower two pictures to get the feeling of a mass of roses fading into the distance.

Note that the three photographs do not show the same rose bush. This is unimportant as long as the photographs help you to visualise the composition.

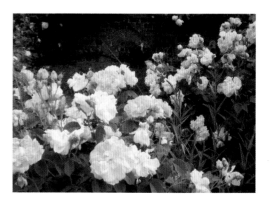

The source photographs for this painting.

Initial sketches

It often helps to make several sketches before beginning, to determine exactly the format which will suit the subject. This stage is particularly important when combining a number of photographs into a single composition.

The sketches on this page show some examples of sketches I made then rejected; a process that helped me to finalise the composition in the sketch overleaf.

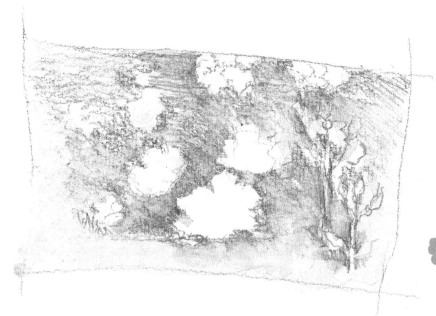

This sketch is an example of combining several photographs into what would be an unsuccessful composition. The dark tones are too heavy at the top, the focal point is not large enough and the stems are too straight and upright. The resulting composition does not look like a convincing whole, instead it looks like a combination of unrelated parts.

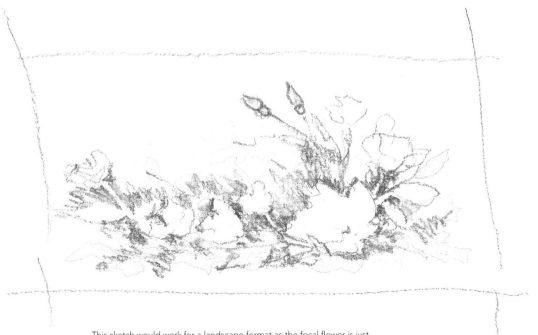

This sketch would work for a landscape format as the focal flower is just off-centre and larger than the surrounding flowers. However, the buds at the top are in danger of distracting the eye and should be smaller. I decided not to use this as I thought that a portrait format would allow room for background roses.

Final sketch

Having used the previous sketches to identify what to avoid and what to look for, I produced this sketch to develop into the final painting, having decided on a square format.

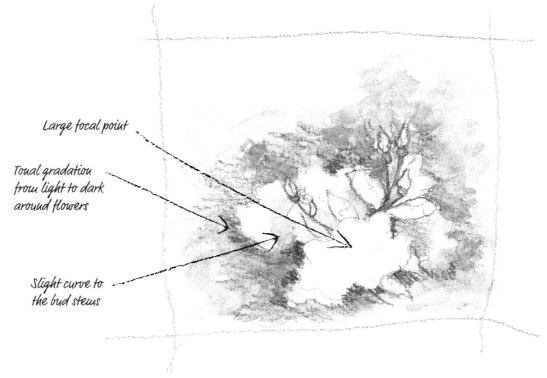

Large focal point

Tonal gradation from light to dark around flowers

Slight curve to the bud stems

Choosing colours and tones

With the composition ready, I produced some small vignettes to practise details and test out the colours I would use in the final painting. Even though they are just scribbled ideas, they help give a guide to beginning the painting.

Main rose

The first washes are dropped in onto wet paper. The colours used are light tints of permanent rose, lemon yellow and a mix of cobalt blue and cobalt violet.

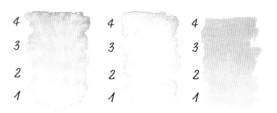

Deeper-toned roses

The pink and blue-violet mix used for these are the same as on the main rose; but the yellow is changed for new gamboge yellow. Note that darker tones are used overall, ranging from 2–6.

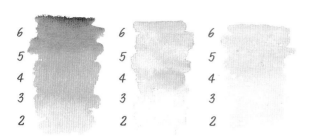

First wash on leaves

The colours used in the leaves – permanent rose, cadmium orange, cobalt blue, and the green mix of new gamboge yellow, quinacridone gold and indigo – are the same as those that will be used in the initial background wash.

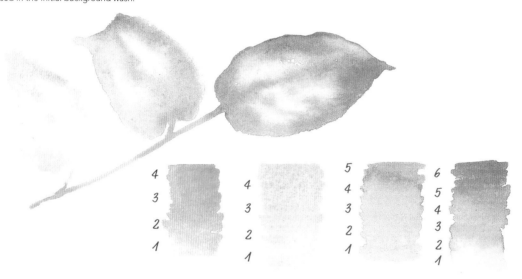

Initial background wash

By using the same colours (permanent rose, cadmium orange, cobalt blue, and the green mix of new gamboge yellow, quinacridone gold and indigo) in the background as the leaves, the two will blend perfectly, creating a natural sense of distance.

All of the colours listed above will be dropped onto wet paper, where the colours will be allowed to merge a little. This creates a pale, soft background.

Completing the painting

Keeping the reference photographs clipped to the side of my easel so that I could quickly check details, I prepared the colour mixes using my notes from the test vignettes. I then thoroughly wetted the paper and dropped in the colours approximately where I wanted them, beginning with the palest. These were encouraged to merge a little by tipping the paper back and forth. By tipping the board, I ensured the paint was guided away from the focal areas as these needed to remain the lightest. When painting your picture, do not attempt to use a brush for this stage as this will leave unsightly marks.

While I am waiting for the background to dry, I start to think as a painter rather than as the person who took the photographs. Taking into account where the colours have settled on the paper, I adapt the composition in my head where necessary, while being sure to keep the original idea in mind. I find this is the most exciting part of the painting.

Using a lovely big size 14 brush throughout the painting, I kept the paper damp so that I could paint very loosely in the initial stages. Several times I adjusted the composition a little as I worked – this is sometimes necessary if the paint merges where you had not planned it to, for example.

Once the background had dried, I could paint the focal flowers. I kept the tones of these leaves and flowers in a mid range, and continued to adapt the composition as I worked. As more detail was added, I used deeper the colours and tones. It is important to remember that the darker the tone, the smaller the area covered.

Adapting as you paint is an important skill to develop. In the reference photographs for this painting, there are prominent leaves in front of the main roses. I chose to leave these out initially, so that I could see where the lovely soft tones of the roses were taking me. As you will see from the finished painting, as I progressed I decided to leave the leaves out altogether as I felt they would be too prominent. This is why I prefer not to draw outlines as I am left free to follow the movement of paint on paper.

Right at the end, when I needed to add the tiny details, I changed to a size 4 brush. I left all of the tiny darks until nearer the end but ensured I did not lose the light of the paper shining through the petals of the flowers.

The finished painting
33 x 38cm (13 x 15in)

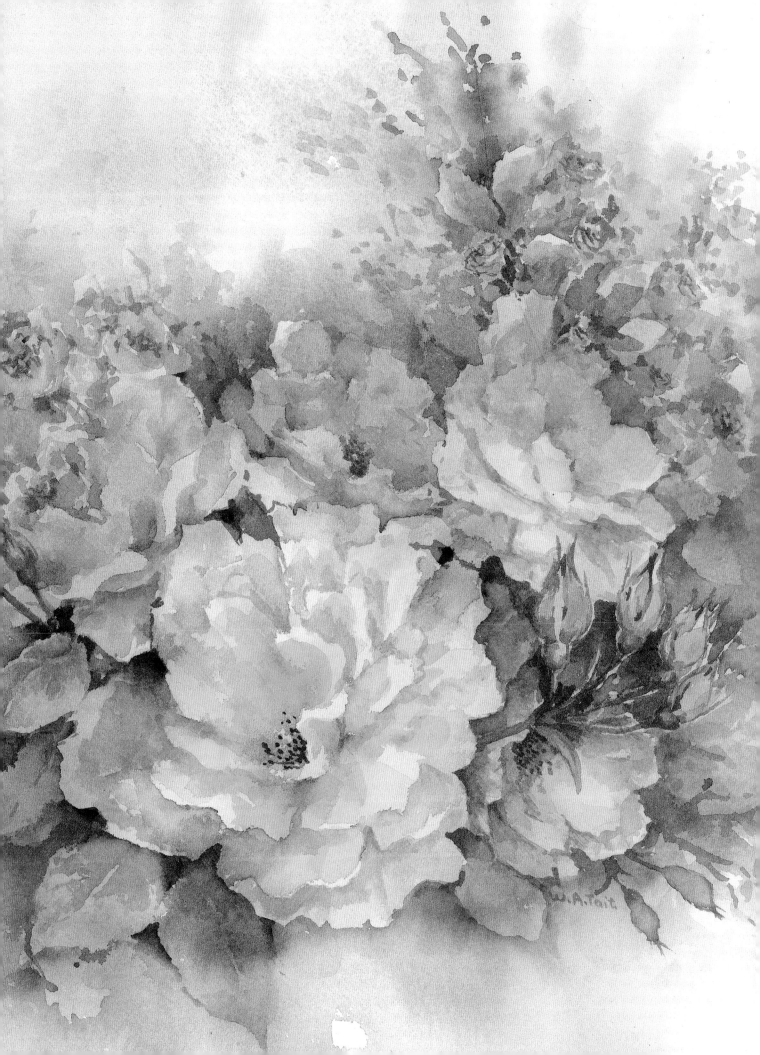

Wild Primroses

Wild primroses are another great favourite of mine, and to see a whole bank of them at the edge of a wood was a wonderful sight. It was a cold day so I took several photographs and went home with the sight firmly fixed in my mind.

I wanted to focus on a group of flowers with just a suggestion of the surroundings, so I took several photographs to help me remember the location and the feel of the place.

Composition

I liked the little fence but decided to employ a little artistic license and move it further into the background so that the focus was on the primrose. The angle of the fence was also changed to fit in with the composition. This way it acts as a pointer to the main group of flowers. I also included a little of the wood behind it, and exaggerated the slope of the ground.

I then used the photograph at the top right to get the idea of the background soft focus flowers and twigs, though the far distance is imaginary and I kept the tones very soft.

The large photograph below was used for the main primroses, although as I needed more detail than this photograph showed, I gathered and painted fresh primroses from my garden.

The source photographs for this painting.

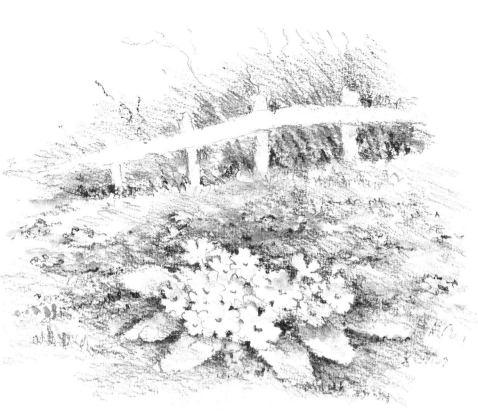

Tonal sketch

I made a tonal sketch of the primroses using watersoluble pencils to help plan the composition. It combines ideas and elements from the four photographs opposite. Making a sketch to help you to decide what to keep and what to leave out is a good idea, especially when there is a lot of detail in the background.

Choosing colours and tones

It is surprising just how pale primroses are, so it helps to try out the colours on spare paper before you begin the actual painting. The colour vignettes of the primroses (see right) show the beginnings of the flowers and leaves along with tonal swatches. Note that these are kept very pale at first as tiny darks will be added later.

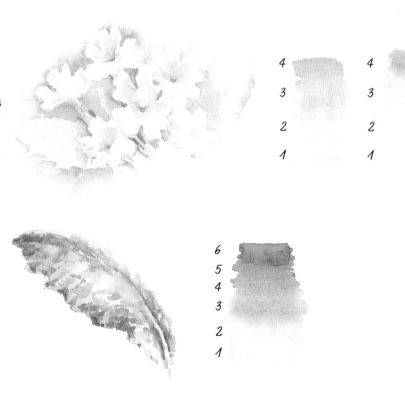

Completing the painting

I decided to put a background in to suggest the area that the flowers were growing. The initial background wash used all the colours that would be in the finished painting: lemon yellow, new gamboge yellow, quinacridone gold, cobalt blue, cobalt violet, brown madder and the green mix. As always, the tones were kept pale and plenty of white paper was reserved where the main primroses would be.

You can see the little fence is painted in negative, although it is dark on the photograph. I simply used the idea of the fence as a prop. I also used blue tones for all the background: partly to suggest distance, but also to show up the warmer-toned yellow primroses and green leaves.

I like the vignette style of this painting as it kept it very fresh and suggests the early coolness of a spring day to me.

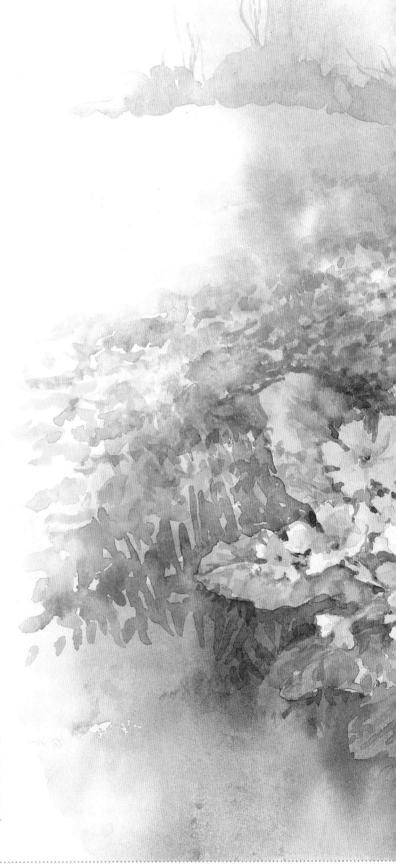

OPPOSITE
The finished painting
38 x 32cm (15 x 13in)

I waited until the following year, when primroses were once again in bloom, before I came back to finish this painting. The finished painting reminds me of that lovely spring every time I look at it.

80

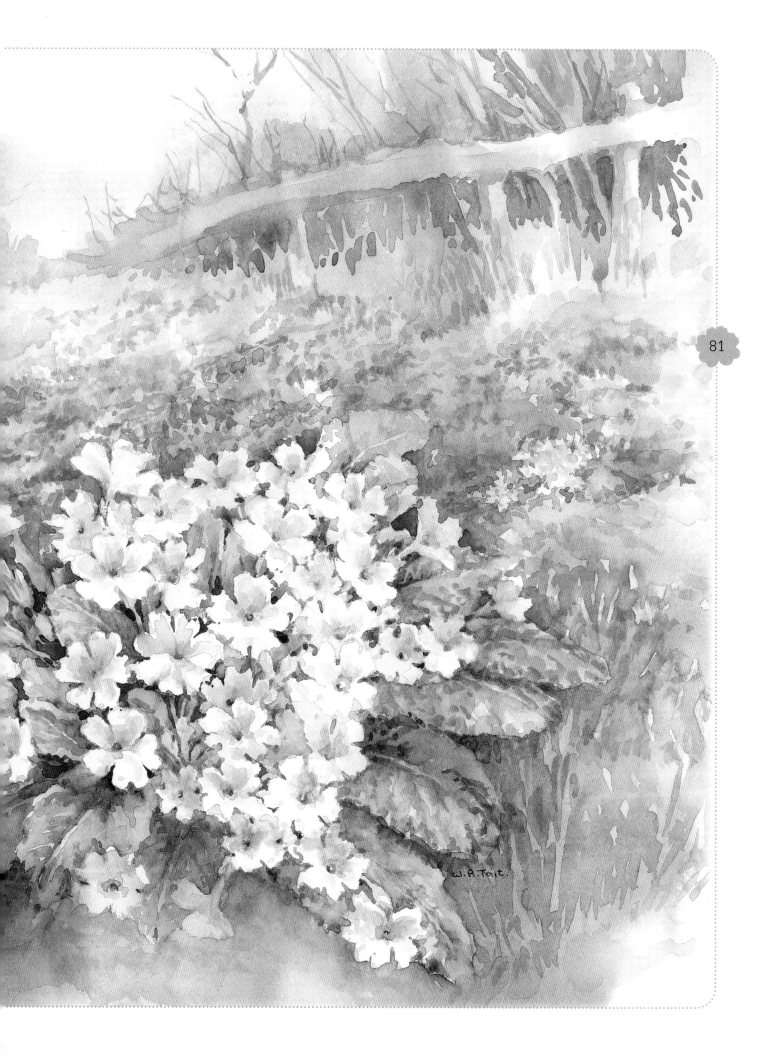

THE FLOWERS

I have chosen three very different subjects for these examples of different ways of painting flowers in watercolour. One of my absolute favourites is the subject for the first painting, *Wildflower Meadow*. Although it is rare for me to use masking fluid, this project uses it to show the freedom it gives; when the initial washes are dropped in, you do not have to worry so much about reserving the areas of white paper.

The second painting, *Wisteria*, shows you how to create a softer effect in your flower paintings. Negative painting with warm hues is used behind the leaves and flowers to contrast with the cool blue-grey flowers. This project also shows how to adapt photographs.

The third project, *'Snowy Owl' Iris*, is an example of a much looser and more free style of painting. It is an example of painting purely from a very small photograph, so the details are not visible at all.

I recommend you paint the three projects in order; from the most traditional and simplest to the most experimental and unusual.

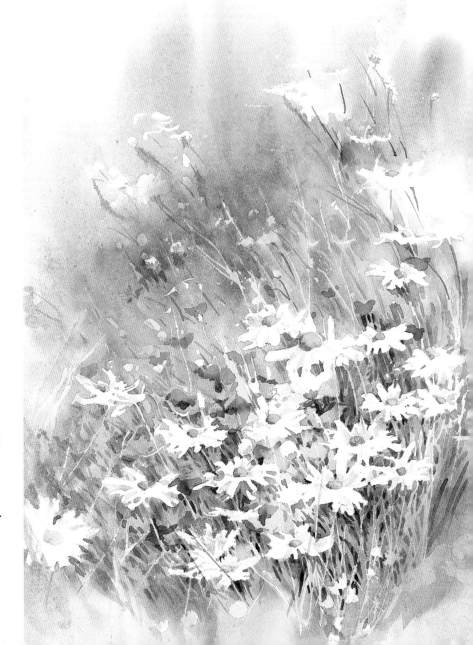

Wildflower Meadow

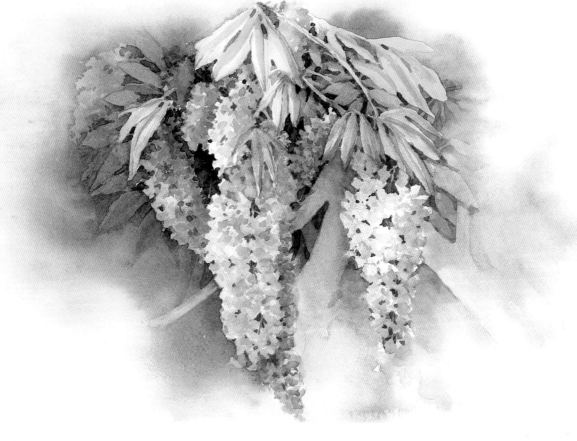

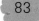

Wisteria

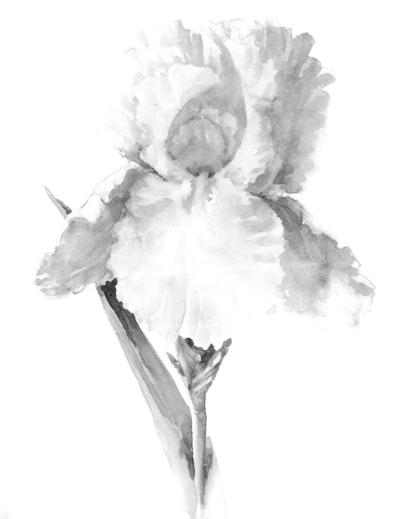

'Snowy Owl' Iris

Wildflower Meadow

Wildflower meadows are among my favourite subjects to paint. When I look at the photographs of these different meadows I remember vividly how I would have loved to have sat in the middle of each field and begun painting straight away.

This project will help to show you how masking fluid can give you freedom and control without sacrificing a fresh feeling to the finished painting.

Painting like this does mean that a lot of imagination is used and the end result can be streets away from the intended painting. I do not think that is at all important. To have the freedom to let the colours flow and see what effects happen is all part of the risk – and reward – of painting in watercolours.

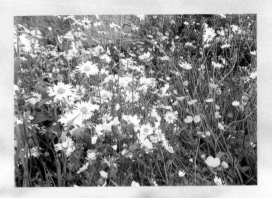

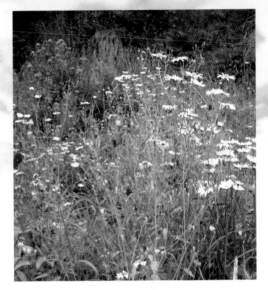

Reference photographs

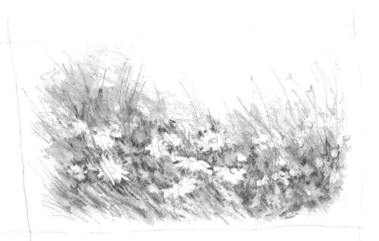

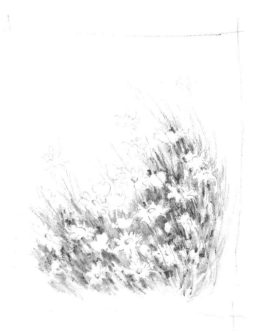

Preliminary sketches

I made these rough sketches so that I could plan the painting and get an idea of the layout and tonal values. The horizontal (landscape) shape I may use at another time, as the vertical (portrait) shape will be better for this step-by-step exercise as I think it will be simpler to follow. In addition, the portrait format is more dramatic as the flowers are larger and therefore form the focal point immediately.

When the finished painting is compared to the sketch and the photographs, you will see that I only used the reference material loosely, as a stepping-off point before I let the paint, water and imagination take over .

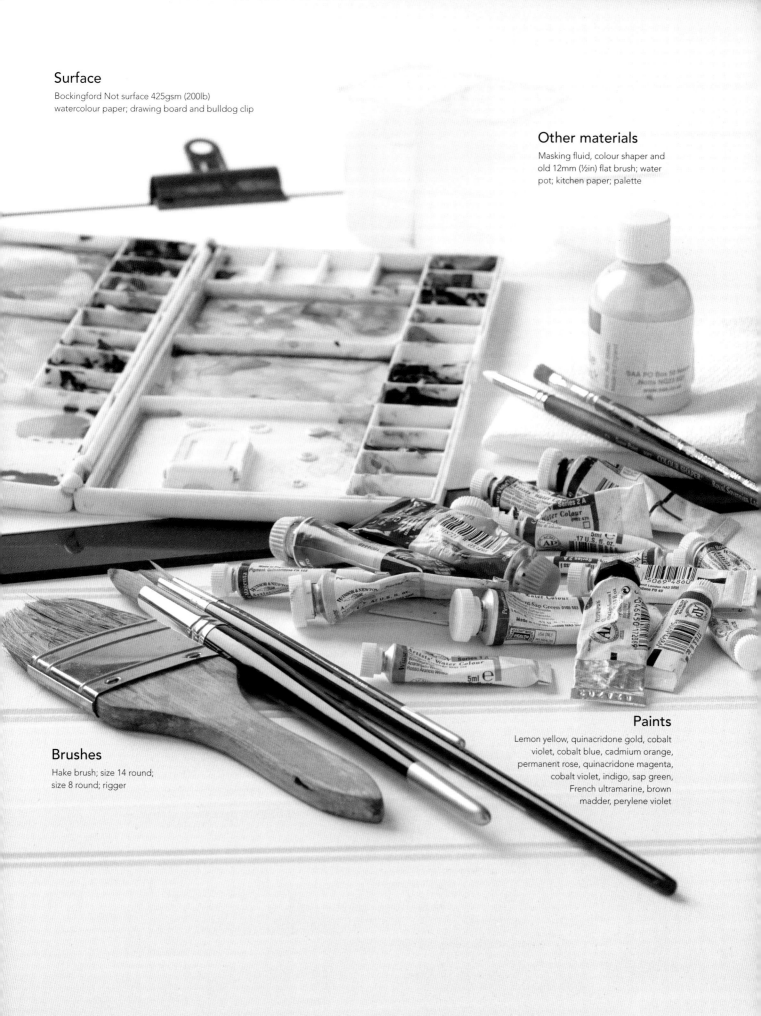

Surface

Bockingford Not surface 425gsm (200lb)
watercolour paper; drawing board and bulldog clip

Other materials

Masking fluid, colour shaper and
old 12mm (½in) flat brush; water
pot; kitchen paper; palette

Brushes

Hake brush; size 14 round;
size 8 round; rigger

Paints

Lemon yellow, quinacridone gold, cobalt
violet, cobalt blue, cadmium orange,
permanent rose, quinacridone magenta,
cobalt violet, indigo, sap green,
French ultramarine, brown
madder, perylene violet

Establishing the underlying structure

Secure the paper to the drawing board using a bulldog clip and prop the board up at a slight angle.

Use the colour shaper to apply masking fluid to the paper in rough flower shapes. Always err on the side of adding more than you think you will need to establish the composition – some can be removed later, and painted over; but you cannot take out paint and reveal clean paper later. Concentrate on the lower third of the paper when adding these shapes.

Draw in a few stems and grasses with the colour shaper and masking fluid. Give these stems a slight curve to lead the eye to the focal point. Next, load the old flat brush with masking fluid, hold it over the painting and draw your finger across it to flick the masking fluid over the painting. This technique is called 'spattering'. Spatter the masking fluid over the main area of the composition, again allowing a few bits to extend over the rest of the painting. Allow to dry.

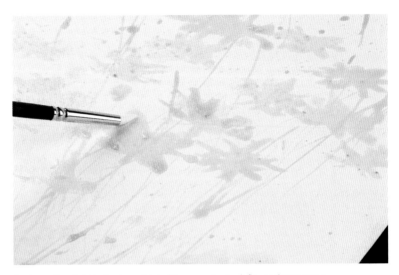

Apply masking fluid to the lower third of the paper in rough flower shapes using the colour shaper.

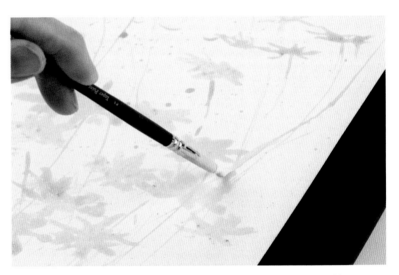

The colour shaper can be used to apply masking fluid in long curved lines. You could use an old brush for this instead.

Spattering masking fluid over the paper produces a wonderful random effect.

The painting at the end of stage 1

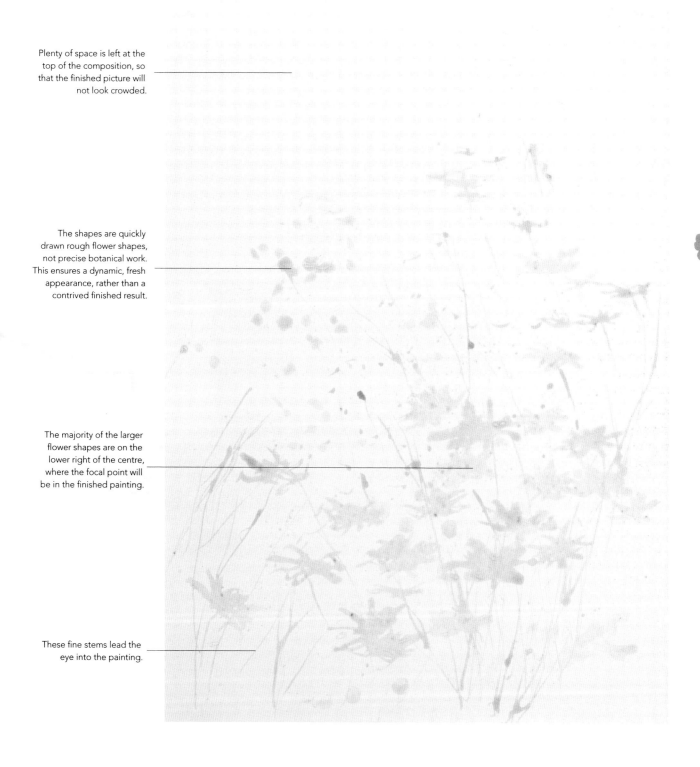

Plenty of space is left at the top of the composition, so that the finished picture will not look crowded.

The shapes are quickly drawn rough flower shapes, not precise botanical work. This ensures a dynamic, fresh appearance, rather than a contrived finished result.

The majority of the larger flower shapes are on the lower right of the centre, where the focal point will be in the finished painting.

These fine stems lead the eye into the painting.

Building the background

Prepare the following wells: lemon yellow; quinacridone gold; a mix of cobalt violet and cobalt blue; a mix of cadmium orange and permanent rose; a mix of quinacridone magenta and cobalt violet; and a mix of basic green (lemon yellow and indigo) and sap green. These should be prepared in a tonal range of 1–5.

Use the large hake brush to wet the paper with clean water. Cover the whole area of the painting, making sure it is all thoroughly wet.

Begin building the background by dropping in lemon yellow around the focal point for sunlight using the size 14 round brush. Without rinsing the brush, drop in quinacridone gold and then the green mix. Work very loosely.

Rinse the brush, then continue building the background using the cobalt violet and cobalt blue mix. Add the quinacridone magenta and cobalt violet mixes at the top of the paper to establish darker areas of background.

While the paint is still wet, enrich the orange and yellow sunlight area in the middle with touches of the warm cadmium orange and permanent rose mix. The paint will dry much paler than it appears here, and this area should establish the poppies, which have quite strong colours.

Tip and tilt the paper gently to encourage the colours to merge a little, without losing your major areas or allowing the painting to become muddy.

Add quinacridone gold to the green mix to strengthen it and build up the darks in the lower right; then use more of the cobalt violet and cobalt blue mix to add darks to the bottom.

Lay the painting flat, then strengthen the green mix further by adding quinacridone gold and more basic green to the mix and build up the darker green tones for depth. Similarly, add some more of the warm cadmium orange and permanent rose mix in the centre to ensure that you do not lose the vibrant colour around this area.

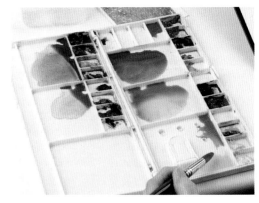

The prepared wells of colour, showing how I have laid out my palette for this stage of the painting.

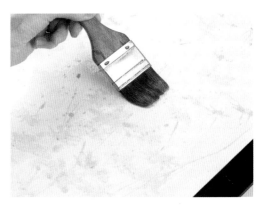

The hake brush in use; producing a glossy wet effect

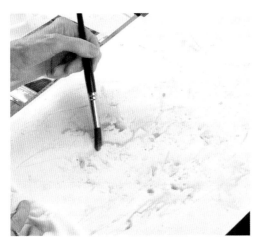

I used a size 14 brush to apply all of the paint at this stage. The colour appears quite bright while it is wet, but this will fade slightly as it dries.

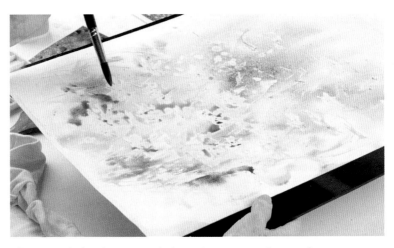

When tipping the board, move it gently; the aim is to encourage the areas of paint to merge slightly – too much movement will make things muddy.

The painting at the end of stage 2

It is important to wet the paper thoroughly right to the edges of the paper so that the colour flows smoothly and does not form hard lines.

The cobalt violet and cobalt blue mix, along with the quinacridone magenta and cobalt violet mix are used for the upper part of the background, and allowed to bleed away to the edges of the paper.

The masking fluid resists the wet paint and reserves clean paper.

Sap green, the green mix and the cadmium orange and permanent rose mix are used in the lower half of the painting to create a variegated backdrop for the flowers.

Warm mixes here draw the eye. Remember the rule of thirds, and drop in the lemon yellow on the lower right of the centre to create a focal point for the painting.

Be careful to avoid the colour puddling too much, as here. Tip the board to encourage the paint to flow.

Small amounts of the blue-violet mixes are used at the very lowest corners to keep the eye being drawn into the centre.

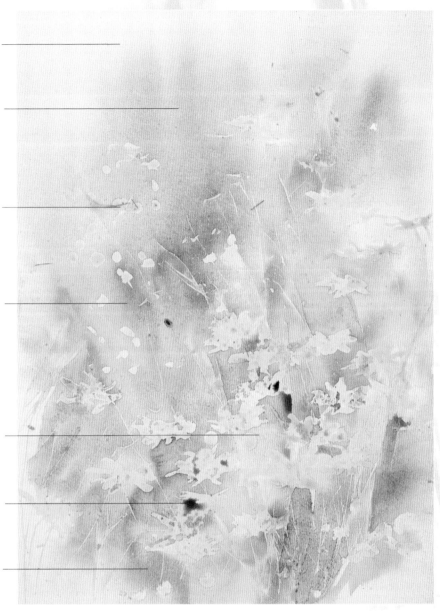

TIP

I have not added colour right to the edge of the paper for this painting; this is because I like to be able to choose the size and format of the final piece once the watercolour has had an opportunity to establish itself – you do not have complete control, and allowing some space for the paint to diffuse into sometimes produces happy accidents from which you can benefit.

Establishing the shapes

While the painting dries, you have some valuable time to plan the composition, taking into account how the paint has settled and dried. Remember that the watercolour is in charge – you may have to change your focal point if the way the paint has run and mixed dictates it. Of course, you can encourage it where to go – this is the skill of watercolour painting – but you cannot force it.

This drying period can be used to prepare the wells of colour for the next stage. These will be using many of the same colours, but in a deeper tonal range of approximately 5–8. Do not clean your palette for these; instead, create the deeper mixes towards the edges of the relevant wells so that you still have some of the paler mixes from stage 2 available. Make a deep blue mix of French ultramarine and cobalt violet in a spare corner of the blue well. Make a rich yellow mix of lemon yellow, quinacridone gold and indigo in a spare corner of the green well. Make a new well of brown madder, perylene violet and cobalt violet.

Once the painting is completely dry, use a clean finger to gently rub away all of the masking fluid. Keep your reference photograph close to hand for quick reference. Using the size 14 round brush, glaze the stems here and there with a very light green, made by adding extra lemon yellow to the basic green mix. This covers the clean paper to remove any starkness, while leaving the areas light and fresh.

Rinse the brush, then use a mix of lemon yellow and quinacridone gold to establish the centres of the daisies. While the paint is wet, pick up a little more quinacridone gold and a touch of the basic green mix to touch in the shaded areas of the centres.

Rinse the brush. Using a stronger mix of cadmium orange and permanent rose, begin to place the poppies, using the reference photograph alongside reacting to the background of the painting to suggest their placement among the daisies. Add small petal shapes with the paint, then rinse the brush. Use the damp brush to draw out the colour a little to create soft highlights and shape the petal. While still wet, drop in deeper tones of the cadmium orange and permanent rose mix. Try to keep them roughly the same size as the daisies; so larger towards the focal point and smaller further away. Make a mix of indigo and cobalt violet, then touch in the poppy centres; allowing the colour to merge with the reds. If necessary, soften the top edge of the deep colour by encouraging it into the red with the tip of the brush.

Shading the daisies

Although the light is coming from the top right, the shadows will be on the bottom of the right-hand petals near the centre of the daisy. This is because the flower forms a shallow cup shape (see left), so the petals here are against the light. The rounded yellow centre collects the light at the top.

When preparing the deeper mixes for this stage, remember to reserve some of the space in the wells for the paler mixes used earlier.

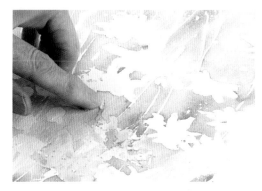

The masking fluid will come away smoothly with gentle rubbing, revealing clean white paper beneath.

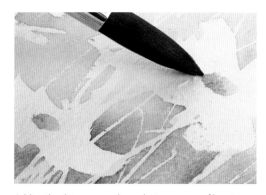

Adding the daisy centres shows the importance of keeping the original mixes alongside the new mixes – it allows you to work quickly and instinctively.

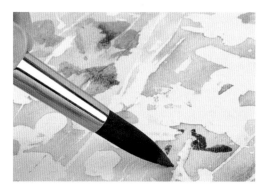

Use the tip of the brush to apply the poppies, carefully working around the revealed areas of clean paper.

The painting at the end of stage 3

The upper part of the painting is left untouched at this point; the main shapes should be kept away from this background area to increase the sense of distance.

Not all of the unmasked areas are painted at this point.

Do not worry about the green glaze going over the blue-violet background when painting the stems. The white of the paper will make the stem stand out and the green glaze will blend into the background.

The smaller poppies here are less developed; they do not have any centres or overlaid detail. This helps them to fade into the background more than the others.

The poppies near the focal point add strong, eye-catching reds to reinforce the warm colours already used here.

The daisy centres help to establish shape and turn the abstract flower-shaped blobs into definite objects.

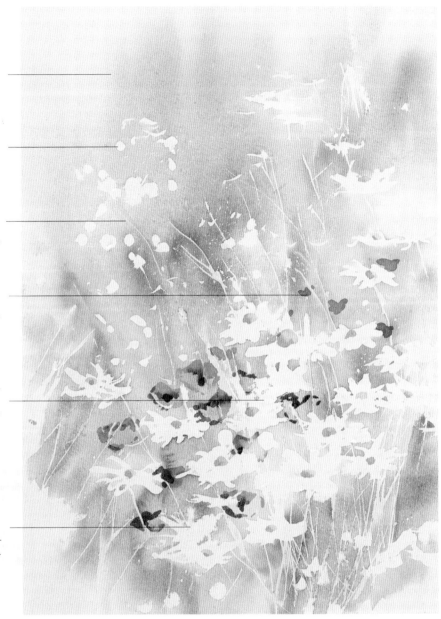

TIP

If any loose bristles come off your brush as you work, leave them in place to avoid muddying the paint. Once the painting has dried completely, you can pick them off carefully.

More controlled work

Change to a size 8 round brush and use the green mix of lemon yellow, quinacridone gold and indigo, at a dark tone of around 7 or 8, to begin improving the shapes of the daisies and stems. Using smaller strokes and working more carefully than before, draw the paint down either side of the stems so that the stem itself remains light and therefore advances towards the viewer. This technique is called negative painting. Similarly, cut into the edges of the daisy shapes to suggest the detail of the petals and improve the shapes.

92

We want the darkest tones of the finished painting to be in the focal area. Even though we are not using the very darkest tones yet, it is important that we establish some darker midtones around this area and keep the remainder of the painting fairly light. Concentrate the shaping around the lower centre, and do not add much (if any) to the areas further back in the background at this stage.

As you work away from the focal point, dilute the mix to reduce the tone to around 5 or 6, then continue working on improving the shapes of the flowers. Throughout this stage, it is important not to lose the impression of freshness and light, so be careful not to go too far.

As you work through the painting you may find that the various stages have taken you away from the original photograph. This does not really matter. To attempt to correct at this stage can mar the fresh approach so it is better left alone rather than try to 'fit' it to the photograph. It is better to develop ideas as they suggest themselves during the painting.

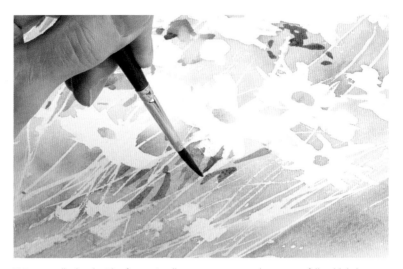

Using a smaller brush with a finer point allows you more control as you carefully add dark tones around the stems. The contrast between the dark recesses and the light stem creates definition and throws the stem forward.

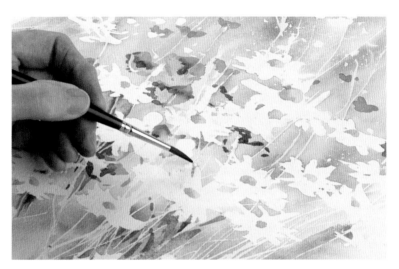

The point of the smaller brush allows you to develop the daisies. 'Cut into' the edge of the white shape and draw the paint towards the yellow centres to suggest the gaps between petals.

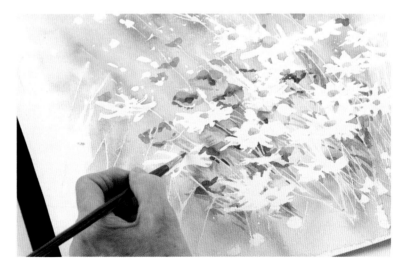

The stems are developed using negative painting in much the same way; by working up to them and leaving some of the lighter colour showing between dark areas.

The painting at the end of stage 4

The detail is concentrated around the lower part of the painting. The upper part remains clean.

Some additional simple poppies have been added here in the midground.

Stems are suggested here through the use of negative painting – leave a slim gap of the light background colour showing between small areas of glazed green.

Strong contrasts created by the use of dark tones against light areas draw the eye, so keep them reserved for the foreground and focal areas.

Careful cutting in helps to develop the shapes, making even those daisies without a obviously identifiable visible centre stand out.

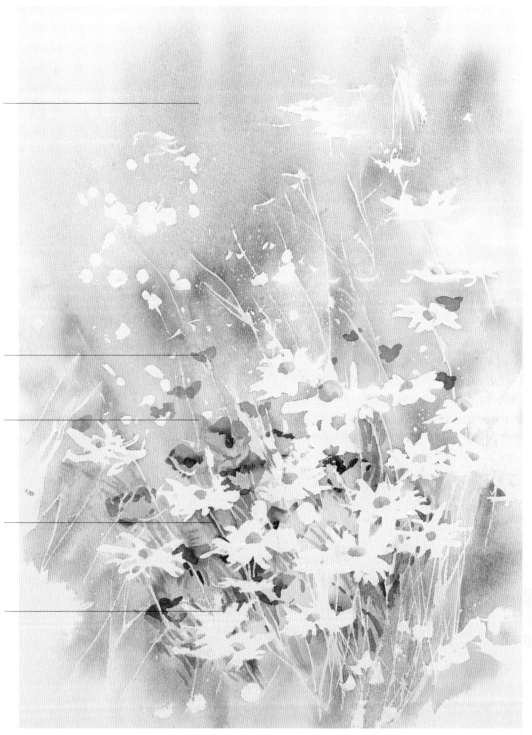

Developing the foreground

While we have used some of the details in the background to help suggest the placement of the poppies, this stage is more detailed and concentrates on mixing the blues, greens and yellows to form a coherent whole. By the end of this stage, we will have used overlaid glazes and tonal work to create more depth to the painting.

Look over your painting. It is likely that the lines of masking fluid will have stopped the paint from mixing smoothly and created lines that break the areas of colour; with one colour on one side of a stem and another on the other. For example, there are some areas on the lower right and lower left that are much more blue than the central area, so we need to draw some of the blue over into the green area.

Using the size 8 round brush, identify the closest mixes on your palette to the colours, and lightly introduce areas of the colour over the other side, drawing it across to create a smooth transition without covering the stem. As you work over the painting smoothing these artificial breaks in the background, mix, mix and mix again – you are trying to create natural variation, so it is not necessary to match the original mix exactly.

Suggest some buds in the midground by using the size 8 round brush to draw lines of the basic green mix (at a fairly light tone) down from a few of the larger white areas revealed by the removal of the masking fluid. Add a little sepal detail at the end of the stems for detail and interest.

Still using the size 8 round brush, add a touch of the basic green mix to the cobalt blue and cobalt violet mix. Dilute to a very light tone – as light as 1 or 2 – and suggest details on the petals.

The lower left-hand corner requires some detailing, in the same way as the rest of the foreground, but as it is away from the focal area, use lighter tones than the centre and right-hand corners.

94

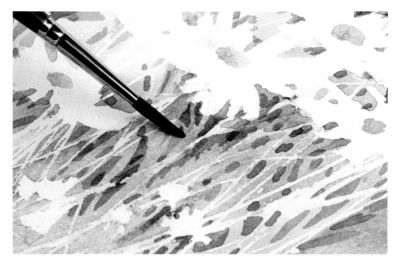

Here, a blue glaze is being introduced from the area on the left side of the stem to the area on the right.

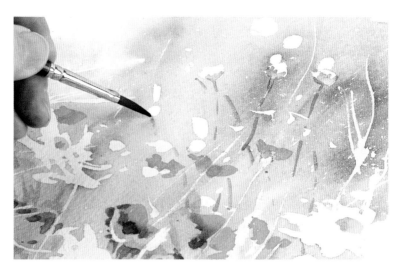

Adding tiny touches of green detailing quickly turns the small areas of white paper into effective buds.

The tones used to add detail to the daisies should be kept very light. Because they are clean white paper, any paint will stand out clearly.

The painting at the end of stage 5

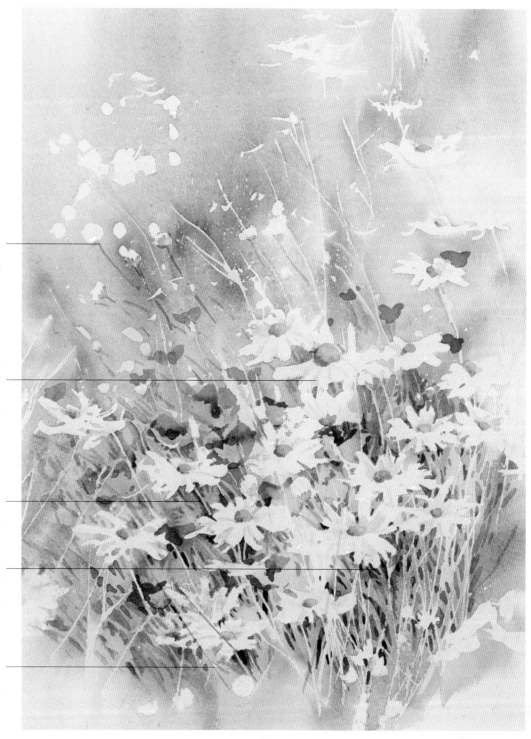

Simple details like these stems help to develop the midground a little without drawing too much attention from the focal point.

The detailing on the daisies is an important addition. Even though it is very subtle, it adds to the overall realism and ensures the daisies look like part of the composition.

Using the same mix of paint on either side of a stem makes it appear that the background is continuous.

Most of the work at this stage is concentrated around the focal area. Having more detail draws the eye.

Light strokes of green to suggest stems are also drawn across some of the foreground flowers in the lower left-hand corner.

Background and details

Tilt the board, so that the paper is flat. Use large strokes of the hake brush to rewet the top quarter of the painting over the background, including the buds, with clean water. Work very quickly so that you do not disturb any of the underlying colour. Switch to a size 14 and drop in a midtone (tone 5) of the cobalt blue and cobalt violet mix around the buds, then tip and tilt the board to encourage the colour to flow smoothly. The aim is to create the impression of distant out-of-focus flowers in the far background. Working wet in wet, add touches of quinacridone magenta to this area around the buds, creating a little detail.

Rinse the size 14 round brush and use a fairly light mix of basic green to glaze the corners in the foreground, knocking back the starker areas. Switch to a size 8 round brush and use a stronger green mix to add some detail to the midground on the right-hand side above the focal point. Add some strokes to suggest stems or blades of grass. Switch to the rigger brush and add a few soft stems across the background in the same way. This brush is well-suited to this task, as it carries a lot of paint, allowing you to produce long stems in a single smooth stroke.

Use negative painting to continue to develop the painting in this way, but do not overwork it. It is important not to fiddle too much, however tempting it may be! You risk losing the freshness and immediacy of the painting.

Soften off the edges of the painting slightly using a very dilute wash of lemon yellow and quinacridone gold, applying it with light strokes of the hake brush. This gives a finishing glow to the painting, reintroducing some of the impression of sunshine.

Adding the blue mix to the rewetted background helps to create a soft background suggestion of flowers to strengthen the area and help frame the focal point.

Adding colour wet in wet results in a smooth blend in hue and tone.

The rigger is the easiest way to create the suggestion of long stems and blades of grass.

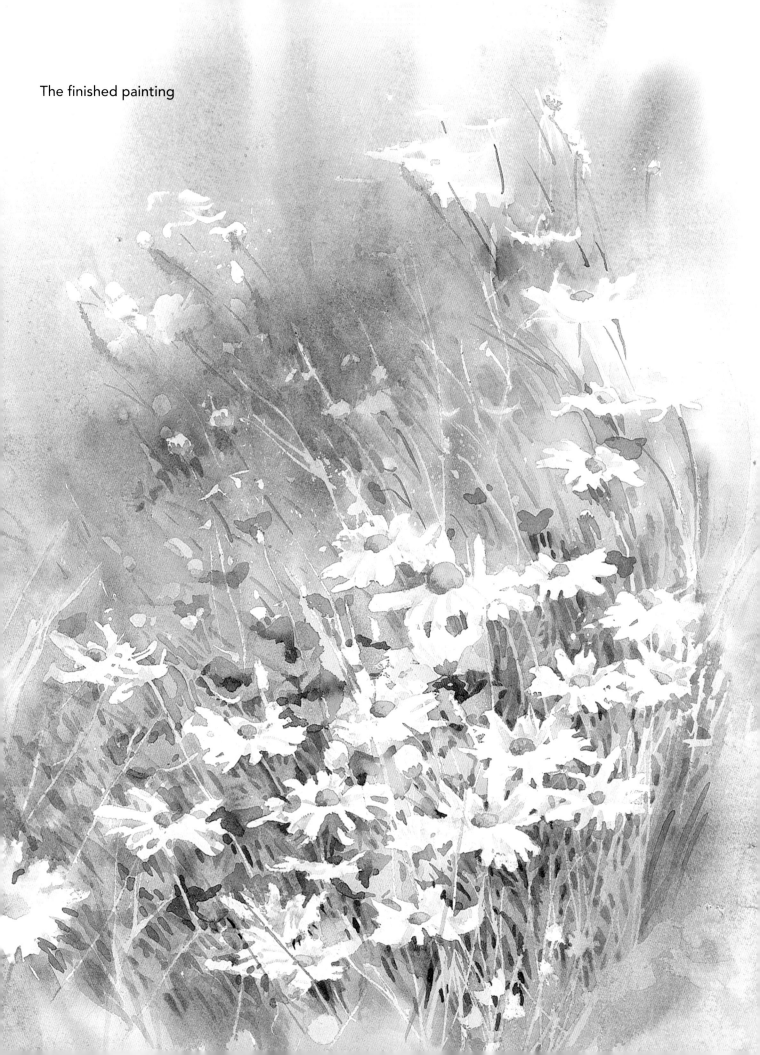

The finished painting

Wisteria

This painting differs from *Wildflower Meadow* in that I have not used masking fluid to reserve the lightest areas and the whole effect is softer; a very attractive approach to flower painting.

It always has to be remembered that photographs are a poor substitute for the real thing and a good bit of imagination must be employed to end up with a successful painting. The shadows of the reference photographs are much too dark and cold and the

actual subject would have had lots more warmth. As a result, I have deliberately chosen a warm mix of brown madder for the negative painting behind the leaves and flowers to contrast with the cool blue-grey of the flowers.

This painting uses a lot of very enjoyable negative painting. By cutting out around the flowers and the supporting poles, great use can be made of the subtle tones of the background.

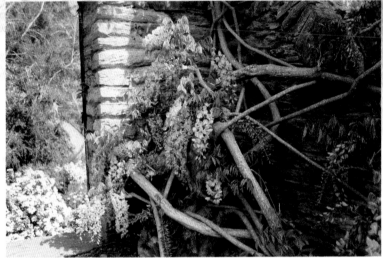

Reference photograph

When I looked at this photograph, taken by a friend, I knew I wanted to concentrate on the flowers and not the ugly bare branches of the wisteria. The focal point in this painting will be in the top left, as this is where the main cluster of flowers are. I have used the branches as compositional aids to direct the eye to the focal point.

Sometimes it can be overwhelming when faced with a subject like this, and an attempt to put too much in can result in an overworked painting. It is far better to choose one section and alter the framework to make a good, simple composition.

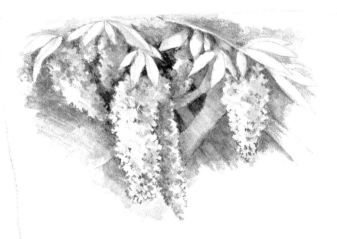

Preliminary sketch

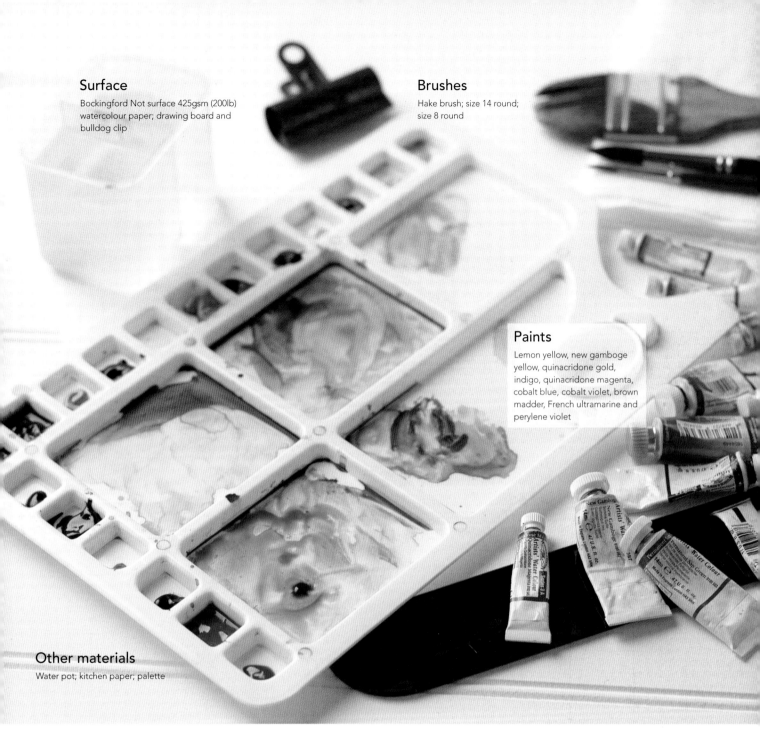

Surface
Bockingford Not surface 425gsm (200lb) watercolour paper; drawing board and bulldog clip

Brushes
Hake brush; size 14 round; size 8 round

Paints
Lemon yellow, new gamboge yellow, quinacridone gold, indigo, quinacridone magenta, cobalt blue, cobalt violet, brown madder, French ultramarine and perylene violet

Other materials
Water pot; kitchen paper; palette

TIP *There are many stages to a painting: initial washes, composition, details, final glazes. Often, however, the most successful paintings go through a seemingly irretrievable messy stage, but this can lead to a depth of colour that can be superb. The trick is to wet the paper thoroughly, drop the colours on, tip the paper to let them merge a little, guiding them to where you want them, then leave it completely alone until it is dry.*

Never try to paint with a brush during the drying stages as this will leave ugly brushmarks which can be disastrous. Instead, go and make a cup of tea while the painting dries, then adjust this background to your composition. As long as it is completely dry, different areas can be rewetted and deepened at a later stage.

Establishing the background

Secure the paper to the drawing board using a bulldog clip and tip the board. Set it at a slight diagonal so that the paint will flow gently from the top left down to the bottom right. Prepare the following wells: lemon yellow with a touch of new gamboge yellow; a warm green mix of lemon yellow, quinacridone gold, sap green and indigo; pure quinacridone magenta; a lilac mix of cobalt blue, cobalt violet and a touch of quinacridone magenta; and a dark mix of brown madder and cobalt violet. These should be prepared in a tonal range of 1–5.

100

Wet the paper with clean water and the large hake brush, working right to the very edges of the paper. Using the size 14 round brush, suggest the sunlit leaves in the top left by dropping lemon yellow in around this area. Without rinsing the brush, drop in the warm green mix across the painting. Work very loosely, dropping the colour in around the darker areas on the reference photograph.

Rinse the brush, then use the wells of quinacridone magenta and the lilac mix to establish the basic shapes of the wisteria. Use the tip of the brush to suggest a little texture to the wisteria areas. Look at the reference photograph throughout as you work on creating the background. Once you are happy with the basic colour application, tear off a piece of kitchen paper, roll it into a loose ball and use it to remove colour from the surface where the lightest areas are on the reference photograph. This creates lifted-out highlights. Work quite firmly to ensure the paper absorbs the colour to create a definite effect of light.

Re-establish a few darks using the brown madder and cobalt violet mix; and the lilac mix with a little more cobalt violet added. As the painting starts to dry, you will find that you can create attractive effects with a little more control. Use the point of the brush with the dark mixes to establish a few suggestions of wisteria petals in the top left. This will be the focal point of the painting.

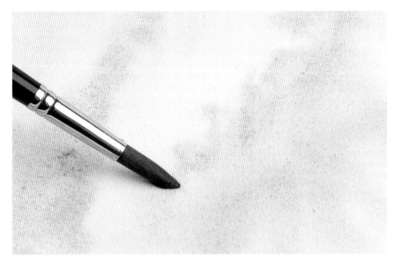

While the paint is wet, touching the end of the brush gently on the edge of the wisteria shapes, as shown, can be used to create interesting textures.

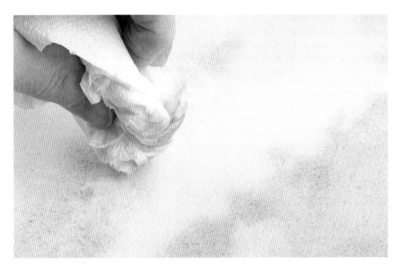

It is important to crumple the kitchen paper into a ball when lifting out, as this reduces the likelihood of the texture of the paper transferring recognisably to the painting. For the same reason, do not use paper with a pattern on! Dab lightly to lift out the paint; there is no need to scrub.

Use the tip of the brush to add small amounts of the dark mixes as the paper starts to dry.

The painting at the end of stage 1

The dark areas you add by re-establishing the darks will provide invaluable 'anchor points' to the composition as you continue the painting.

The lifted-out areas leave areas of light that will be developed into wisteria racemes (the dangling groups of flowers) over the course of the painting.

These interesting textures form the beginning of the wisteria flowers.

The background is kept light and loose at this stage.

Creating supporting areas

Using the size 14 round brush, begin to add in darks around the focal point and central area, using a mix of brown madder and French ultramarine. Begin to suggest the branches through use of negative painting, applying the paint mainly with the point of the brush.

This stage of the painting is about suggesting the basic shapes such as the supporting branches and flowerheads, distinguishing them from the background on the right-hand side of the painting. Throughout, you are using negative painting to suggest areas of the forms, creating 'lost and found' edges. These lead the eye through the painting. Throughout, do not follow the reference photograph slavishly. This is your painting; so use your reference as guidance only.

Fix the basic shapes of the flowerheads in your mind's eye, rather than obsessing about precise detail. Add a little cobalt violet to the same mix, then use a midtone (tonal range 4–5) to create edges to the petals on the right-hand flowerhead with the size 14 round brush. Work an area, then rinse the brush and bring the damp side up some of the edges to gently merge them into the background, leaving others a little more obvious. This negative painting throws forward areas of the pale background as the surface of the petals; while the new midtone additions become the shadows behind and between them. As the paint dries, use a stronger tone (tonal range 6–7) to repeat the process, building up and over the same parts for the deeper recesses.

Using a light tone (tonal range 3) of the warm green mix – lemon yellow, quinacridone gold, sap green and indigo – add leaves over the top of the right-hand flowerhead, reinforcing them with darker tones (tonal range 5–7) from the same well for detail and shadow. Draw the midtone green over the stem running through the flowerhead, then use a very deep dark mix (tonal range 9–10) to add tiny touches of the dark mix – brown madder and French ultramarine – in the deepest recesses.

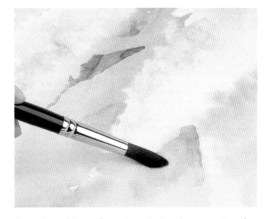

Through careful use of negative painting, the suggestion of branches can be built up. Note that the shapes you add do not need to follow any of the shapes on the paper, but instead lead the eye to the flowerheads of the wisteria.

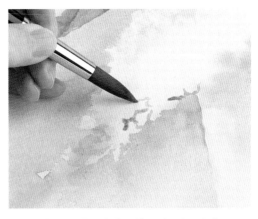

Build up detail on the right-hand flowerhead gradually.

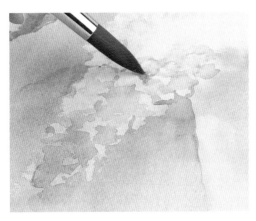

If any hard lines develop on the flowerhead, you can soften them away using a damp brush before the paint dries completely.

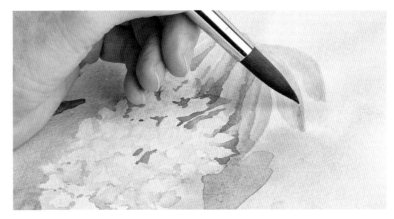

The shape of the flowerheads will start to emerge as you develop the deeper recesses and leaves.

The painting at the end of stage 2

Anchor points like this will help to work out where to place the supporting areas.

This midtone area creates a barrier to the eye, so that the viewer's attention is drawn to the focal flowerhead below.

The same deep violet mix is used as the background behind the leaves and the flowers below. This ensures continuity and realism.

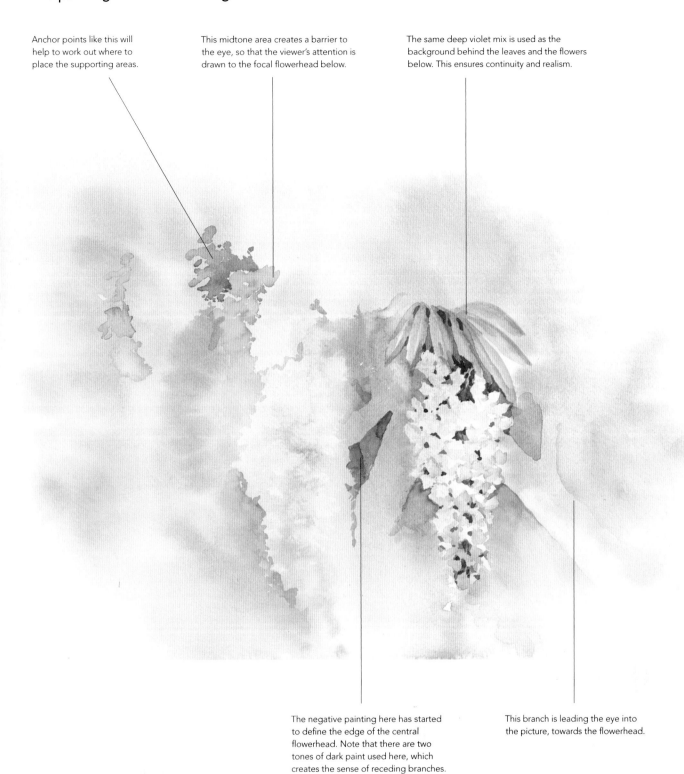

The negative painting here has started to define the edge of the central flowerhead. Note that there are two tones of dark paint used here, which creates the sense of receding branches.

This branch is leading the eye into the picture, towards the flowerhead.

Retaining the sense of light

This stage requires careful work to both add detail around the focal point while not losing the sense of light and transparency in this critical area. To achieve this, we need to use very delicate glazes, and use the background as much as new paint.

Change to a size 8 brush and use a mix of lemon yellow and new gamboge yellow to introduce the very light leaves on the top left. Draw the edges with lost and found lines (as in stage 2), leaving spaces in the centre where the background light shows through. Use the warm green mix (lemon yellow, quinacridone gold, sap green and indigo) to add very subtle shading wet in wet.

Add a tiny touch of the dark mix (brown madder and French ultramarine) to the warm green mix to create a light-toned brown (tone 2 or 3), and add some branches to draw the eye towards the focal point as well as connect this area to the supporting areas on the right.

Develop the canopy over the supporting areas with the warm green mix with a little more indigo; adding shading with further quinacridone gold and indigo. While the paint is wet, add a little of the dark mix around the transition between the leaves and flowerheads.

As you work, balance the new area against the established supporting areas. For example, as I added detail to the shaded flowerhead in the centre, I used a light tone of the same mix to glaze the right-hand side of the supporting flowerhead.

Apply very small touches of the dark mix around the top canopy above the supporting flowerhead, creating the suggestion of background leaves using negative painting. As you work towards the edge of the paper, use lighter tones and soften the colour away into the background with a damp brush.

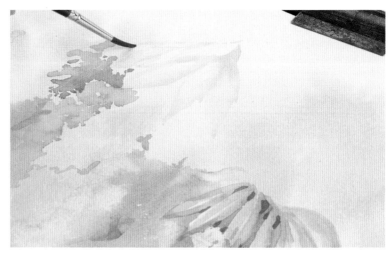

Keep the leaves at the top very light, so that you do not draw the eye away from the focal point.

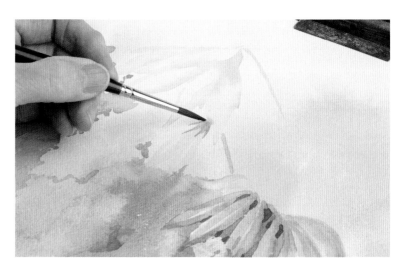

Painting in connecting branches adds a little detail to the area. Such small touches are important to help build overall realism.

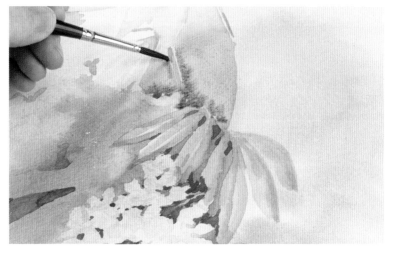

Use the tip of the brush when adding darker tones around the leaves for added control.

The painting at the end of stage 3

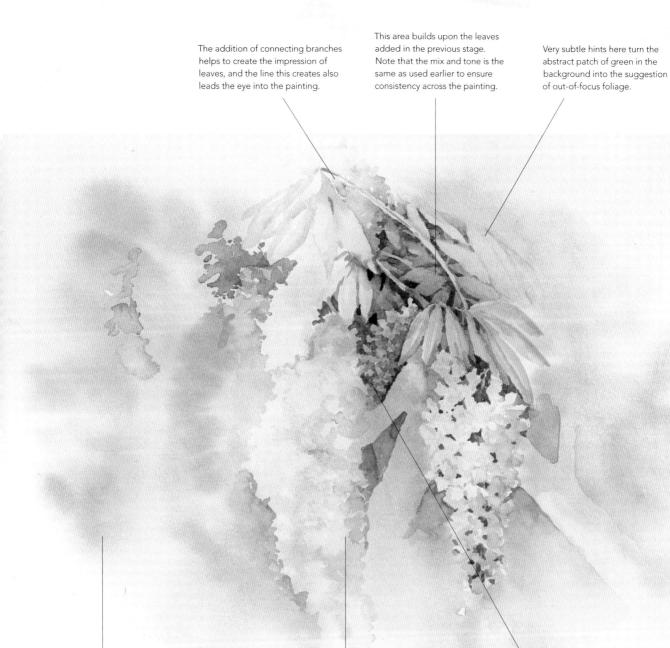

The addition of connecting branches helps to create the impression of leaves, and the line this creates also leads the eye into the painting.

This area builds upon the leaves added in the previous stage. Note that the mix and tone is the same as used earlier to ensure consistency across the painting.

Very subtle hints here turn the abstract patch of green in the background into the suggestion of out-of-focus foliage.

The overall impression of the background remains light – the dark additions are kept relatively small.

Some subtle additions here mark the start of developing the focal area.

This new flowerhead area has been developed with the darker mix. Note that the colour already on the paper is retained as highlights here.

Balancing the image

At this point, we can use the same technique and mixes as before to develop the remaining areas of the painting. Use the warm green mix (lemon yellow, quinacridone gold, sap green and indigo) for the leaves, foliage and other green areas; the lilac mix (cobalt blue, cobalt violet and a touch of quinacridone magenta) for the flowerheads; and the dark mix (brown madder and cobalt violet) for deeper shading. Use the size 14 round throughout, changing to the size 8 only for the smallest details.

The critical part of this stage is to balance the image. Rather than concentrating on sections in isolation, look at the whole picture as you paint. If you have a particular mix on your brush and notice that an area you have already worked needs strengthening or altering, use the paint on the brush to alter it. This will ensure that the various mixes on your palette are used over the painting as a whole, avoiding any mixes from standing out, and also ensure the colours across the painting are in harmony.

With that borne in mind, you can also intentionally vary the mixes to draw the eye. For example, the area of the flowerhead near the focal point is in the light, so add more quinacridone magenta and water to the lilac mix to further emphasise this.

An important part of this stage is to break up the large central flowerhead with detail. This can be achieved through negative shaping, using more blue in the cobalt lilac mix to suggest areas in deeper shadow (on the lower right-hand sides) and more cobalt violet and quinacridone magenta to the areas that are catching the light (on the upper left-hand sides). Adding glazed leaves with the warm green mix also helps to create areas that frame the focal point and break up the large flowerhead into smaller sections. Use a deeper tone of the warm green mix for the areas of stem visible behind the mass of petals. This creates visual anchors that help the eye to make sense of the area. These can be further strengthened with the addition of the strong dark mix in the recesses around them.

With the details on the remaining foreground areas developed, suggest a few leaves in the background using similar green tones to those used for the stem.

Glazing the leaves with quinacridone gold brings warmth and adds an inviting quality to the painting.

The size 14 round can be used for surprisingly small areas of detail, such as the darks by the stems of the flowerheads. The advantage is that it holds a large amount of paint, so you can use one brushload to paint all the details in one area for a consistent appearance.

Adding more leaves on the left-hand side balances the existing leaves so that there are areas of detail and interest on both sides. Note that these darker leaves are painted with the same mix used for the stem of the main flowerhead. Again, this helps to keep the painting coherent and balanced.

The painting at the end of stage 4

Adding leaves and flowers here adds 'weight' to the left-hand side and frames the focal point.

Using quinacridone gold to paint these leaves helps to relate them to the leaves on the right-hand side.

Be careful not to overwork areas. Where you do not need to adjust them, leave them alone to help retain the sense of light.

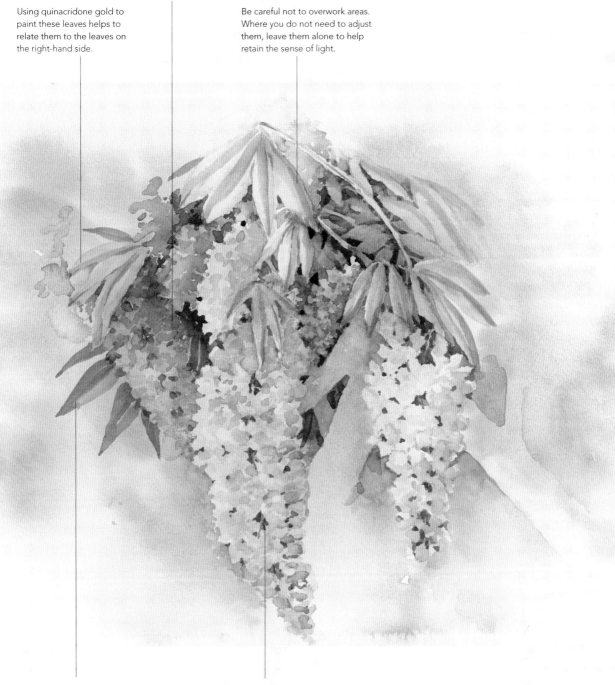

These background leaves are painted with the same dark green as the stem of the main flowerhead.

As the focal point, the main flowerhead has received a lot of detail and contrast, like the dark stem visible here.

Re-establishing the focal point

The focal point – where the eye comes to rest – has drifted down towards the lower left as the painting has continued; so we can draw it back up to the upper right by strengthening the contrast in this area. We will achieve this by strengthening the background here and increasing the contrast between the darks and highlights.

Add more water and more colour to each of the wells, making a puddle of each of the original mixes (see stage 1). Add a little cobalt blue to the quinacridone magenta to knock it back a little and make a pinker lilac mix. Make sure that each well is full of rich, fluid colours before you continue.

Lay the board flat, then wet the background on the left-hand side of the painting using the hake brush and clean water. Work right up to and over the leaves. Work quickly to ensure that you do not pick up any of the paint in place. Change to the size 14 round brush and lay in the yellow mix (lemon yellow and new gamboge yellow) wet in wet. Work towards the flowers, as the point where you lift the brush away from the paper will be where the most colour is deposited. Pick up the board and tilt it to encourage the colours to move where you want them to go.

Rinsing the brush every time, load it with the other wells and use the tip of the brush to add touches of the other colours near the flowerheads. Because these are still dry, the colour will blend away only into the wet area, which creates a beautiful diffused area away to the left. Again, pick up and tilt the board, encouraging the colour to bleed away from the dry area.

While the paint on the left-hand side dries, use the point of the size 14 brush with the deeper mixes on your palette to develop the shadows in the recesses across the rest of the painting. Keep these additional shadow areas very small. Similarly, use the wells to adjust the tonal values of the rest of the painting, taking the new area on the left-hand side into account. For example, add a light-toned glaze of green to the central branch to give it a little more shape. While the paint is still wet, you can lift out areas to suggest background branches that draw the eye into the centre. Rinse and dry your brush and draw the body of it across the wet paint in one smooth, steady motion to create a clean effect.

Allow the paint to dry completely before continuing. As the paint on the paper dries, the wells will also thicken and dry. Switch to the size 8 round and begin to pick out some details on the top left-hand side using the dark mix. Use the body of the brush to draw rough leaf shapes in negative, then draw out the colour with a damp brush to create a lost edge. Finally, draw the faint dilute wash away using the damp hake brush right to the edge of the paper. This prevents the new area of detail from sitting in a patch of colour that stands out from the rest of the background.

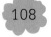

The prepared palette, with full wells ready to be used.

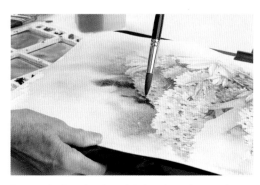

Because the flowerheads are left dry, other colours can be dropped in nearby and the colour will only bleed into the wet areas. This allows you to work right up the edge of the wisteria flowers.

Tilting the board while all the added colours remain wet encourages them to merge and spread away from the flowers.

A dry brush will lift away the layer of wet paint. You can use this to suggest subtle branches in the background.

The painting at the end of stage 5

The strengthened background helps to keeps the eye from wandering out of the painting.

Small dark area in the recesses add detail.

Subtle glazing on the background branches knocks them back a little.

Adding stronger washes around the leaves reduces the contrast between them and the background, which helps them to blend in.

This branch creates a line that leads into the painting, towards the focal point.

Strengthening the colour here adds contrast between the dark background and the light main flowerhead, which draws the eye towards the focal point.

Rebalancing and final details

With the area at the top left strengthened, we need to restore balance to the painting as a whole. Prepare a new set of wells with rich puddles of colour. Using the same techniques as in stage 5, slightly deepen the background and add details on the right-hand side. Do not darken this too much; the contrast between light and dark here should be less than on the left-hand side, so that the eye is still drawn there.

Use this stage to refine the background leaves through lost edges and negative painting, remembering in particular to take the colour right out to the edges of the paper to avoid unwanted hard lines.

Look at the painting overall once you finish strengthening the right-hand side, and rebalance once again by adding any final details across the painting. I have used the size 14 round brush to add some further darks in the background by the focal point, and also used the size 8 round brush to add a few hints of detail in the background.

When wetting the top right-hand corner of the paper, remember to avoid the foreground shapes, such as the leaves.

You can use the point of the size 14 brush to add additional darks in the recesses on the upper right-hand side.

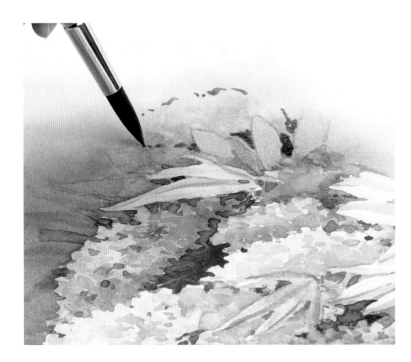

To add soft details, use the tip of the brush to apply paint onto the wet paper. Compare this picture of the top left-hand corner with the image opposite, where the paint has dried.

The painting at the end of stage 6

Careful negative painting here
suggests a background flowerhead.

Dark paint in the recesses of
these midground flowerheads
adds depth to the painting.

This area combines negative
painting with glazing.

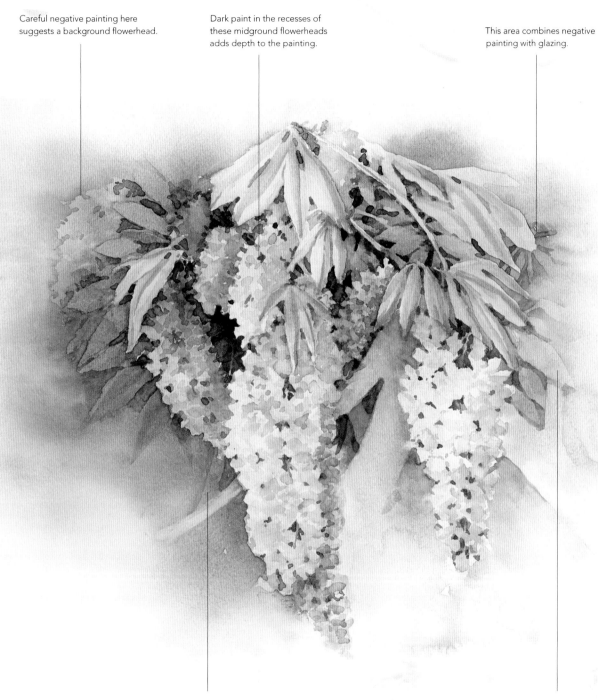

The lifted-out branch is detailed
with a second offshoot.

Leaf shapes suggested
through negative painting.

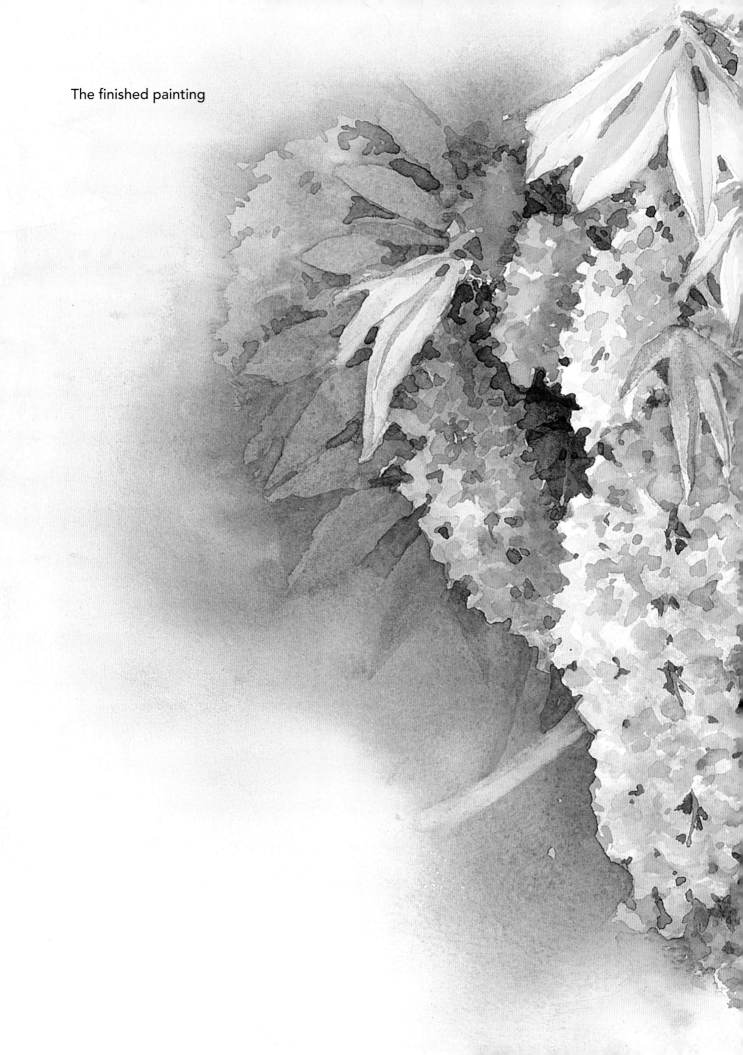

The finished painting

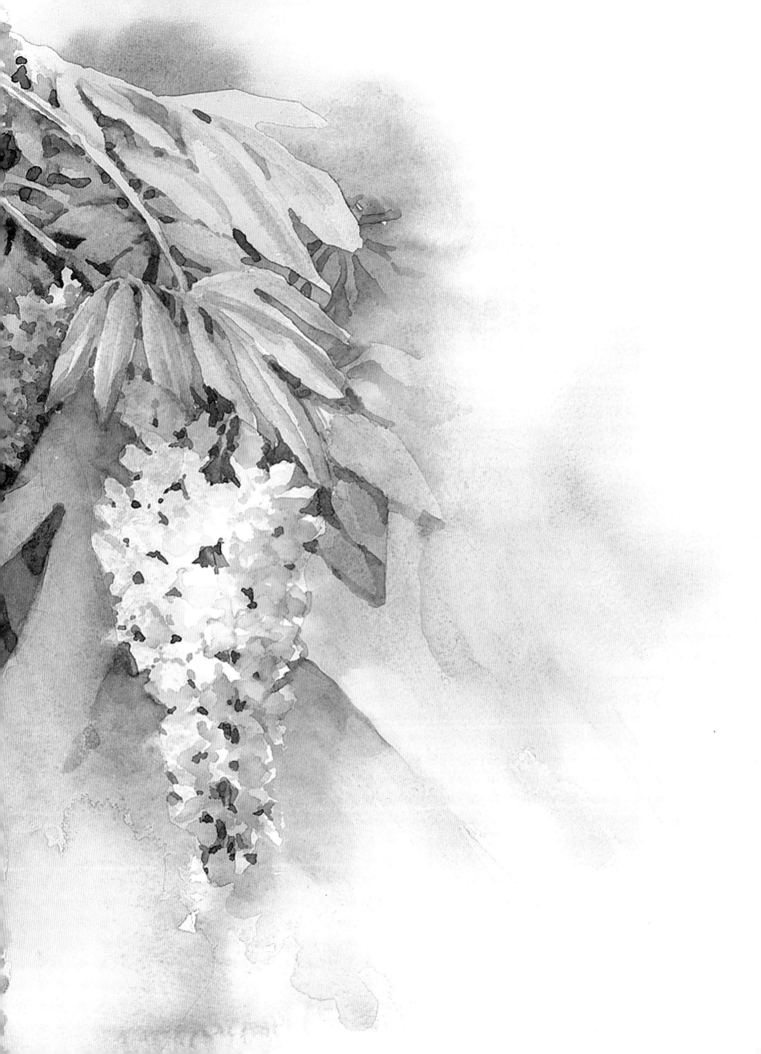

'Snowy Owl' Iris

This painting is very free and painted quite quickly without any 'fiddling' at the end. It shows how to paint a white flower on white paper without a background even though the photograph of the flower has a very dark contrast behind it. This has been achieved by exaggerating every tonal contrast, especially on the shadow side of the petals.

Irises can be painted in much more careful detail than this one, but I wanted to see if using a spray bottle to move the paint would work.

It many ways, this third project has a lot in common with the more experimental work in the play days section (see page 126). It was exciting – if a little scary! – to paint in the studio. However, it is a very enjoyable exercise if you do not let yourself worry about the end product too much.

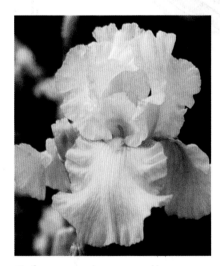

Reference photograph
This photograph is used with kind permission from Claire Austin Irises.

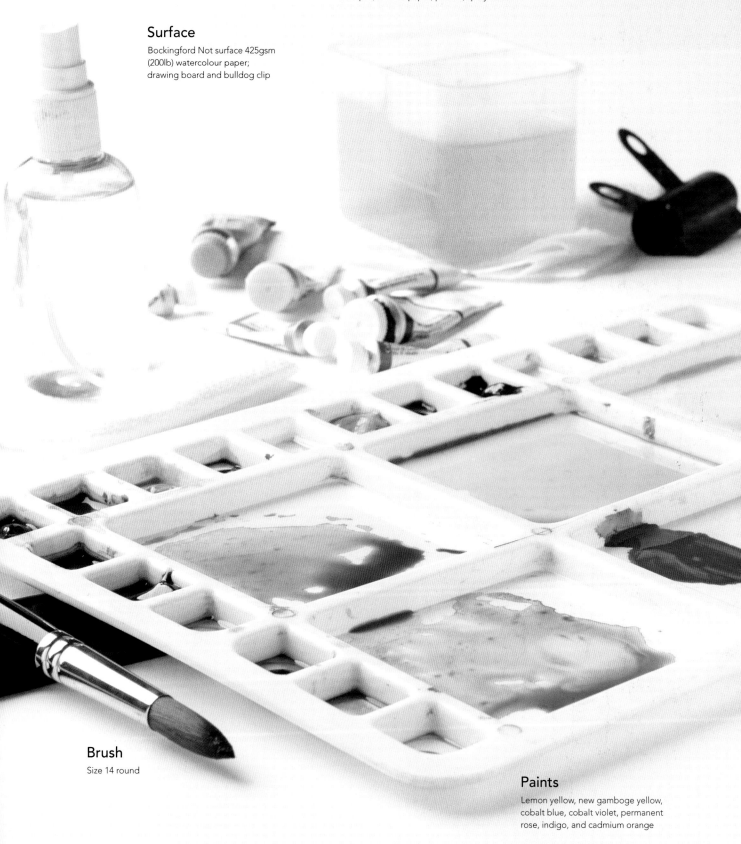

Other materials

Water pot; kitchen paper; palette; spray bottle

Surface

Bockingford Not surface 425gsm
(200lb) watercolour paper;
drawing board and bulldog clip

Brush

Size 14 round

Paints

Lemon yellow, new gamboge yellow,
cobalt blue, cobalt violet, permanent
rose, indigo, and cadmium orange

Creating the standard petals

Secure the paper to the drawing board using a bulldog clip and tip the board. Prepare the following wells in light tones (around 2 or 3): a yellow mix of lemon yellow with a touch of new gamboge yellow; a lilac mix of cobalt blue and cobalt violet; a pink mix of permanent rose and a touch of cobalt blue; and a basic green mix (lemon yellow and indigo). In addition, make two small areas of deep cadmium orange and deep permanent rose, both in a midtone (5) in a spare area on your palette.

116

Using the size 14 round brush and the lilac mix, paint in the shadow areas of the white upper petals. These are the upright petals of the iris, called the 'standards' because they stand upright. Work fairly quickly, referring to your reference photograph throughout. Use the side of the brush and work loosely. As you come to the edges of the petals, pick up a little of the pink mix and apply that wet in wet. Hint at detail in the deeper shadows, using the tip of the brush with a slightly deeper tone of lilac (by picking up the paint from the corner of the well).

Rinse your brush, load it with the yellow mix and allow it to bleed into the petal, using the photograph as a guide for placement. This will become the centre of the flower. Still working wet in wet, build up some of the other shadow areas in the same way with the lilac and yellow mixes.

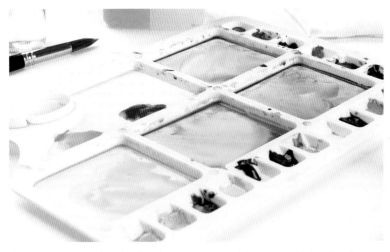

The prepared palette. Note that the mixes are stronger and deeper towards the edge of each well.

The darker tones of the lilac mix are simply taken from the edges of the well – the mix is otherwise identical to the initial wash.

Touch the yellow in lightly, allowing the paint to displace the wet lilac. Do not be tempted to agitate the paint with the brush, as this risks making it muddy.

The painting at the end of stage 1

The paint is applied in very light tones, bleeding out into the white of the paper.

Leave spaces between areas as you work, so that the wet paint does not flow from one petal into another.

The colours are worked in quickly around the centre of the flower, wet into wet.

Plenty of space is left at the bottom of the paper for later application.

Creating the falls

The lower petals are called 'falls' because they hang down. Using a slightly lighter tone of the same lilac mix, made by diluting the mix with a little water, lay in the edges of the central lower petal with the size 14 round. With that in place, use a slightly deeper tone of the lilac mix (still only 3–4) to establish the falls on the sides. These are in shadow, so you use a slightly darker tone; you can also pick up a touch of the pink well along with the lilac mix to warm the mix a little.

Drop yellow and more of the lilac mix in wet-in-wet to add detail and interest near the centre of the flower.

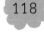

The colours on the central fall should be picked out with very dilute light tones; leaving clean white paper for most of the surface.

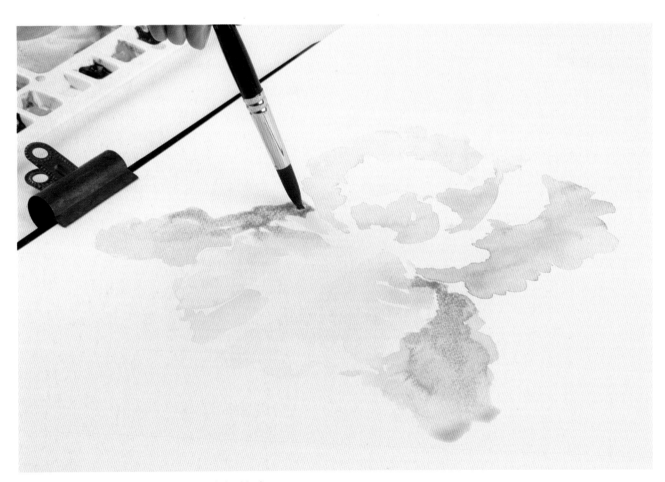

The remaining two falls are darker because they sit behind the first.

The painting at the end of stage 2

Darker tones create the impression that these background falls are further away, in shadow.

The central fall is painted with lighter tones to make it stand forward.

As in the previous step, some space is retained. The painting is currently contained in the top three-fifths or so of the paper.

Painting the centre

Now comes the scary but exciting part! You do not have a great deal of control over the next stage, but it can be very rewarding. The critical point is not to fiddle. Let the water and colour do the work for you.

Strengthen the yellow mix with more new gamboge yellow. Using the size 14 round, add areas of the stronger yellow mix and the cadmium orange in the centre of the flower. Very quickly, and holding the spray bottle near to the paper, spray the area, using the force of the water spray to push the paint outwards. Continue spraying to re-wet the whole painting, working outwards from the centre.

Roll some kitchen paper into a ball and firmly lift out the colours from areas that you want to remain white. In particular, pay attention to the area surrounding the centre. You want this to be strongly orange, but not to spread so far that it becomes too dominant. Next, use the point of the brush to add strong touches of pure colour – the strong orange and pink mixes – wet in wet to the central area, allowing and encouraging them to merge outwards. If the water pools too much in any area, lift out the excess gently with clean kitchen paper.

Rinse your brush, then add a little modelling to the white petals while the paper is still wet, by pulling a tiny amount of the lilac colour from the deeper parts onto the whiter areas; and to add some more structure by deepening the shadow areas a little. Additional details can be added with very soft tones of the lilac and yellow mixes.

Continue defining the detail in the centre by rinsing and drying the brush and using it to lift out colour. As it continues to dry, drop in tiny dark touches of the lilac mix. This relies on careful observation of the wetness of the paper. Too dry, and the marks will be too stark; too wet, and they will diffuse away.

Knowing when modelling stops and fiddling begins is crucial; and experience will teach you this better than any instruction. Remember that this is simply a piece of paper. Enjoy the process, and if it doesn't work, turn the paper over and have another go. When you get this right, it is worth the effort of trying!

The initial paints are applied a little deeper than you would usually use, as the spraying dilutes and softens the colours later.

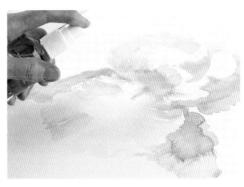

When spraying, work outwards from the centre of the painting,. This ensures the paint is pushed in the direction the flower would grow.

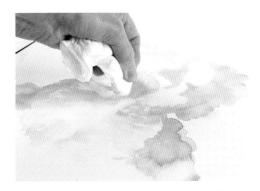

Lifting out enables you to adapt to almost anything that the spraying causes.

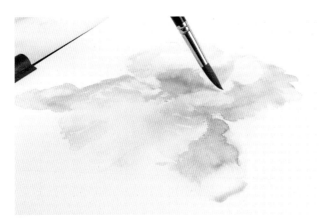

The rewetted colour on the petals will move, so you can remodel the standards and falls at this stage. As the paper dries, you will have more control, but the softness of the final effect will be reduced, so be aware of this.

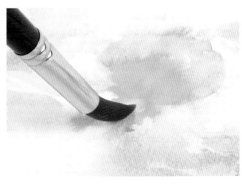

A dry brush can be used to lift out with more precision than kitchen paper.

The painting at the end of stage 3

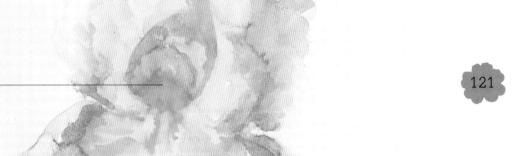

The white standard petals are modelled with subtle touches of the lilac mix.

Strong touches of yellow draw the eye to the focal point in the centre of the flower.

Slightly stronger tones are used to model the falls in the background.

The central fall remains very light in tone – it is made up of mainly clean paper, with the shading suggesting the shape negatively.

Putting the flower in context

The petals are largely complete at this point, with only a little extra detail at the very last stage to complete them. However, the picture is not a complete composition; so we will add a stem and leaves to put the flower in context and give it some supporting contrasts.

Load the size 14 round brush with the green mix and paint the bulbous part of the stem, then draw it downwards in a steady smooth stroke, lifting the brush away as the paint runs out. Without rinsing the brush, pick up a little of the lilac mix and add this to the stem, wet in wet, as shading. Paint in the caul (the papery case left after the flower blossoms) using the same two colours, allowing them to mix on the brush and paper to achieve a greyish violet colour.

Restate the shadow on the stem using the dried areas of the green mix. The paint in this part of the well will have become very dark while you have been painting. While you have the dark green on the brush, add a shadow directly underneath the central fall to add contrast. Use a dry brush to soften the transition between the shadow and the green of the stem to prevent hard lines forming. Rinse the brush, dry it, then use the body of the brush to lift out colour from the caul, to suggest the folds and texture of the papery case.

Load the size 14 round with a midtone of the green mix (tone 4 or 5), and draw the body of the brush across the paper to create a leaf. Run it up to the petal, then add a small stroke past the petal to suggest it running behind it. This will help to bring the white petal forward and give it form. Glaze the length of the leaf with the same mix, to add the shadow of the flower on it. Pick up some of the darker tone from the drier edges of the green well and reinforce the shadow areas near the petal.

Dip the tip of the brush into the drier parts of the pink, lilac and green wells to pick up a little dark neutral mix of the three wells. Use this to reinforce the modelling on the caul.

Rinse the brush thoroughly, then load it with a very strong mix of cadmium orange and permanent rose. Use the point to restate the centre of the flower, then rinse the brush and soften the colour away into the surrounding orange area. Use the strong mix to add hints of the orange visible behind the standard petals.

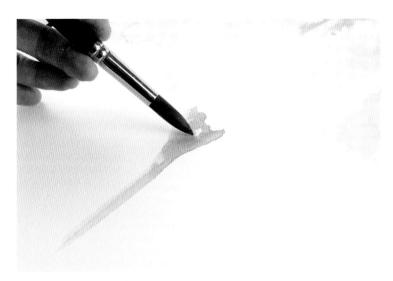

The top of the stem should finish below the central fall. This contrast in tone helps to bring out the petal edge in a similar way to negative painting.

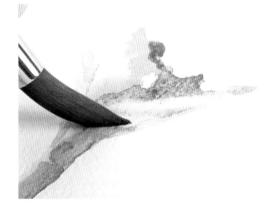

The end of the size 14 brush can lift out surprisingly fine lines – perfect for helping to create the caul's papery texture!

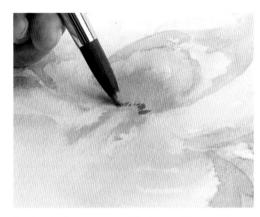

The fine detail at the centre of the flower will become the focal point of the whole painting.

The painting at the end of stage 4

The background remains clean white paper, leaving the flower vignetted.

A hint of red adds the suggestion of detail in the centre.

The leaf continues past the fall here. This helps to suggest an edge to the petal.

Texture is suggested by lifting out the paint while wet.

The stem combines colours from the petals and the leaf, helping the painting as a whole to be harmonious.

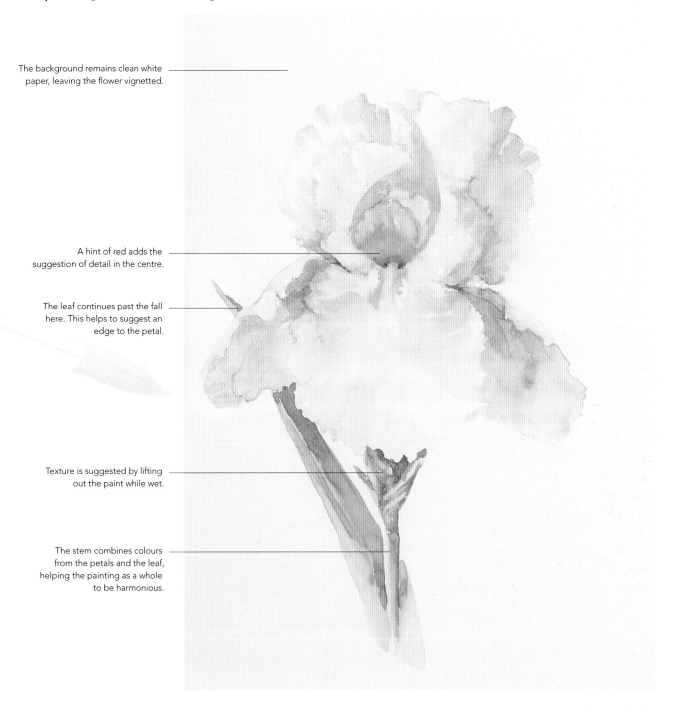

Final details

The first of the final details is to add violet to the shadow areas of the green leaf. This is to harmonise the colours of the leaf with the flower and the rest of the composition. Load the size 14 round with the dark tone taken from the drying edges of the lilac well, and use the side of the brush to apply the paint.

Add more water to the lilac (cobalt blue and cobalt violet) and pink (permanent rose and a touch of cobalt blue) mixes to create lighter versions, and use these to add detail to the edges of the petals, and also to add depth across the painting as a whole.

124

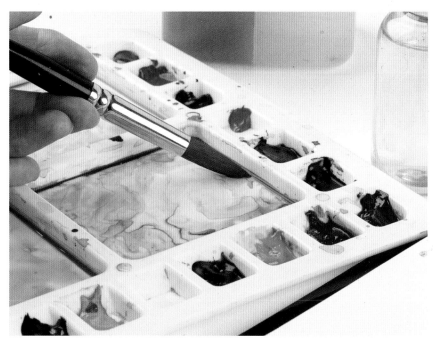

By this stage of the painting, much of the paint in the wells will have been used up, creating lots of interesting mixes and leaving strong tone in the edges.

Note

I often add a subtle abstract background to white flowers to give them something to stand out against; but in this case the iris has sufficient structure and interest in itself that no background is necessary.

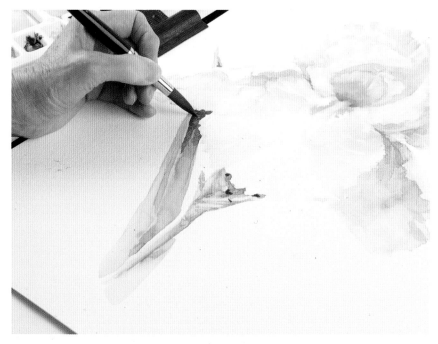

Depending on how the rest of your painting has developed, final details – such as a shadow glaze of the lilac mix on the leaf – can be relatively unimportant. Assess your own painting and judge for yourself what needs to be done. Again, be careful not to overwork or fiddle.

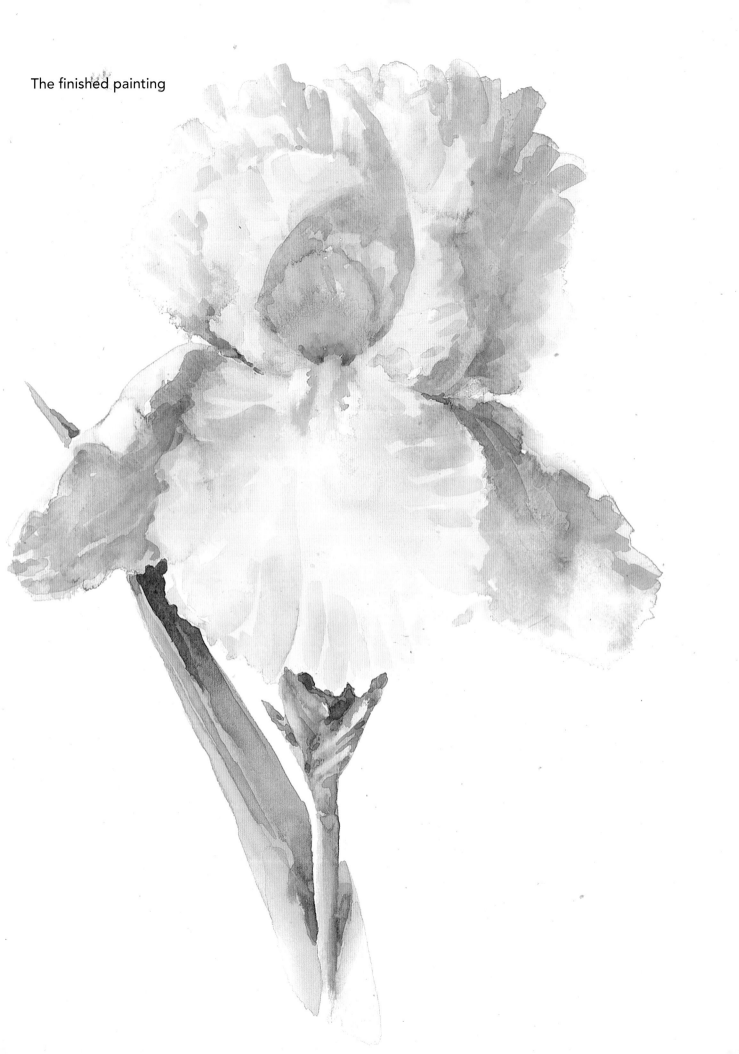

The finished painting

Moving on

When I was teaching watercolour flower classes it struck me how many people were scared of that white piece of paper. I agree, it is intimidating if you feel pressured into producing a finished work of art. Each time you paint you put a little part of yourself down on paper, and if you do not paint very often the nerves can take over. I am attempting to take the nervousness away by encouraging you to play.

On the following pages there are one or two ideas to try. Above all, enjoy experimenting. Good luck!

Play days

Every now and then I have a play day. This means that I forget about painting 'real' flowers, though sometimes I use them as a starting point. I just let my imagination take over and enjoy the feeling of using paint.

Recently I gathered together several photographs of poppies and daisies, got a much larger piece of paper than usual and began to experiment. Sometimes I feel that I do not do this enough and it is good to try a few different aspects of painting occasionally.

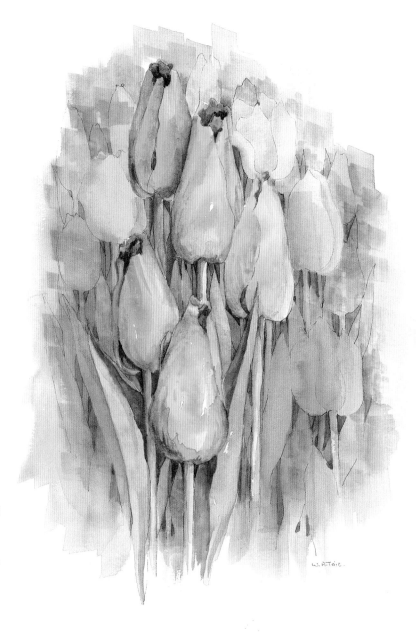

Unusual pen background

The germ of the idea for this painting was planted when I went to buy bulbs for the garden and saw a picture of tulips; although I did not use the photograph for the final painting. In fact, I did not use a photograph as reference at all!

I began this painting on dry paper and painted the pink and yellow tulips. After looking at it for some time, I decided to draw with a pen and added background tulips, shadowing them in a pale indigo wash. I then tried painting in the background using a flat brush to get the 'blocky' effect. I then painted a green wash overall. Another play day experiment, just to get the feel of doing something slightly different.

Hibiscus and Buddleia

A friend had these flowers in her garden and I was delighted by the subtle tones of pinks and lilacs. I painted them *in situ* which I thoroughly enjoyed. However, when I returned to my studio I felt that I had not captured the feeling of the flowers that I was after in the painting – I had lost the subtlety in trying too hard to be accurate.

On one of my play days, I decided to take drastic action. I mixed some deeper tones of the violets and blues that I had been using, wet the paper all over with a large 50mm (2in) brush and dropped these colours into the darker areas. This I allowed to spread and merge, lifting the paler flowers out with tissue.

After the paint had dried, I tidied up one or two areas and sharpened a lost edge here and there before I decided it was finished. I like the painting much better now, which shows that drastic action can sometimes turn something a wee bit ordinary into an adventure!

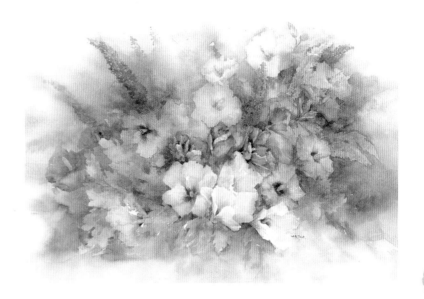

Using plastic wrap

I had a photograph of pink poppies so decided to try using plastic food wrap. I dropped in stronger background colours than I usually use, then put plastic wrap over the wet paint, pulling and pushing it about to make patterns of lines and swirls. I then left it to dry before peeling it away, to reveal a background filled with unusual shapes. I then painted into the negative spaces left by the plastic wrap to complete the painting. On reflection, I think I should make the background colours even stronger, perhaps using inks or gouache – something learned to try another day.

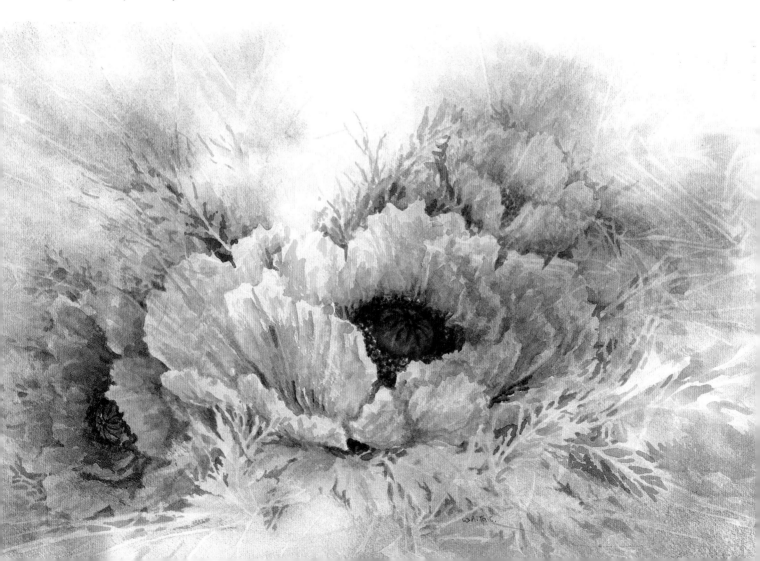

Using different media

This book concentrates on using watercolour paints, but there are different watersoluble products coming onto the market all the time, each with their own characteristics. Some of these may suit the way you like to work, or you could simply experiment with them in concert with your watercolour paints.

 If you are a little nervous of watercolour washes or would like to have more control than watercolour gives you, these are worth a try. The following pages show some flowers painted with media other than watercolour, and in combinations of different media.

Comparing different media

The roses here have been painted in three different media, showing that the same effects can be obtained whether you are using watercolour, gouache or Inktense pencils. If you are nervous about starting out with a new medium, why not start by repainting one of your unsuccessful watercolours?

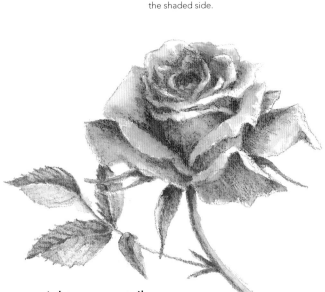

Watercolour
The paper has been allowed to shine through on the right-hand side where the light has caught the tops of the petals; and blue has been added on the shaded side.

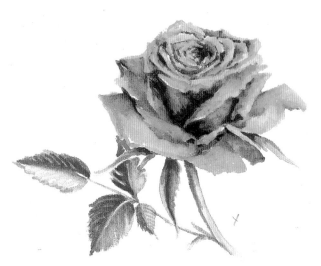

Gouache
The techniques used for this gouache rose are much the same as those used for the watercolour version (see above right), though as gouache paints are more opaque than watercolour, a little white has been added to the highlights.
 As with the watercolour rose, I used my usual technique of painting the petals with a brush, beginning with pale tones and gradually adding darker tones and colours.

Inktense pencils
This time I drew the petals lightly, blending with water as I went along. I then added different reds and pinks with dry pencils, shading where I needed darker tones. Once complete, I gently added water to transform the dry pencil into paint.

Using more than one medium

Some media can be combined – watercolour works well with pen, ink, watersoluble pencils and more. Experiment during your play days to see what effects you can create and what results you can achieve by combining different media.

Poppies in watercolour

26.5 x 38cm (10½ x 15in)

This painting was begun in the same way as many I do: I dropped in colour almost randomly to wet paper; keeping the inspirational photograph in mind for the positions of the colours. I decided to keep the colour running vertically and just kept adding deeper colours and tones as it dried.

Once dry, I drew a little with pen then deepened the tonal values behind various flowers using the same colours as before. As I applied wet paint I discovered that I had picked up a watersoluble pen, but I quite liked the odd blurry section so it might be something else to explore another time! I kept deepening smaller areas to bring out the flowers until I was aware that the whole thing was getting fiddly, so I stopped.

This painting will never be framed as I feel that it is just an exercise, but I had a lot of fun doing it and I love the colour mixes so it was worth spending the day 'playing'!

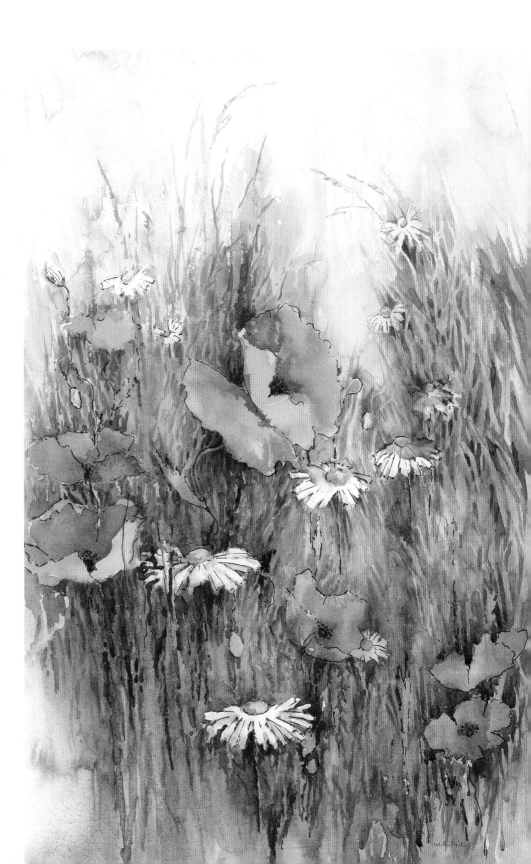

Gouache

Gouache is very similar to watercolour but it does have opaque colours. This means you do not always have to remember to leave areas free of colour for the paper to shine through as highlights.

If you want to use gouache it is a good idea to keep it completely separate from traditional watercolours, as it will spoil the transparency if mixed with them. I use a different plastic palette altogether.

I occasionally add white gouache to paint for highlights if I feel that a painting needs livening up. Sometimes you end up just making a mess and losing a painting, but it can end up as a semi-abstract which is much more energised. Never lose sight of the fact that painting should be all about pleasure and to let go sometimes can be very satisfying. Gouache, with its rich colours, is very suitable for this sort of experiment.

I have only a small selection of gouache colours but have included this painting to show another slightly different approach to watercolour flower painting.

OPPOSITE
High Summer
23 x 30.5cm (9 x 12in)

For this painting, I gathered together several garden photographs, a very large sheet of heavyweight paper and a big flat brush, then began painting quite loosely. I stood working at those for some time, then realised I was not getting the effect I wanted so decided on drastic action. I sprayed water over the painting, let it puddle in various areas and encouraged the colours to bleed into each other a little. I then dropped in more colour and let it spread until it blurred some edges. With kitchen paper I blotted out the light areas, then had fun adding even more colour – drier and in smaller areas this time, so that the rich colour mixed in various places. Because I used gouache , I I had access to an opaque white, which I added to blue and used to add highlights to the pale blue delphiniums.

A selection of gouache paints.

W.A.Tait.

Watersoluble oils

Although my first love is watercolour, I sometimes used to paint in conventional oils, with varying degrees of success. A couple of years ago I discovered watersoluble oils. Many people use them if they do not like the smell of turpentine, but I like them because I can use them in the same way as watercolour and have the advantage of using opaque colour at the end of the painting. Some oil brushes are useful to have in addition to your watercolour brushes.

I begin by using thin washes of paint and gradually build up the colours to a satisfying richness. One advantage over watercolours is that any mistakes or alterations can be scrubbed out with a wet cloth and painted over. While the paint is thin, they dry quite quickly, though once the subsequent layers go on the drying time can be two or three days.

When the painting is finished with some impasto areas, it is difficult to tell that it has not been painted with conventional oils.

A selection of watersoluble oils and oil brushes.

Cherry Blossoms
46 x 43cm (18 x 17in)

One of my favourite subjects at my favourite time of year. Whatever the medium, I always love painting blossom. I really enjoy all the different tones of pink – from the very palest to the rich darks in the shadows. I have found that a creamy white added to the edges of the petals catching the light creates a wonderful impression of sunlight in the painting. Watersoluble oils are fantastic for creating such effects.

Inks

A basic pack of acrylic inks is exciting to work with, and you can use the same brushes as for watercolours to apply them. When the background colours are dropped onto wet paper, using my usual method, they merge and blend beautifully. It has to be remembered that the colours of inks are much stronger than watercolours and it is easy to add too much. A little goes a long way with inks.

Inks dilute well and can be used in the same way as watercolour, but all the colours are very staining so mistakes can be quite hard to disguise. I was surprised to find that I could get such delicate tones with a very basic kit of six colours that were not necessarily my choice.

I find that caution is the key in the early stages of painting when using inks, and to try the colour on practice paper as you go along.

A selection of inks.

Cherry Blossoms

61 x 46cm (24 x 18in)

I make no excuses for another blossom painting, made using inks with watercolour technique (reserving the lights and finishing with tiny darks), this time. For this painting, I began by dropping a little of the colour onto wet paper leaving very pale pinks where the blossoms would be, then allowed it to dry.

Next I painted the palest blossoms, rewetting each small area, gradually adding the deeper pinks. The lovely bronze leaves came next, then the branches of the tree, tucked behind the blossoms and providing the strong contrasts. Whatever medium you are using, these darks should always be the smallest area in the painting.

To finish, I mixed a pale blue-pink and added a few out-of-focus blossoms into the background.

Inktense pencils and artbars

Inktense pencils are easy to use and transport, and are available in a wide range of colours. Applied as though using a normal pencil, they can be used dry or wet depending on the intensity of tone that you require. Artbars are wax-based solid blocks of pigment that I mostly use to add backgrounds, sometimes spreading the colour with a wet brush and adding depth later when the main flowers are complete. Like inktense pencils, the colours can be used wet or dry depending on the effects required. It must be remembered though, that once water is applied the colour will be much more intense. I find that a smooth hot-pressed paper works best for these media.

A selection of Inktense pencils

I have used both inktense pencils and artbars by wetting them, splaying a brush onto them and then spattering the colours over areas of the paper at the end of a painting, which is fun to do. Any spatters in unwanted areas can be quickly removed with a wet brush. When wetted, artbars can be used with a sponge to stipple an interesting background too.

Whether you use these materials together, separately or in combination with watercolours, the answer – as always – is to experiment, have fun and enjoy what happens.

A selection of artbars

Field Poppies

The poppies were first drawn lightly using Inktense pencils. Blue sky was added using soft diagonal lines which were then wetted and merged with a brush. The same treatment was used for the background cornfield. I applied dry colour to the poppies, then wetted them and used the pencilled colour as paint. When this was dry I drew in the details of the centres. Once all the details were in place, a fine brush was used to take colour off the pencils to deepen the negative areas behind the stems with browns and greens.

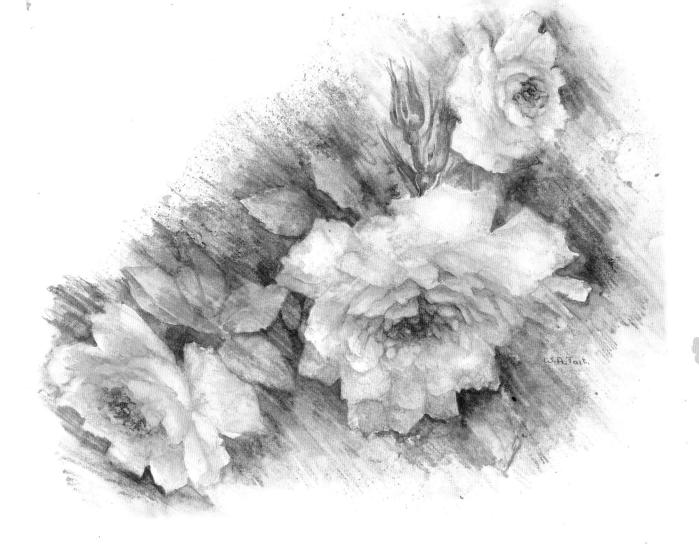

Wild Roses

I began this painting by softly scribbling a soft background with dry artbars, which was then sponged. Next, I lifted colour out with a brush for the flowers.

Most of the leaves were then defined with dry Inktense pencils and were then wetted with a brush to deepen the negative areas behind them. The tiny twigs and centres to the flowers were added to finish the painting.

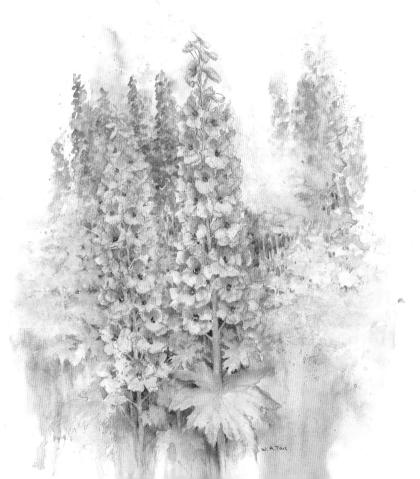

Delphiniums

Produced in inktense pencils, these delphiniums were first drawn in lightly in mid blue. The background was then added using very soft pencil, that was subsequently wetted with a brush to make a soft wash.

The foreground leaves were given the same treatment in different tones and colours of greens. I then went back into the delphiniums and added the tiny details and shading.

Rescuing paintings

The full impact of a picture is often not apparent until the final stages, and it is easy to succumb to impatience and abandon a painting that requires only a little more work to really become something special.

Over the next few pages I have included several paintings that I do not think work successfully, along with my tips on how to improve them. Perhaps you can apply these tips to paintings you may have abandoned and can rescue.

Fuchsias: identifying the problem

I painted this while I was giving a demonstration to an art club. When I picked it up again some months later I could see that there was a 'hole' right where I wanted my focal point.

With a grid (see page 41) laid over the picture, it is obvious that there is no real focal point as the grouping of the flowers is too random, leaving the green hole where the flowers should be.

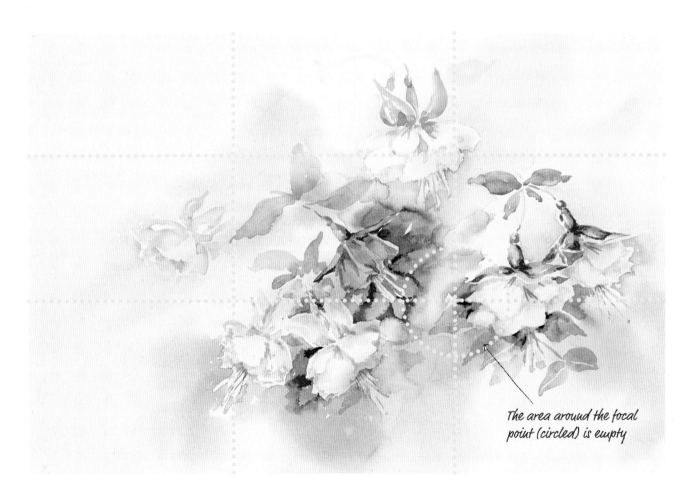

The area around the focal point (circled) is empty

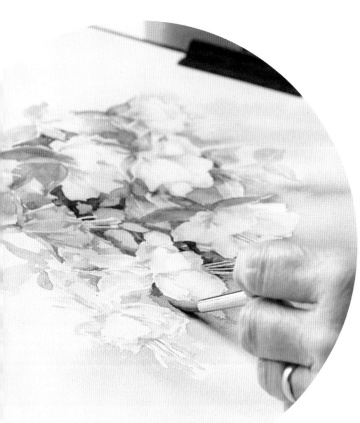

Rescuing this painting

The composition needs to be reweighted and strengthened in tone overall, especially around the focal point.

This composition was fairly easy to remedy as I added more leaves, popped another flower into it and made sure that the darkest part of the background was behind it. This moved the focal point to the right-hand crossing of the grid. I also added a little pen drawing to sharpen one or two areas.

When a painting needs rescuing, always look at the areas behind the flowers and the tiny darks surrounding them, not the flowers themselves. This way the freshness can be kept.

Fuchsias

Once I had added the additional flowers and darks around the focal point, I used a sepia fineliner pen to add further contrast and definition to the flowers. This finished painting shows how further development can pay off – so it is sometimes worth the risk!

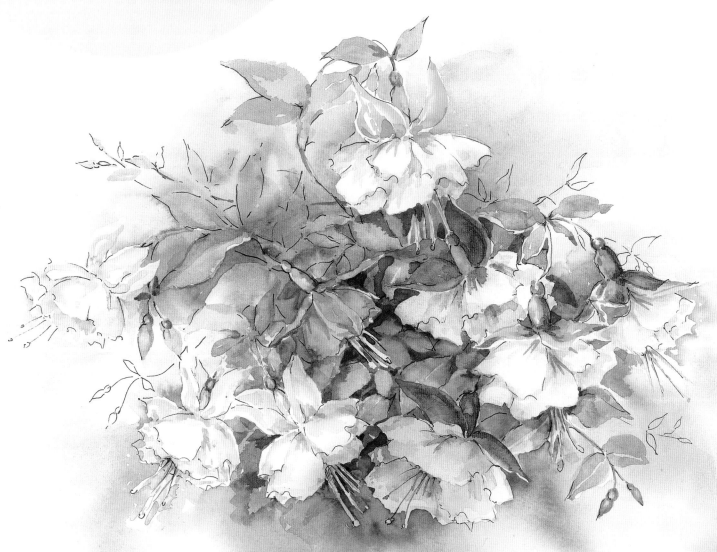

Roses in my Garden: identifying the problem

This painting was going quite well until, working on a whim, I put in the tall blue flowers on the left-hand side. Unfortunately, these unbalanced the composition, drawing the eye away from the focal point.

If you are quick, you can sometimes wash out unsuccessful experiments by keeping the colour wet and then lifting it out with kitchen paper. In this case, I have attempted to wash them out unsuccessfully and the painting remains slightly unbalanced.

However, all is not lost. There are a number of ways to rescue paintings affected like this. The first is to crop the painting, to bring the focal point out of the centre; and the second is to continue painting, rebalancing it by adding weight to the right-hand side.

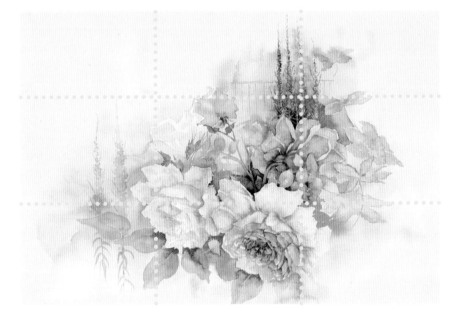

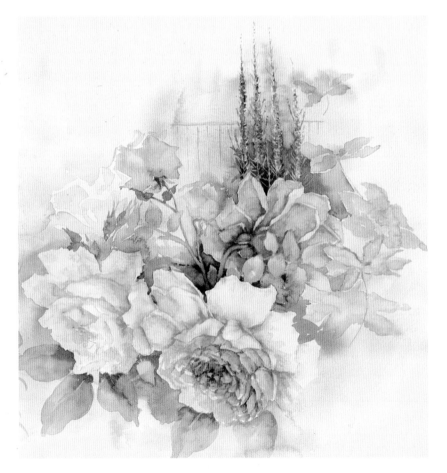

Cropping

Here, the painting has been improved by simply cropping the left-hand section away. The square format brings the balance of the painting to the right and places the blue flowers and foreground roses on the grid intersections (see below).

You can crop a painting by cutting the paper or, if you are cropping only a small amount, by simply covering part of the painting with the mount (sometimes called a mat) before framing it.

Pushing forward

It can be intimidating to continue working on a painting that seems finished, but you can rebalance the painting by deepening the tone on the area you wish to draw the eye towards.

In this example, as the roses had long finished flowering in the garden, I decided to deepen the areas behind the main rose (my ballerina) and add a little more background behind the clematis on the right. This brought the focal point back to the right-hand side. I also cropped the painting more closely around the flowers, making an almost square painting.

141

Roses in my Garden

The refined painting is a great improvement on the earlier version.

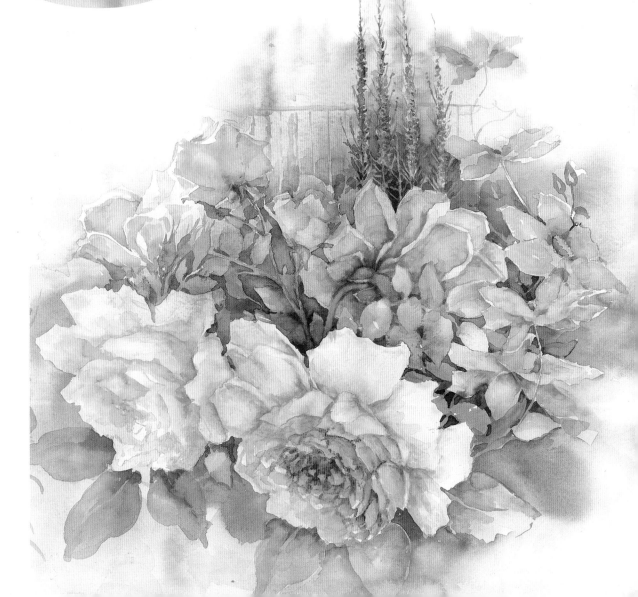

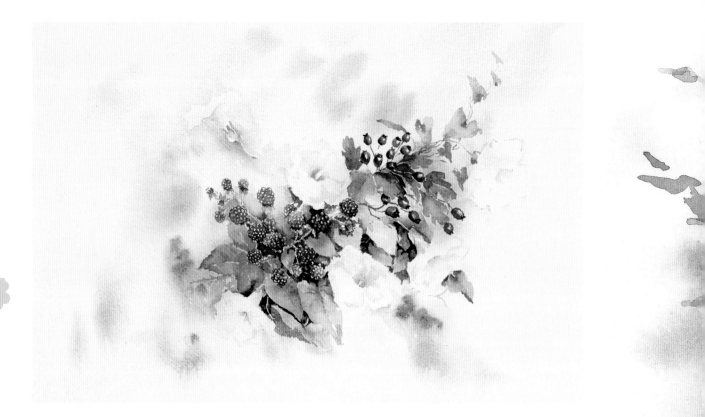

Blackberries and Bindweed: **identifying the problem**

The focal point in this painting at the moment is the blackberries. This is not working because the white flowers will always take the eye first and they are currently too evenly spaced either side. There is also a line running across the painting which needs to be broken up a little.

The painting would work much more successfully if the focal point were moved and the balance of the painting as a whole adjusted.

This demonstrates the importance of evaluating your painting as you work. If you can identify potential difficulties earlier, then you can take measures to fix things before they turn into problems. This is particularly important when working with white flowers, as you have to reserve the area in which they will sit until you come to work on them near the end of the painting.

Rescuing this painting

Here I introduced more white flowers and foliage to the top left. This was possible because the background here was still light.

The contrast between the white flowers at the top left and the dark foliage behind them helps to draw the eye. This gives a balanced, pleasing result to the finished picture.

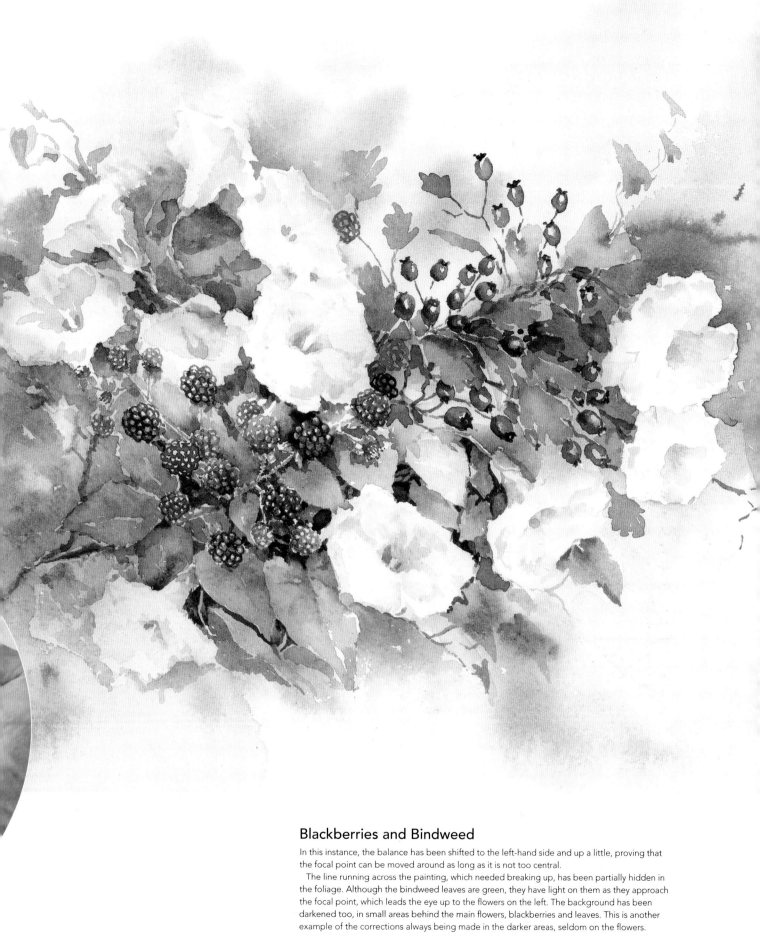

Blackberries and Bindweed

In this instance, the balance has been shifted to the left-hand side and up a little, proving that the focal point can be moved around as long as it is not too central.

The line running across the painting, which needed breaking up, has been partially hidden in the foliage. Although the bindweed leaves are green, they have light on them as they approach the focal point, which leads the eye up to the flowers on the left. The background has been darkened too, in small areas behind the main flowers, blackberries and leaves. This is another example of the corrections always being made in the darker areas, seldom on the flowers.

Index

144